Native Arts
of North America

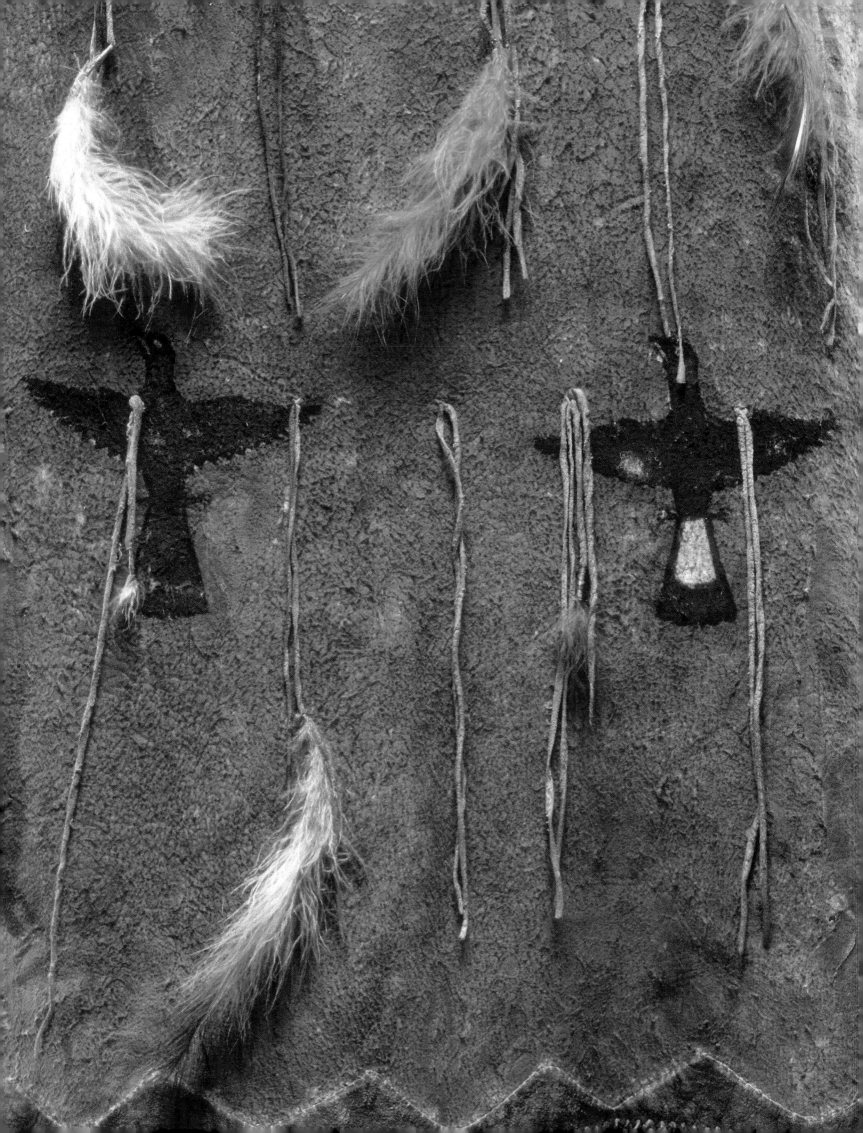

Native Arts
of North America

David W. Penney

Telleri

© FINEST SA/PIERRE TERRAIL EDITIONS, PARIS 2003

ISBN 0-681-69258-8

Printed in Italy

F. Kabotie

Contents

Introduction

This book attempts an impressionistic history of Native American art. It is not a Native American art history. This may not seem like an important distinction, but it is. A Native American art history would be a history from a Native point of view, eschewing the imposed structures of the academy in favour of local ways of knowing and telling. Several writers of Native descent are currently exploring what kind of thing such a history might be. I follow their work with interest, but I am not one of them.

I am a museum curator, a professional scholar and writer, trained in the discipline of art history. I write this book from the garnered wisdom of other books, from my study of museum collections and from my conversations with Native people: artists, writers, scholars, intellectuals, religious practitioners, both traditionalists and progressives. The diverse group of my acquaintances adds up to no consensus, and my queries to them have not been systematic or comprehensive. I have engaged in this dialogue for some time, reading, listening and looking. All I can pretend to do here is share with the reader the little I believe I have learned. Many things are missing. I have not discussed the arts of the Arctic peoples, and my treatment of the 20th century is cursory.

There are two salient issues that I hope inform every chapter of this book: one has to do with art, the other with history. Over time, different kinds of things have been called art for different reasons. Less than one hundred years ago to call many of the objects illustrated in this book 'art' was a revolutionary act. Few

would see it that way today. Now when we talk of Native American 'art', we do so as an expression of respect and admiration, although the word often clouds the facts of what such objects really are – smoking pipes, regalia, storage jars, and such. The artfulness of these various things lies in the ways their visual appearance has been constructed to give them cultural meaning. My emphasis in the chapters that follow will be on these processes of meaning, rather than on aesthetic appreciation *per se*.

The second issue concerns history. 'Traditional' Native American culture is often seen as conservative and unchanging. There are certainly conservative elements in that culture, particularly today when the preservation of tradition has become a question of cultural survival. Yet all the Native people of my acquaintance wrestle with the question of what it is to be of Native descent in the modern world, of how to be 'modern' and 'traditional' at the same time. This is not a situation unique to the late 20th century; the history of Native American art is a history of change. The artists of each generation learned the traditions from their elders, only to transform them in the light of their historical experience. As a result, there is no single Native tradition; rather, there are myriad linkages between past and present, each of them defined by the creativity of the individual artist.

In this book I explore the relationships between Native American 'art' and Native American 'history'. In doing so, I have been helped by a great many friends, colleagues and scholars, to whom I would like here to reiterate my gratitude. I dedicate this book to my children, Hilary and Joel.

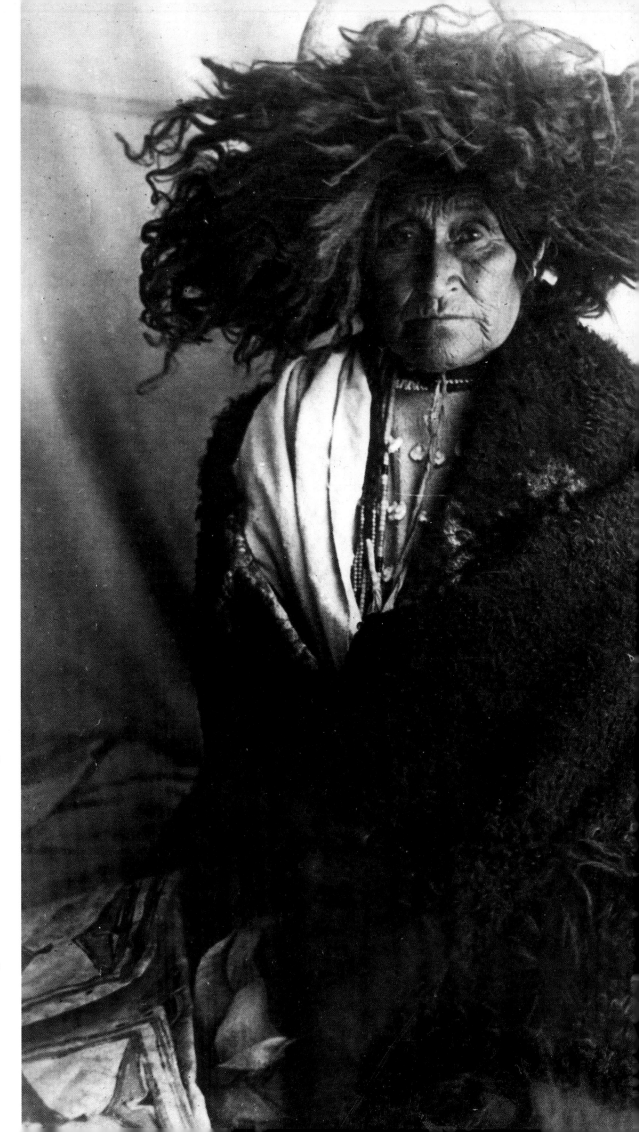

WOMEN HEALERS
Early 20th century.
Waterton Lakes National Park
Reservation,
Canadian Rockies.

Page 12 |
BEAR EFFIGY BOTTLE
1300–1500, Mississippian culture,
Arkansas or Tennessee.
Fired clay,
height 19.5 cm (7 3/4 in).
University of Arkansas Museum, Fayetteville.

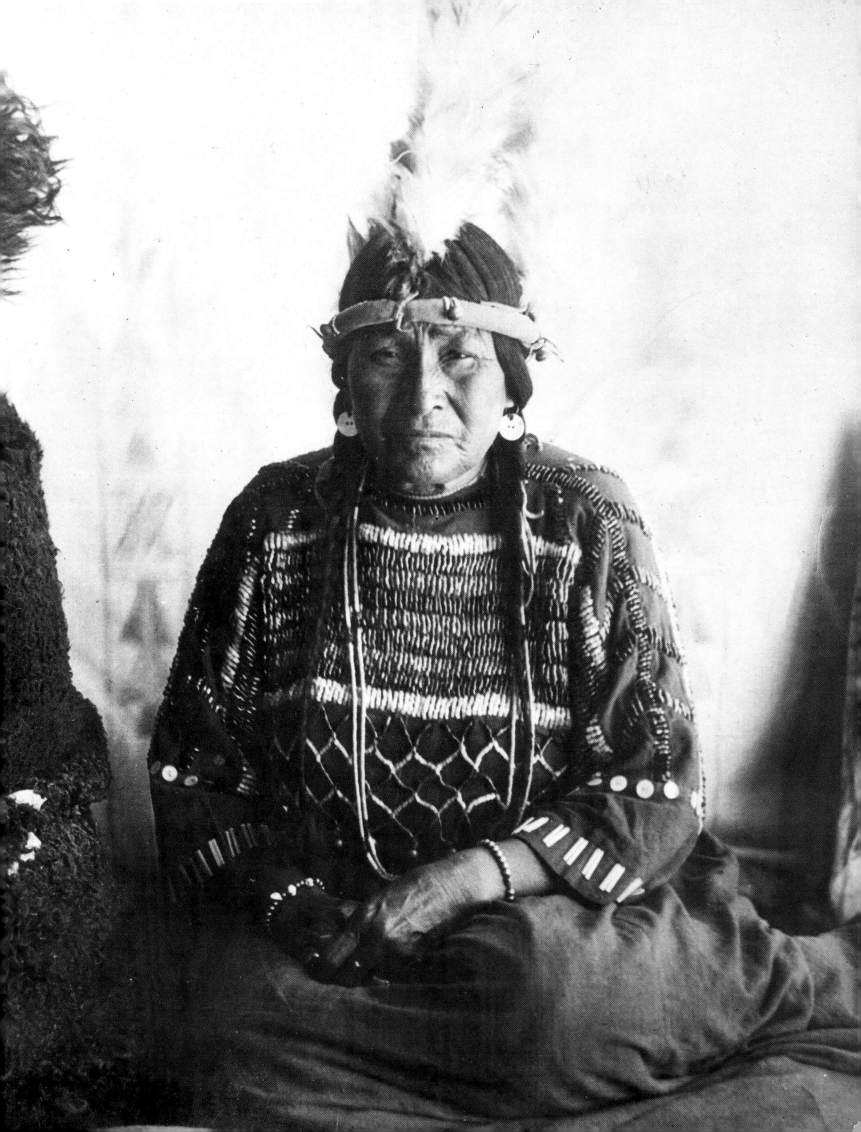

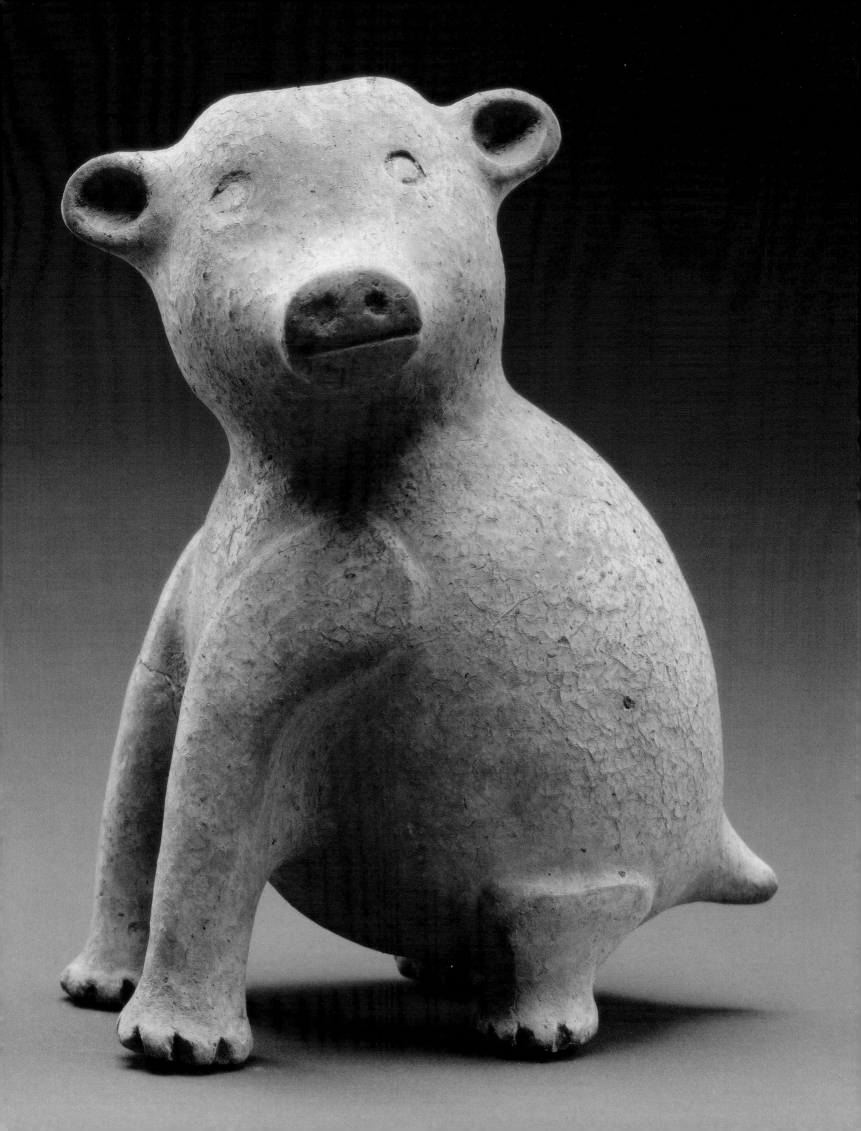

1. Mound Builders of the Midwest

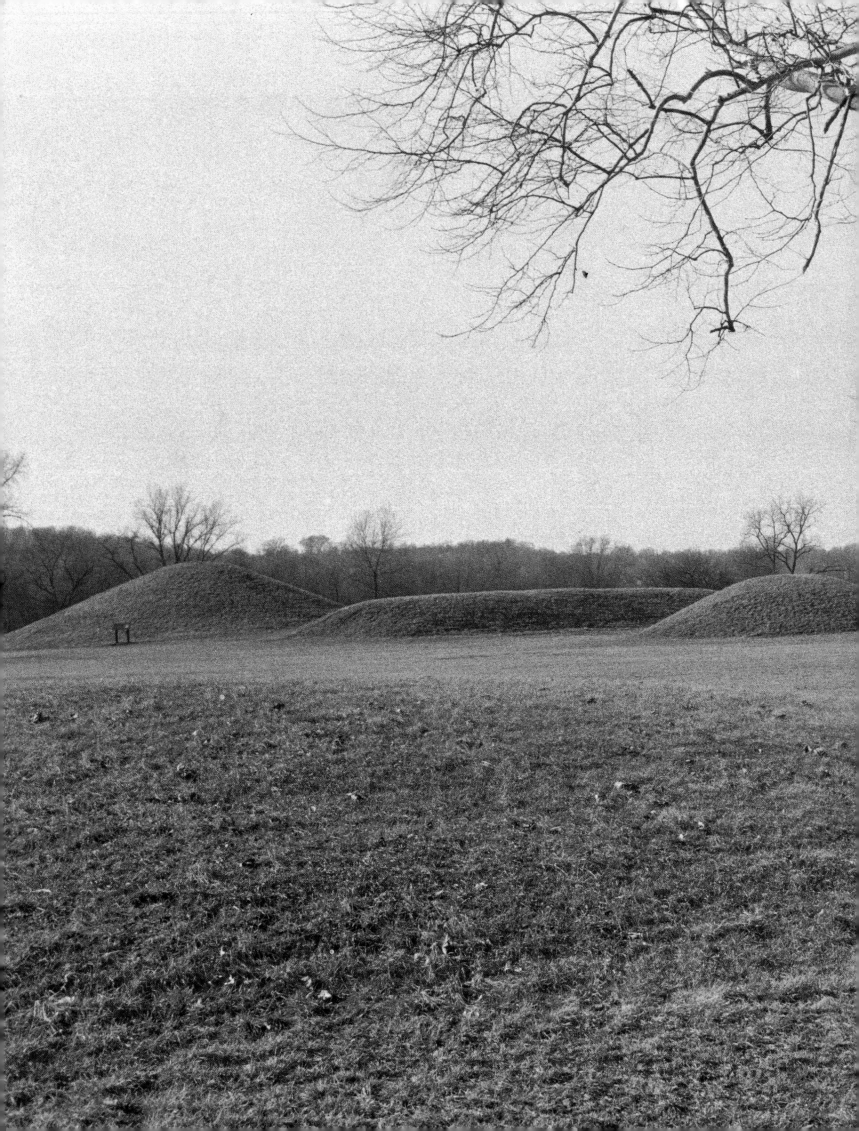

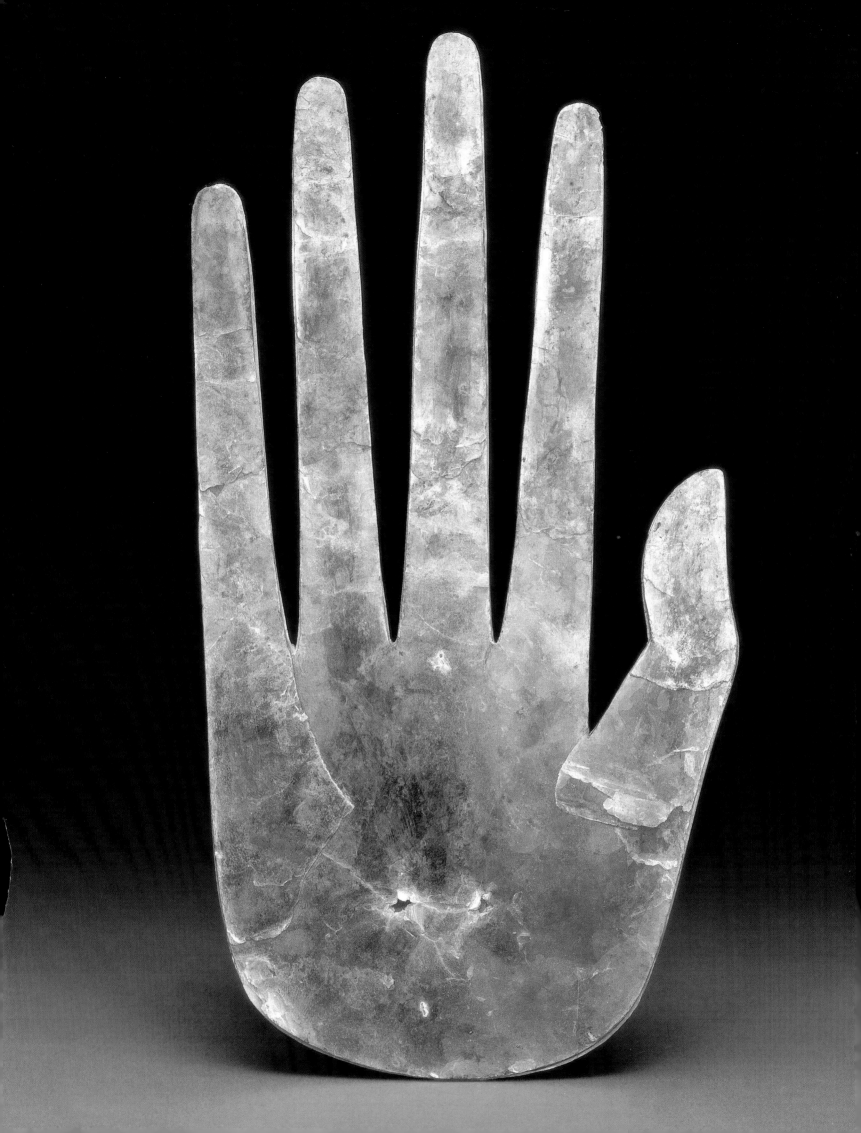

The conical mounds and earthworks of the Midwest are some of the most intriguing archaeological sites in North America. Beginning three thousand years ago, ancient North Americans erected earth structures throughout the eastern woodlands. The most extensive sites are found in southern Ohio, where they cluster along the lower terraces of the Scioto river and its tributaries. Several feature circular and octagonal enclosures that rise over 10 feet high and may measure some 1,500 feet across. Some have avenues that stretch for miles between earthen embankments. Inside the earthwork enclosures or stationed like satellites in their vicinity are more mounds, conical and loaf-shaped, from 5 to 20 feet in height. These monuments so impressed European American settlers in the early 1800s that they could not believe they were the work of ancient American Indians, preferring to imagine instead a race of extinct 'mound builders'.

| Pages 14–15
MOUND CITY NATIONAL MONUMENT
200 BC–AD 600,
Hopewell culture.
Chillicothe, Ohio.

The Hopewell culture

They were wrong, of course. Radio-carbon datings indicate that the southern Ohio earthworks were built between 200 BC and AD 400, an era now known as the Middle Woodland period (as distinct from the Early Woodland period – 1000–200 BC – and the Late Woodland period – AD 400–900). The hunter-gatherer society that made them live not in large towns or villages, but in homesteads and hamlets scattered across the rolling woodlands. The earthworks were collaborative projects built over the span of several generations. Archaeologists have named the culture that made them the 'Ohio Hopewell' after a site located on the Hopewell family farm, where a group of twenty-five mounds were constructed within an extensive oblong enclosure.

When archaeologists excavated these mounds, they unearthed the remains of large wooden structures ranging from 50 to 150 feet in length, built from posts sunk into the ground and covered with sheets of bark or woven mats. They were oblong or oval-shaped and often partitioned into several rooms. In these rooms the remains of the dead were carefully laid out in shallow log tombs or cremated in pits. Offerings were placed around the bodies or gathered together in massive caches sunk into the floor. These 'charnel houses' could accommodate the hundreds of bodies, all members of the same social group, that accumulated

HAND
| 200 BC–AD 400,
Hopewell culture,
Ross County, Ohio.
Mica, 28.9 x 15.9 cm
(11 3/8 x 6 1/4 in).
Ohio Historical Society, Columbus.

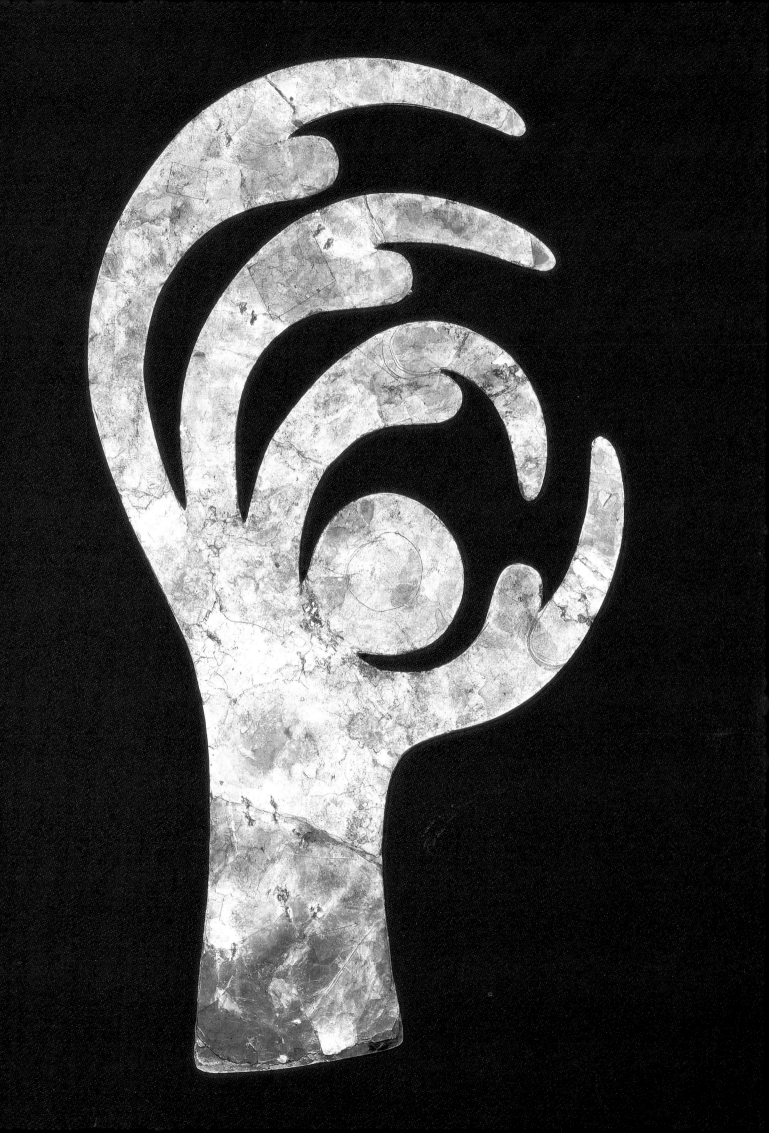

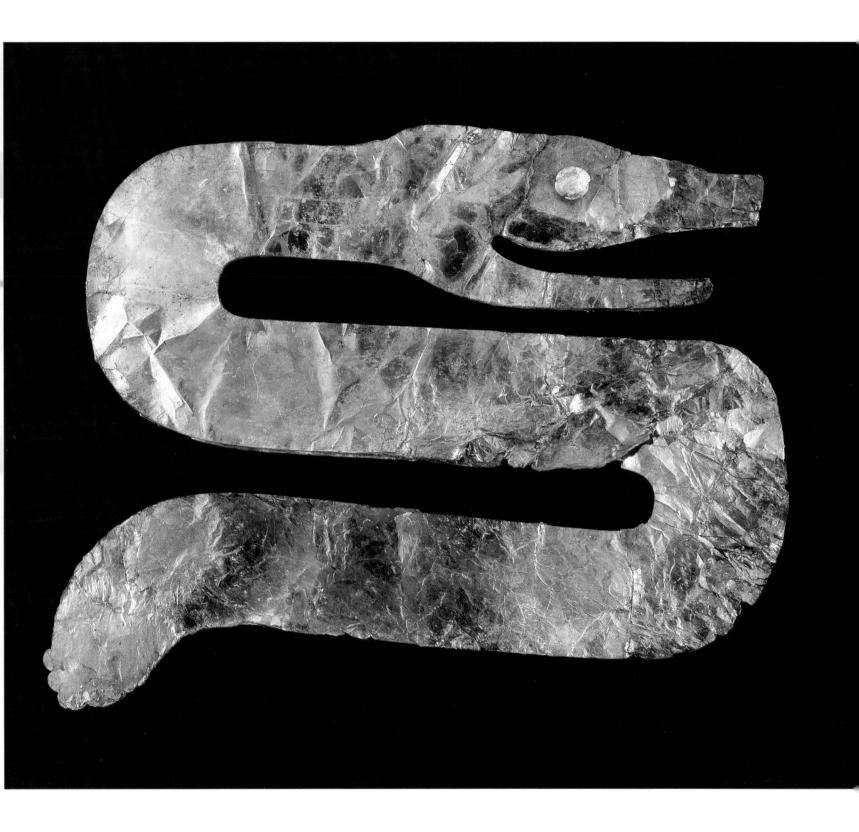

SERPENT
200 BC–AD 400,
Hopewell culture, Turner site,
Hamilton County, Ohio.
Mica, 27.3 x 33.7 cm (10 3/4 x 13 1/4 in).
Peabody Museum, Harvard University, Cambridge.

HORNED SERPENT'S HEAD
200 BC–AD 400,
Hopewell culture, Ross County, Ohio.
Copper, height 50.8 cm (20 in).
Field Museum of Natural History, Chicago.

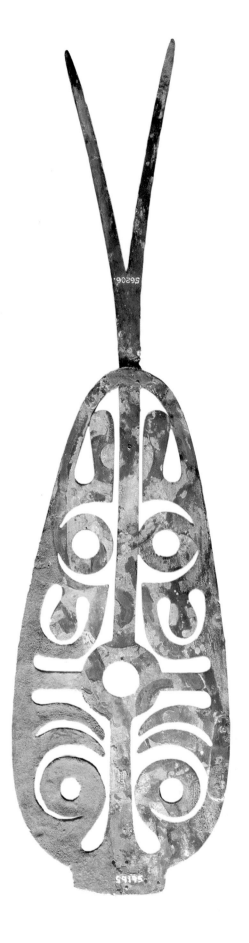

over a long period of time. The mortuary ceremony was concluded when the structure itself was burned and a mound of purifying earth piled up over its charred foundation. Work then began on another charnel house, and thus the cycle continued.

The artefacts and works of art placed beside the dead make up a rich and varied assortment of mortuary offerings. Burial 47 in mound 25 of the Hopewell site consisted of two male adults laid side by side. A cup made from a large conch shell lay near the head of one, along with a small collection of bone needles. He was wearing a necklace of shell and freshwater pearl beads, and an axe blade of copper wrapped in fabric along with the remains of a small hawk or falcon was lying on his chest. Another copper axe lay lower down his abdomen, and near his hand was a seven-inch blade of amber chalcedony. Close by was a remarkable effigy of a human hand cut from a paper-thin sheet of muscovite mica. Two more mica effigies represented the feet and arching talons of an eagle.

Archaeology has little to tell us about the ideas that informed the creation of such objects. However, the traditional symbolism and cosmology of more historically recent Native peoples can provide some clues. The use of mica was itself significant, since the ancient Hopewell people travelled a great distance to procure it from quarry sites in the southern Appalachians. Many Hopewell burials are covered with carpets of roughly-shaped sheet mica, though delicate mica effigies are rare. It was probably the colour and lustre of muscovite mica that attracted these early ritualists. Like water, and the trade mirrors prized by later Native peoples, mica may have represented a 'window' onto the land of the dead. For the historic woodlands tribes, the colour and lustre of exotic materials – copper, shell, white quartzite, red pipestone – came to symbolize different aspects of spiritual power. Ohio Hopewell burial offerings are rich in such materials, suggesting that they had the same significance for this ancient ancestral people.

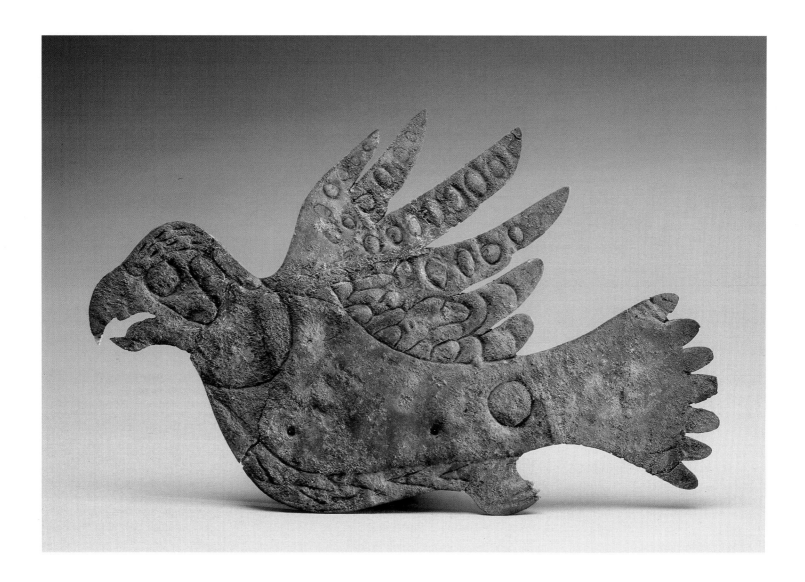

The image of the human hand relates to a larger theme encountered both in the art of the Hopewell and in their mortuary rituals: the preservation of portions of human bodies and the representation of these body fragments as effigies, particularly heads and hands. Thus an additional human skull was placed beside the two men of burial 47. Images of heads, hands and headless torsos made from mica and copper have been found in other Ohio Hopewell mounds.

The mica cut-outs of eagle claws from the same burial 47 exemplify another important theme in Hopewell art – the preserved part of an animal that also on occasion accompanied the Hopewell dead. I have already mentioned the small hawk or falcon wrapped in cloth, along with a copper axe, which lay on the chest of one of the men of burial 47. Such remains were extensively used by the historic peoples of the woodlands region in making up sacred bundles. These bundles had healing

properties; they brought success in warfare, as well as general well-being. Woodland peoples regarded the animals in question as spirit helpers, to whose power the sacred bundle could give them access. Archaeological discoveries attest the existence of a whole ritual practice surrounding this belief.

The images of animals that abound in Hopewell art may well represent spirit beings. Some of the spirit beings most commonly recognized by historic tribes can be identified in Hopewell art. A stone effigy 'boatstone' and a sheet mica effigy from the Turner site both represent the horned serpent or underworld monster of the Ojibwa and the Odawa, who lived beneath lakes and rivers and raised great tempests with its tail. The oral traditions of many woodlands tribes also describe a great, celestial thunder bird, like a giant hawk or eagle, who has powers over thunder and lightning. Its metaphorical analogues – eagles, hawks and falcons – figure extensively in Hopewell art. The thunder bird and the underworld monster together personify the spirit powers that reside in the over-arching dome of the sky-world and the watery subterranean underworld, between which lies the earth. Images of eagles, falcons and horned serpents from major Hopewell burials represent the earliest visual expressions of these cosmological figures which can be found throughout North

| Page 22
FALCON

200 BC–AD 400,
Hopewell culture, Mound City
site, Ross County, Ohio.
Copper, 13.3 x 24.1 cm
(5 1/4 x 9 1/2 in).
The Mound City Group National Monument,
Chillicothe.

RAVEN EFFIGY PLATFORM PIPE

200 BC–AD 400,
Crab Orchard culture, Rutherford
site, Hardin County, Illinois.
Conglomerate, 6 x 12.1 cm
(2 3/8 x 4 3/4 in).
Illinois State Museum of Natural History and Art,
Springfield.

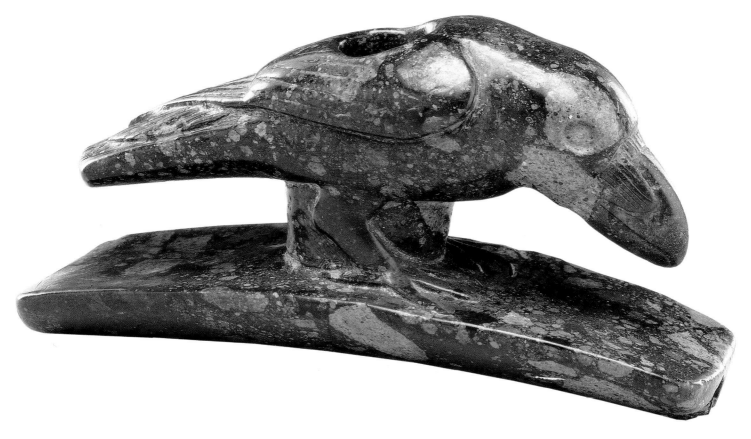

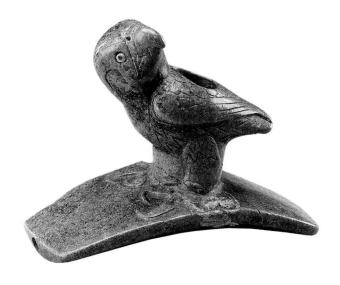

America. These powerful beings are associated with the richest and most prominent tombs, which suggests that the social ranking visible in Hopewell mortuary practice may have been linked to the spirit powers which men and women were able to acquire and control during their lifetimes. The objects placed beside them during their funeral ceremonies were the symbolic expression of those powers.

Interactions and influences

The mortuary offerings of the Hopewell were made out of materials procured from many different sources: marine shell cups and beads from the south Atlantic coast, mica from the southeast Appalachians, even obsidian from the upper Yellowstone river in present-day Wyoming. These materials had been gathered by a system of trade linking Ohio with distant regions of the greater continent. Indeed, several contemporary Middle Woodland cultures, located to the north, south, east and west, have left behind clear signs of their involvement both with Hopewell-related funerary practices and with cross-continental networks of exchange.

Many geographically distant cultures of this period also practised variants of Hopewell mound burial, although none as elaborate as the Ohio form. In the Illinois valley and adjacent portions of the Mississippi, people of the Havana culture collected their dead in log crypts covered with sheets of bark and piled modest earthen mounds on top. The Crab Orchard people of southern Illinois and adjacent Indiana built similar kinds of crypts. People of the Marksville culture in the lower Mississippi valley arranged their dead on broad earthen platforms, again

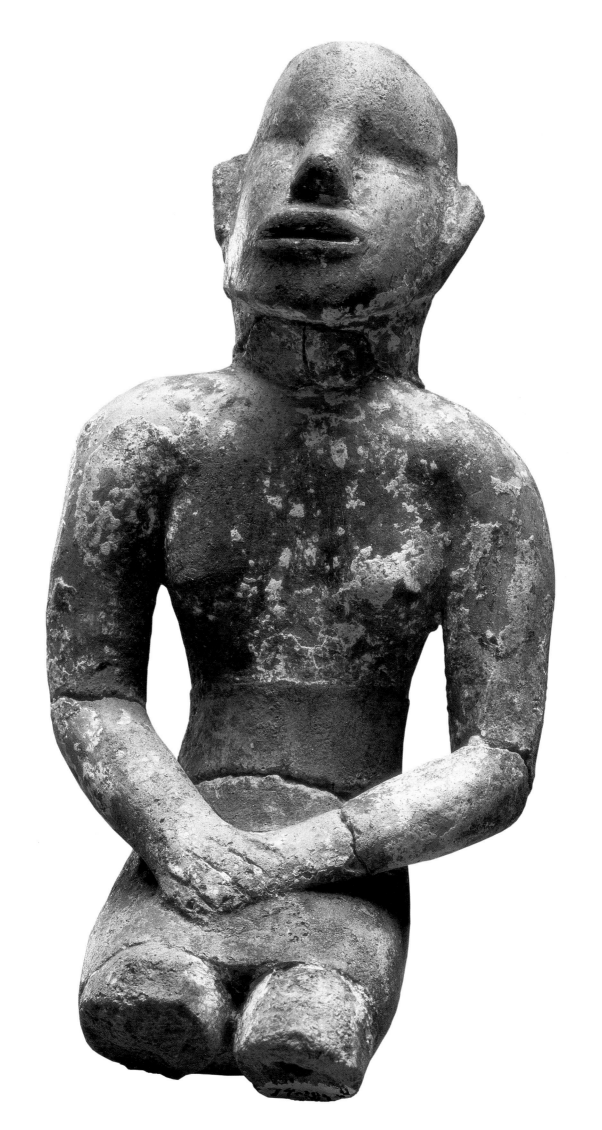

HUMAN EFFIGY URN
600–900, Weeden Island culture,
Buck Mound, Okaloosa County, Florida.
Fired clay, height 38.4 cm (15 1/8 in),
diameter 24.1 cm (9 1/2 in).
Temple Mound Museum, Fort Walton Beach.

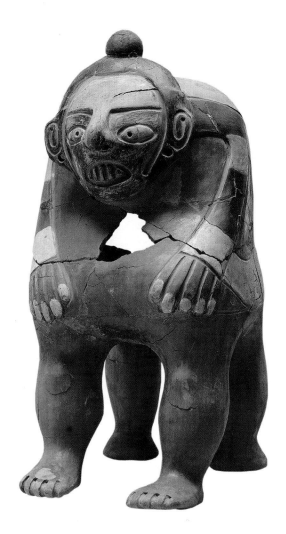

with a mound piled on top. Burial mounds were also constructed by the Copena culture of Tennessee, the Porter of the Gulf Coast and the Swift Creek of northern Florida and southern Georgia, among others.

More than the broad outlines of burial mound ritual, it is the use of distinctive Hopewell burial offerings that unites these geographically disparate cultures. Copper axe blades and breast plates, copper 'panpipes', marine shell cups, and several other categories of objects have been found in burial mounds in Ohio, Illinois, Louisiana, Tennessee, Georgia and Florida, linking these cultures together in an interaction sphere of ritual practice and shared knowledge of a single symbolic system.

The effigy platform pipe is one of the most aesthetically remarkable inventions of this common culture. A crematory pit in the charnel house at the Tremper mound – an Ohio Hopewell site located near the confluence of the Scioto and Ohio rivers – was found to contain a cache of over two-hundred smoking pipes along with hundreds of other artefacts. Many of the pipes were carved with striking images of animals of many different species, shown standing or seated on a horizontal platform which functioned as the mouthpiece for the pipe. Each of these small masterworks captures the characteristic gestures and unique markings of the species, down to the texture of their fur or feathers, rendered with engraved marks.

Two other caches of effigy platform pipes were found at Mound City, another Ohio Hopewell site further up the Scioto river. Individual pipes have also been recovered from isolated single burials in Havana and Crab Orchard mounds, hundreds of miles to the west, in present-day Illinois. The pipes from Illinois are so similar to those from Tremper and Mound City that one might think they were goods obtained from a common source by trade. However, the distinctive materials used for the Illinois pipes confirm their local manufacture. Some individual pipes may indeed have been exchanged, but it was above all the idea of the pipe, in

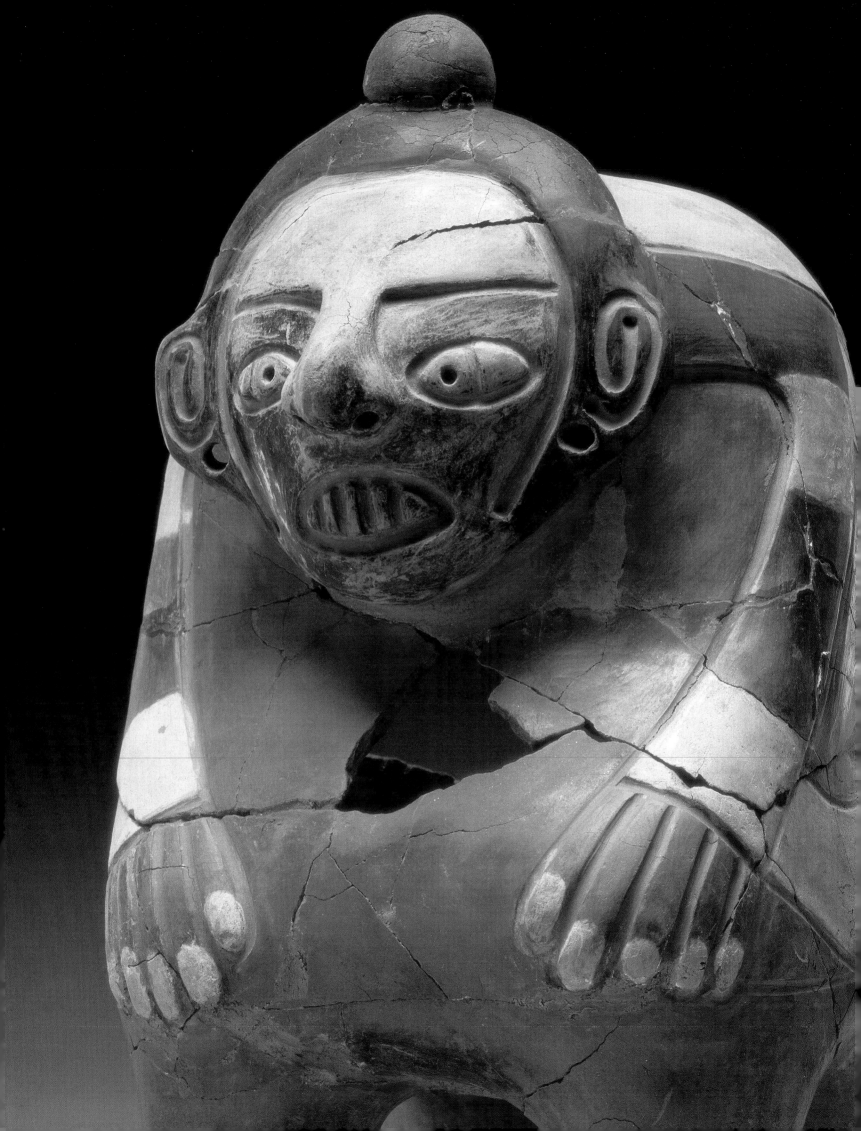

CASTELLATED VESSEL
400–900, Weeden Island culture,
Fowler's Landing site,
Levy County, Florida.
Fired clay, height 13.3 cm (5 1/4 in),
diameter 16.5 cm (6 1/2 in).
National Museum of the American Indian, New York.

all its symbolic and ritual significance, that circulated through the Hopewell trade network.

The tobacco plant is sacred to indigenous peoples throughout the Americas. In the tobacco origin stories of many North American tribes, it is commonly explained that the Creator gave men tobacco so they would have something to offer up to the spirit beings in thanks for their blessings. Pipe smoking accompanies nearly every form of ritual among the woodlands and Plains tribes, from the formal greeting of strangers to the most sacred moments of religious ceremony. Some individual pipes are seen as closely linked to the general health and spiritual well-being of an entire clan or tribe. Through appropriate rituals, the powers of such a pipe can be transferred to others; in such a case, the pipe itself is not necessarily offered. Instead, the owner transfers to another the rights to reproduce the pipe and the knowledge necessary to practice its attendant ritual. The exchange of religious prerogatives instead of objects is common throughout North America, and may help explain how Hopewell ritualism and its accompanying artefacts spread far and wide across the eastern woodlands.

Small human figures in fired clay can also be found throughout the Hopewell interaction sphere. A figurine from the Block-Stearns site in northern Florida is characteristic of a style found at mound sites from Florida, through Georgia, north to southern Indiana and Illinois. The figure is small and dressed in a simple skirt, without ornament. It has abbreviated limbs and a square-tapered brow. Figures of similar size but in quite a different style have been found at Ohio Hopewell (Turner), Havana and Crab Orchard sites in Illinois. They abound in descriptive detail, illustrating precisely how people sat, what they wore, how they arranged their hair. As such, they are the earliest artefacts to show us the physical appearance of ancient Americans. The relationships between the two figurine styles define two axes of cultural influence, one extending from the South-East to the Midwest, the other running east-west between the Scioto and Illinois valleys.

What was the purpose of all this artistic and ritual activity? Middle Woodland communities were, for the most part, egalitarian societies. The prominence and authority one achieved

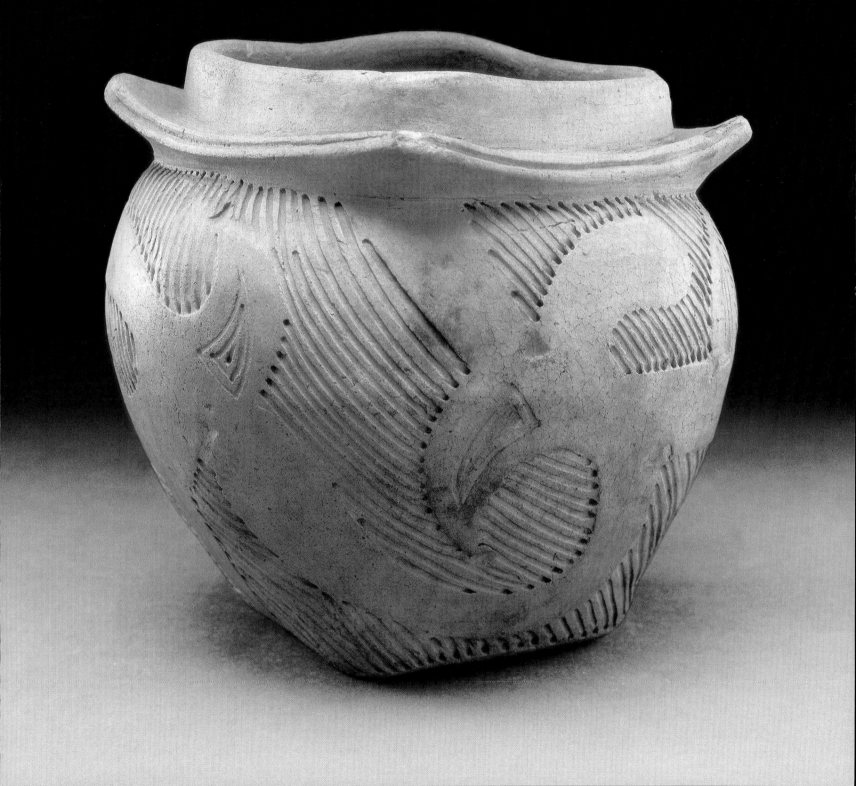

during one's lifetime stemmed from personal effort rather than birthright or class. Evidently, the procurement, display and ritual use of exotic Hopewell objects stood as a measure of social rank. Obtaining the rights to these kinds of objects required diligent cultivation of relations with outsiders. The funeral ceremony may have been an opportunity for family groups to display the objects of power their loved ones had accumulated over their lifetime, or to assemble such a collection on their behalf, as happened in the case of child burials, which were often the occasion of great ostentation. Mortuary rituals seem to have included great feasts where the social rank of the dead was publicly acknowledged. The impressive earthworks of the Ohio Hopewell might then be interpreted as a means of marking where such festivals took place, as a sign to travellers from throughout the woodlands who would come to share, support and sanction the dead who were honoured there, bringing with them treasures and sacred knowledge from their own communities for exchange. Within this expansive network of cultural interaction, the symbolic object signifies a knowledge and power that can be transported, transferred, possessed and displayed.

2. Art of the Mississippi Chiefdoms

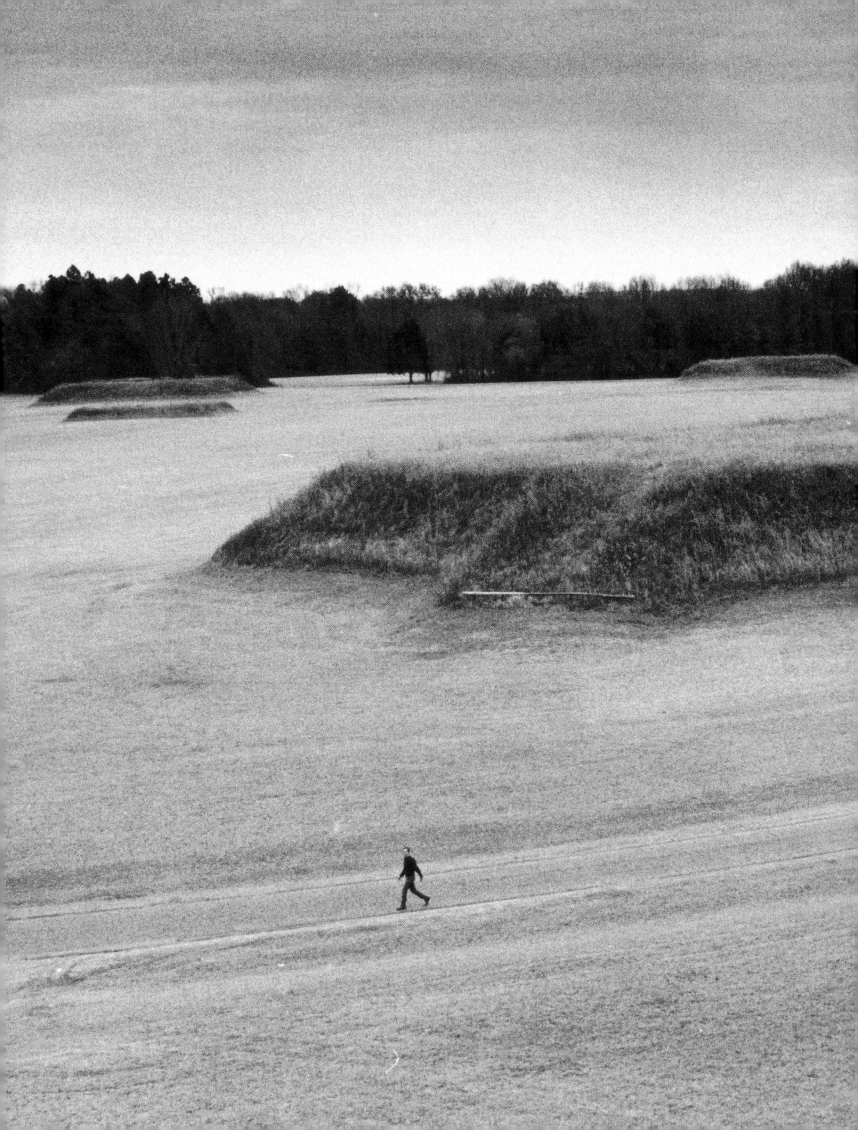

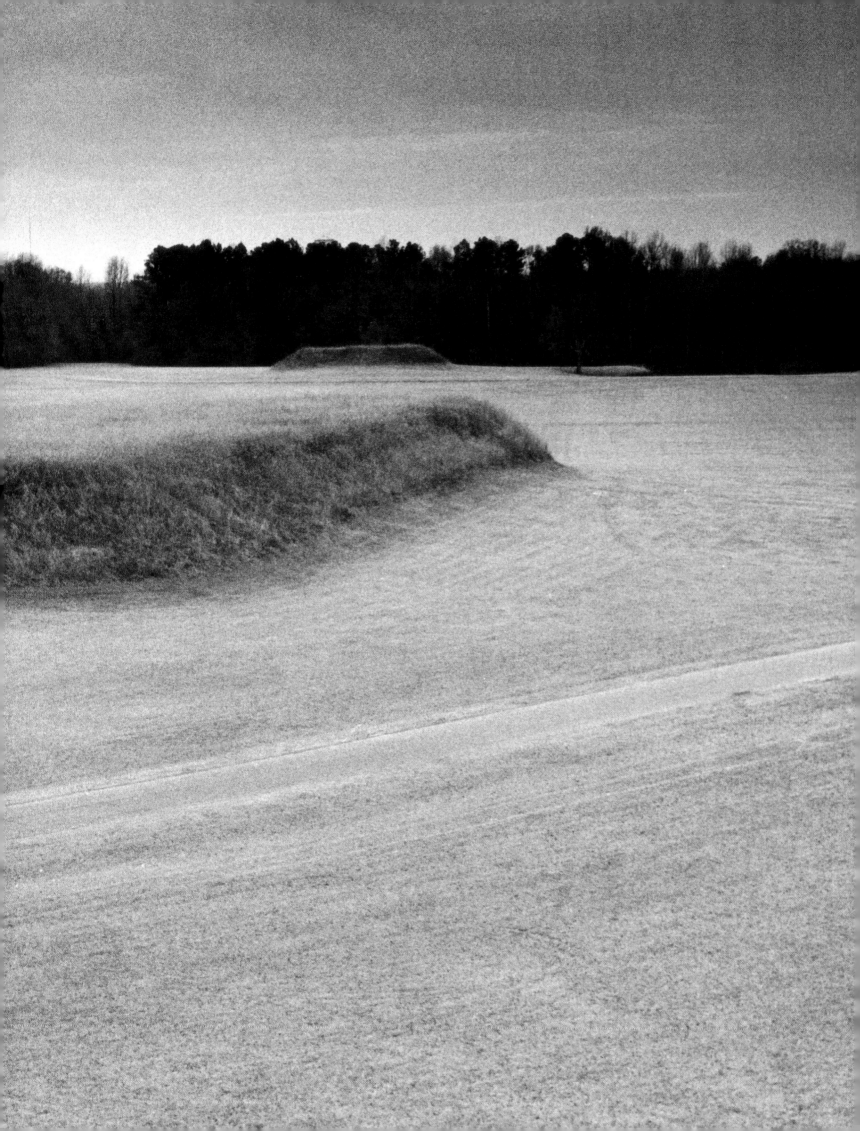

The Tombe of their Cherounes or cheife personages, their flesh clene taken of from the bones faue the skynn and heare of theire heads, w^th flesh is dried and enfolded in matts laide at theire feete. their bones also being made dry, or couered w^th deare skynns not altering their forme or proportion. With theire Kywash, which is an Image of woode keeping the deade. x x x x x

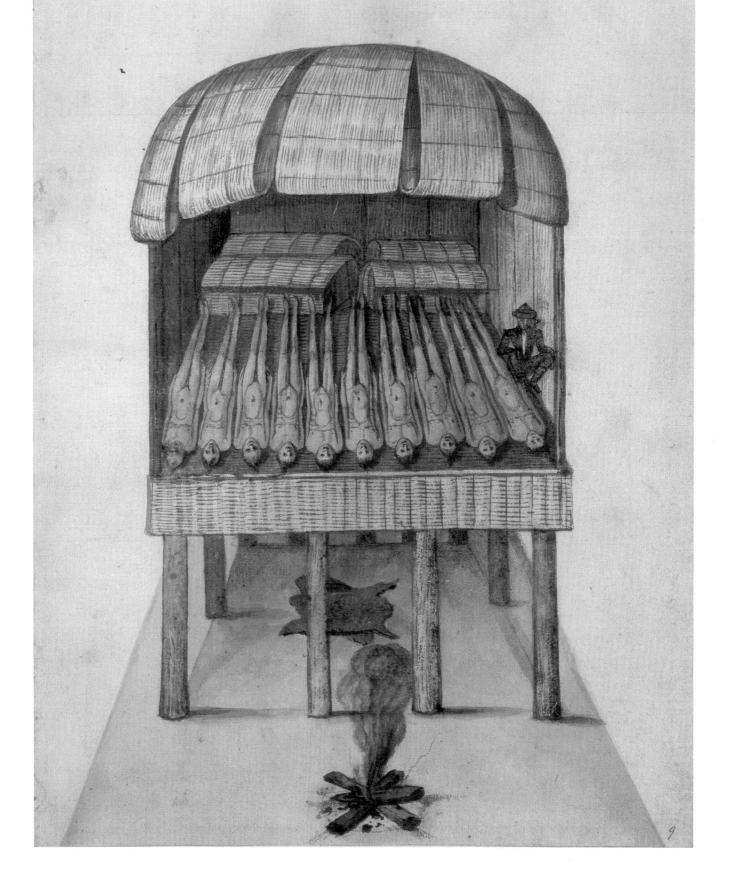

9

The cultivation of corn, beans and squash, the three sisters of traditional Native American agriculture, began in the eastern woodlands region during the Late Woodland period, as early as AD 400. By AD 900, intensive cultivation of the rich bottom lands of the central Mississippi valley permitted a radical reorganization of community life that would have a profound effect on the history of the American South-East. At a site known today as Cahokia, people gathered together in a large nucleated community that would grow by AD 1200 into a city of 25,000 dwellers. This city was the centre of an extensive network of satellite communities that spread across the fertile American Bottoms, where the Mississippi, Missouri and Illinois rivers meet near present-day St Louis. All told, these lands may have supported as many as 120,000 souls at the height of Cahokia's prosperity.

An architecture of earth

Cahokia is dominated by the largest man-made structure of Native North America: a massive earthen mound that rises in four terraces to a height of over 30 metres, with a base measuring 316 by 241 metres. The mound is flat on top, offering a foundation platform for a structure made of wood, thatch and bark which has not survived. Known as Monks Mound, after the monastery that temporarily perched on its top during the 19th century, this enormous earthwork was constructed in fourteen stages, beginning in around AD 900 and reaching its final dimensions by AD 1200. Each stage was itself a mound with a flat top surmounted by a wooden structure. These structures functioned as temples, elite residences or repositories for human remains, on the lines of the Ohio Hopewell charnel houses. After a period of activity, each successive structure was destroyed and its contents carefully buried along the edges of the platform mound. A new earth layer was added, enlarging the mound and providing a new platform for the construction of another temple or residence. To the south and east, Monks Mound faced onto open plazas that were bounded by sixteen smaller platform mounds enclosed within a wooden palisade. Over one hundred additional platform mounds and earthworks can be found spread across the expanse of greater Cahokia.

| Pages 32–33
MOUNDVILLE SITE
| 1200–1500, Moundville culture, Hale County, Alabama.

| John White
CHARNEL HOUSE OF THE POWHATAN CHIEFS
| 1580s, watercolour on paper, 29.5 x 20.4 cm (11 5/8 x 8 in). British Museum, London.

The construction of the first platform mounds in AD 900 corresponded to the institution of a hereditary chiefdom at Cahokia. Political power was invested in a small number of hierarchically-ranked lineages. The pre-eminent chief became the political and religious leader, and his person was regarded as sacred. The leadership occupied the residences that stood on certain platform mounds, administered the temples built on others, while the remains of their dead were cared for by priests in mound-top charnel houses. The chiefly lineages – and the mounds that symbolized their power – were both the literal and symbolic centre of society, the power that drew the population together into a single community and orchestrated their energy and resources as a coherent whole. This pattern of community organization, based on intensive corn agriculture in prime riverine locations, is known to archaeologists as Mississippian culture, after the locale where it originated. It expanded throughout the Mississippi valley and into the South-East, reaching the Atlantic seaboard after AD 1200. Not only did Mississippian culture spread widely, it endured. Early European explorers and colonists encountered Mississippian chiefdoms: El Inca Garcilaso de la Vega's history (1605) of the ill-fated expedition across the American South-East (1539–43) led by the Spaniard, Hernando de Soto, records descriptions of Mississipian towns, chiefs and temples. The archaeological remains can thus be complemented by these literary accounts.

Mississippian chiefs reckoned their descent from powerful spirit beings. By virtue of birthright, their bodies were charged with a power that remained long after life had left them. Priests, who were members of chiefly families themselves, cared for the mortal remains of the elite in the charnel house temples. Garcilaso recalled entering one such temple in a town in present-day Georgia which was filled with the preserved bodies of dead chiefs accompanied by sculpted images of ancestors and ancestral spirits. Like the Hopewell charnel house ceremonies centuries earlier, Mississippian temple rituals were cyclical, requiring periodic purifications that included the destruction of the temple and the burial of its contents. The platform mound was then extended with a fresh layer of earth to prepare for the construction of a new temple.

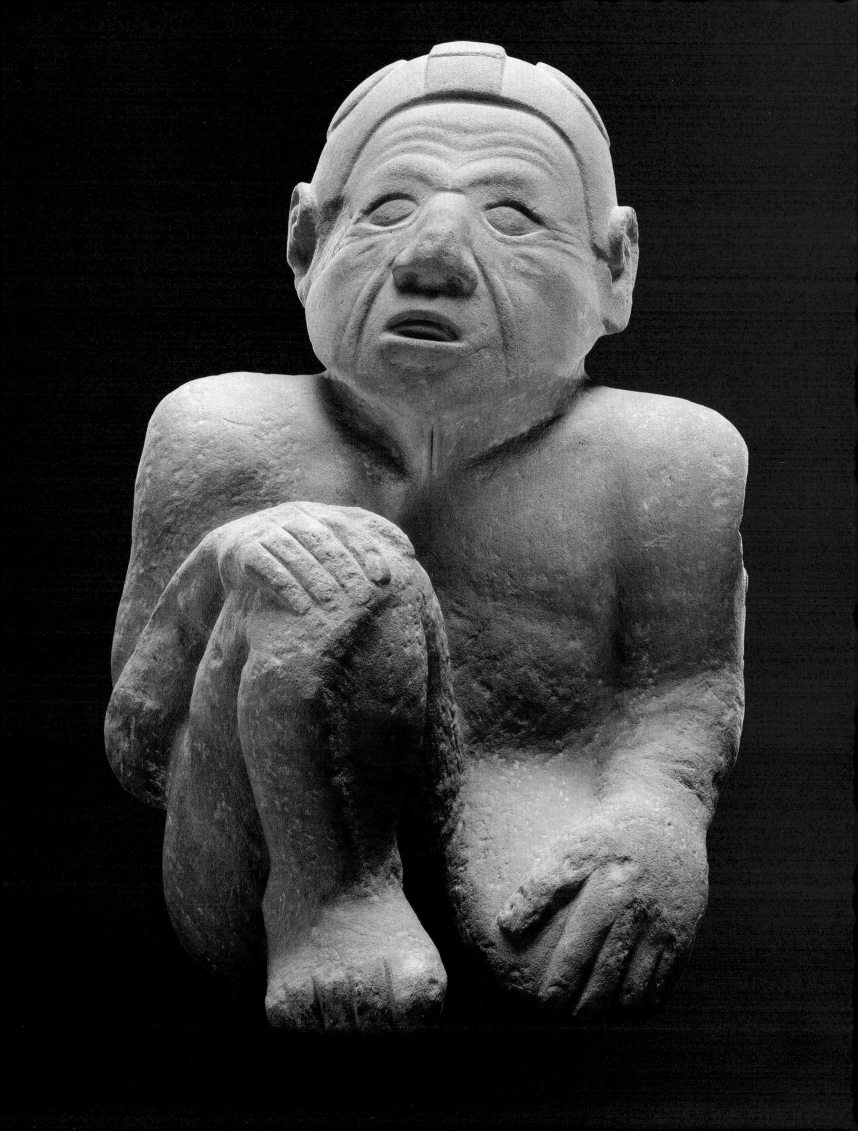

Symbols and rites

Sculpted images of ancestral spirits have been found in several temple mounds. One of the most refined is a painted sandstone figure recovered from a cave in Tennessee. Mississippian towns were fierce rivals and frequently fought one another. Garcilaso wrote that during the conquest of the town of Capaha by enemies from a neighbouring city, the victors sacked the temple which housed the remains of past chiefs. This act of desecration was intended to destroy the spiritual power of Capaha. The Tennessee sandstone figure may well have been hidden so as to spare it a similar fate.

The figure is of a chief, shown kneeling on one leg while the other is pulled up towards his chest, his hand resting on the knee. His face is lined with age; a single horizontal blue stripe is painted across the cheeks and nose. He wears a close fitting cap or helmet. His mouth is open and, despite his otherwise animated expression, his tongue is sticking out – an expression which in Mississippian art usually denotes a corpse. Similar seated figures made of stone, wood and ceramic have been removed from temple mound sites throughout the South-East. Many are shown in a cross-legged posture which resembles the way in which the limbs of the dead were bound up close to the torso.

Images of dead chiefs abound in Mississippian art, so much so that archaeologists have referred to them as evidence of a 'death cult'. A stone pipe from the Bell Field site in Georgia is carved in the crouching form of a bound corpse, the face locked in a grimace, its dried lips pulled back exposing the teeth. A series of jars recovered from towns along the Mississippi river are modelled to represent the heads of the honoured dead, their identities often specified by distinctive markings (perhaps tattoos) on their faces. A figurine carved in red bauxite found in the 'great mortuary' of the Spiro site, in north-east Oklahoma, shows a warrior in armour bending over a crouching corpse. This sculpture has been interpreted as a soldier executing a prisoner, but it could easily be one of many Mississippian representations of an elaborately costumed warrior with a portion of a preserved body, often a head. Thus, an engraving on a circular pectoral made of seashell, called a gorget, shows a dancing figure laden with ornaments grasping a human head in one hand.

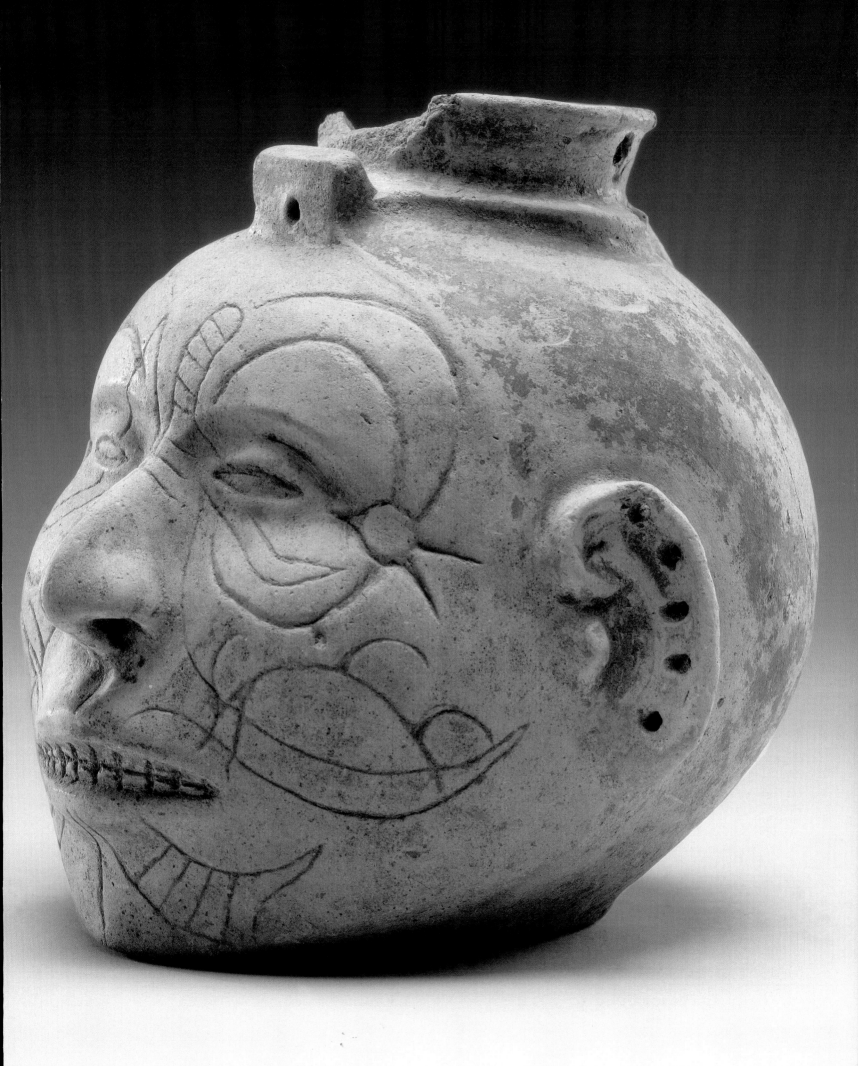

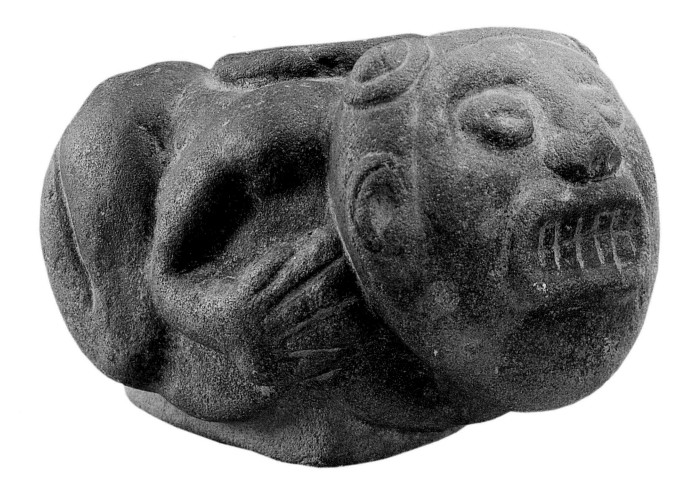

The heads, hands and legs of the elite received special attention as relics and are often represented in art. A disk-shaped palette stone from Moundville, Alabama, used for grinding pigment for body paint, is engraved with a design which shows an upright human hand with an eye at the centre of the palm. Two horned rattlesnakes, knotted together, encircle the hand. The eye is a metaphor for the Sun, the pre-eminent sky spirit and origin of the chiefly lineage. The eye in the palm indicates that the hand in the image is a chiefly relic. The horned serpents are the guardians of the underworld; with their knotted bodies they open a passage for the ancestor. Art and ritual served to evoke the ancestral dead who resided in the spirit world, and thus rein-forced the ruling lineage's right to govern. Craftsmen would cre-ate magnificent symbols to sanction the prerogatives of these leaders. Men of high rank sometimes wore 'frontlet' head-dresses fashioned from thin sheets of copper with repoussé-designs. A cache of seven such head-dresses, known as the 'Wulfing plates',

CROUCHING HUMAN EFFIGY PIPE
Detail. 1400–1600,
Mississippian culture, Bell Field site,
Murray County, Georgia.
Sandstone, 9.5 x 15.9 cm
(3 3/4 x 6 1/4 in).
University of Georgia, Department of
Anthropology, Athens.

WARRIOR
1100–1300, Caddoan culture,
Spiro site, Oklahoma.
Bauxite, height 25.4 cm (10 in).
National Museum of the American Indian,
New York.

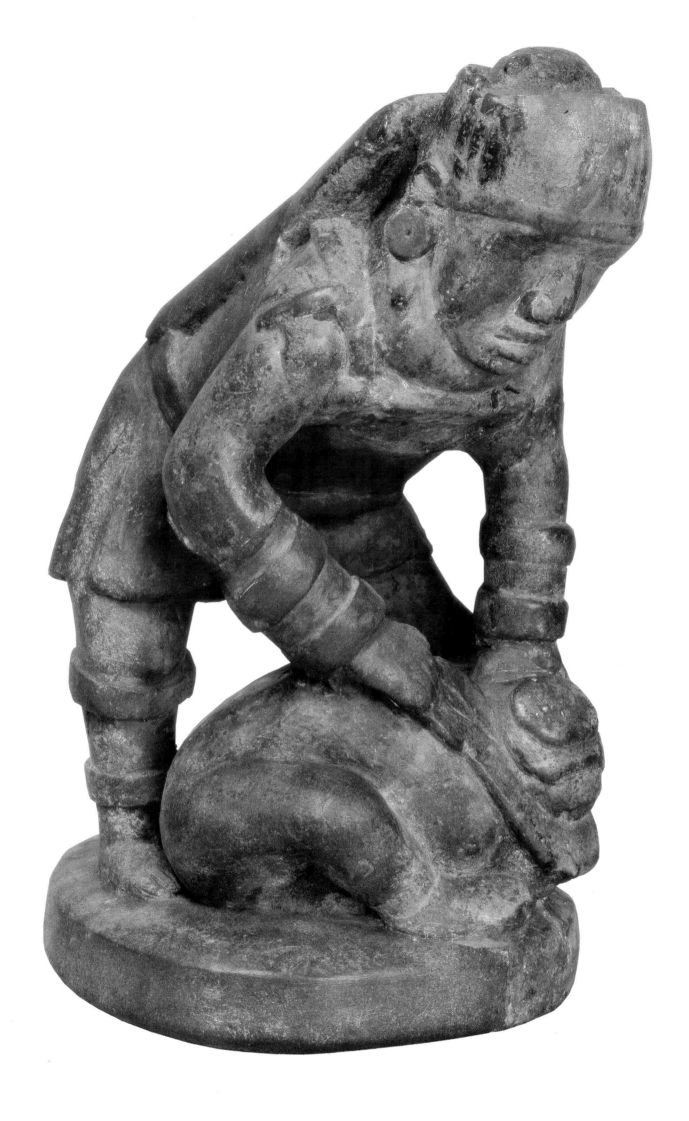

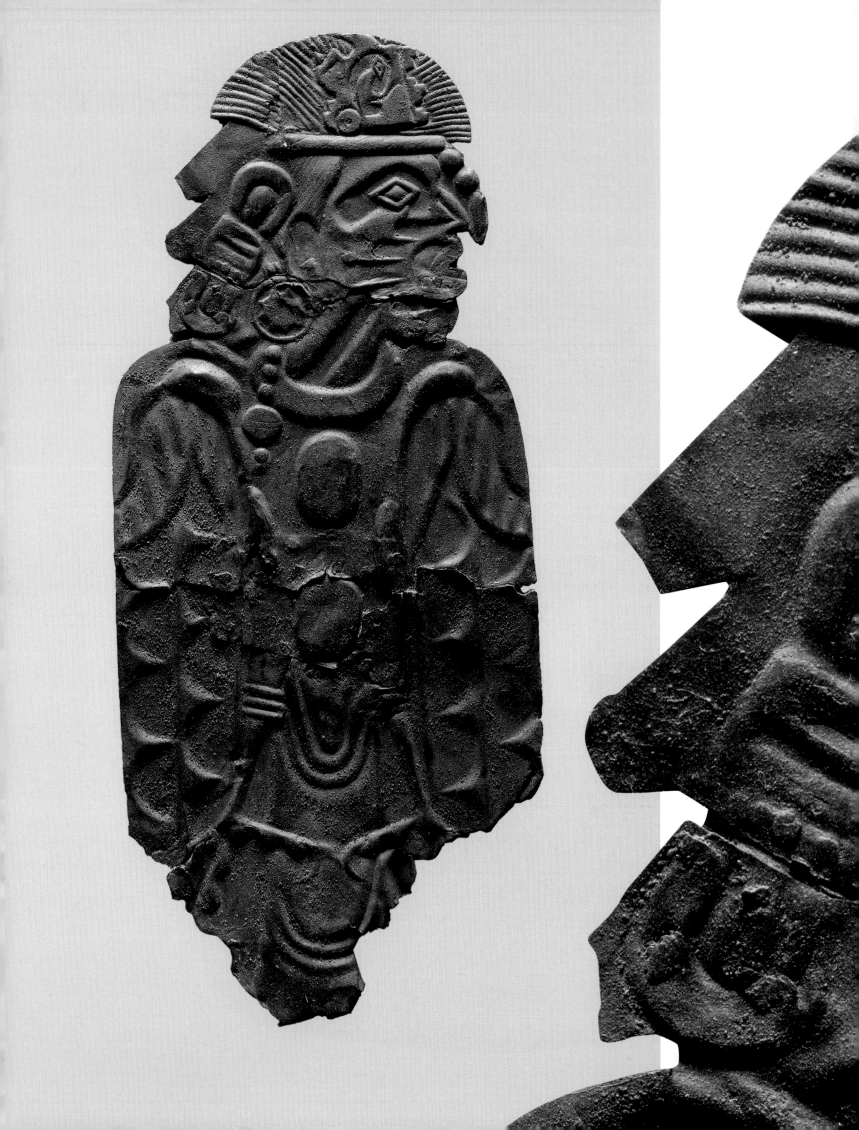

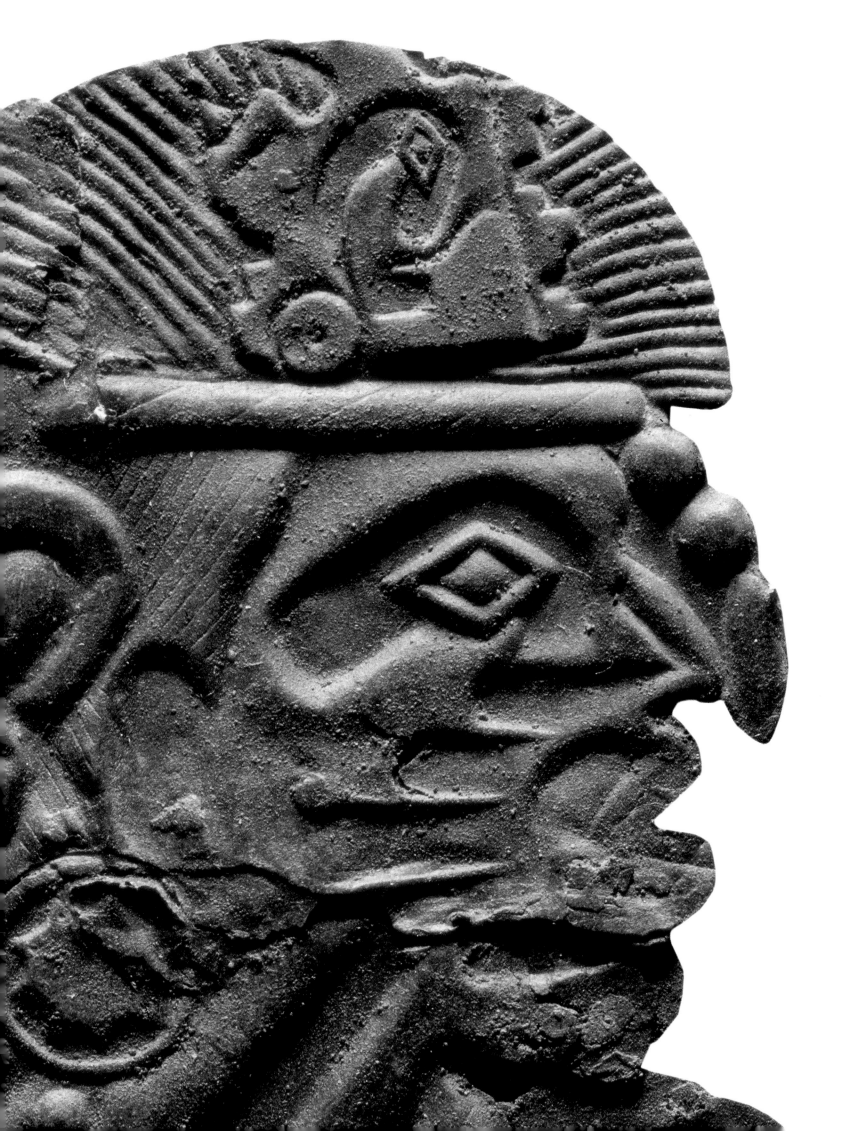

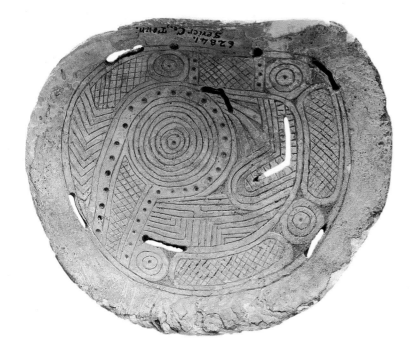

RATTLESNAKE GORGET
1200–1400, Dallas culture, McMahan
Mound, Sevier County, Tennessee.
Seashell, diameter 16.5 cm (6 1/2 in).
National Museum of the American Indian, New York.

ENGRAVED PALETTE STONE
1200–1500, Moundville culture,
Hale County, Alabama.
Stone, diameter 34 cm (13 3/8 in).
Alabama Museum of Natural History, Alabama.

| Pages 42–43
WULFING PLATE
| 1200–1400, Cahokia culture,
Malden, Dunklin County,
Alabama.
Copper, height 31.8 cm
(12 1/2 in).
Washington University Gallery of Art,
| Saint Louis.

came to light accidentally when a modern-day farmer was ploughing his field in eastern Missouri, near Cahokia. One shows a 'bird man' – half-eagle (or falcon), half-human being – who himself wears an effigy headdress, probably of copper, in the form of a human head. Many other Mississippian ornaments depict similar bird man figures, which may represent either spirits associated with the community's leaders, or the chiefs themselves in a supernatural form. A shell gorget from the Etowah site in north-west Georgia shows a kneeling figure with a beak nose, deer antlers, large bird wings rising from his shoulders, and feet like the talons of an eagle. A seashell cup recovered from the Spiro site is engraved with the image of a similar figure, who has plumes hanging from his outstretched arms and a bird's tail spread between his legs.

A general survey of Mississippian ornaments would reveal a vast array of monstrous creatures which combine the attributes of human beings with those of many different species of animals. Birds and serpents (or snake-like felines) predominate, thus restating the cosmological opposition of sky and underworld. Two of the most common shell gorget designs illustrate this double theme: one shows a horned rattlesnake coiled into a spiral, while the other depicts the face of a bird with forked motifs carved over its eyes. Sometimes, the engraved designs resemble the markings of the peregrine falcon. At others, they appear

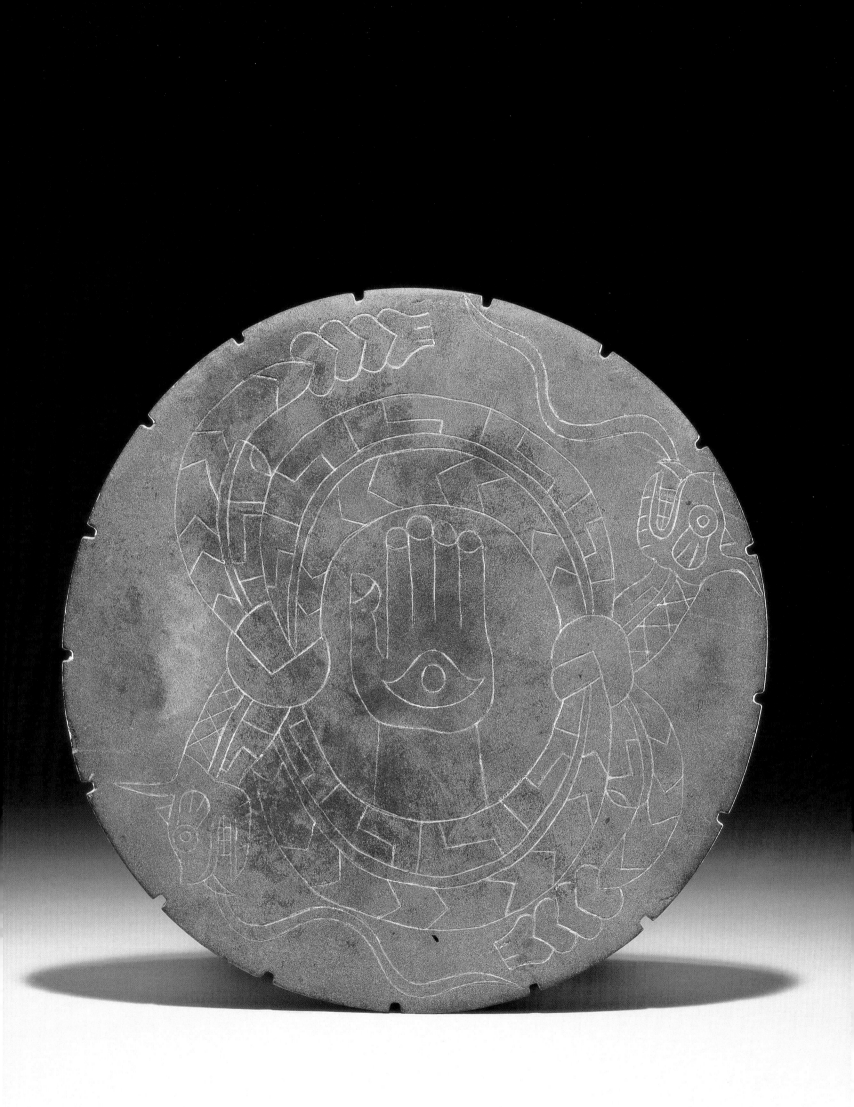

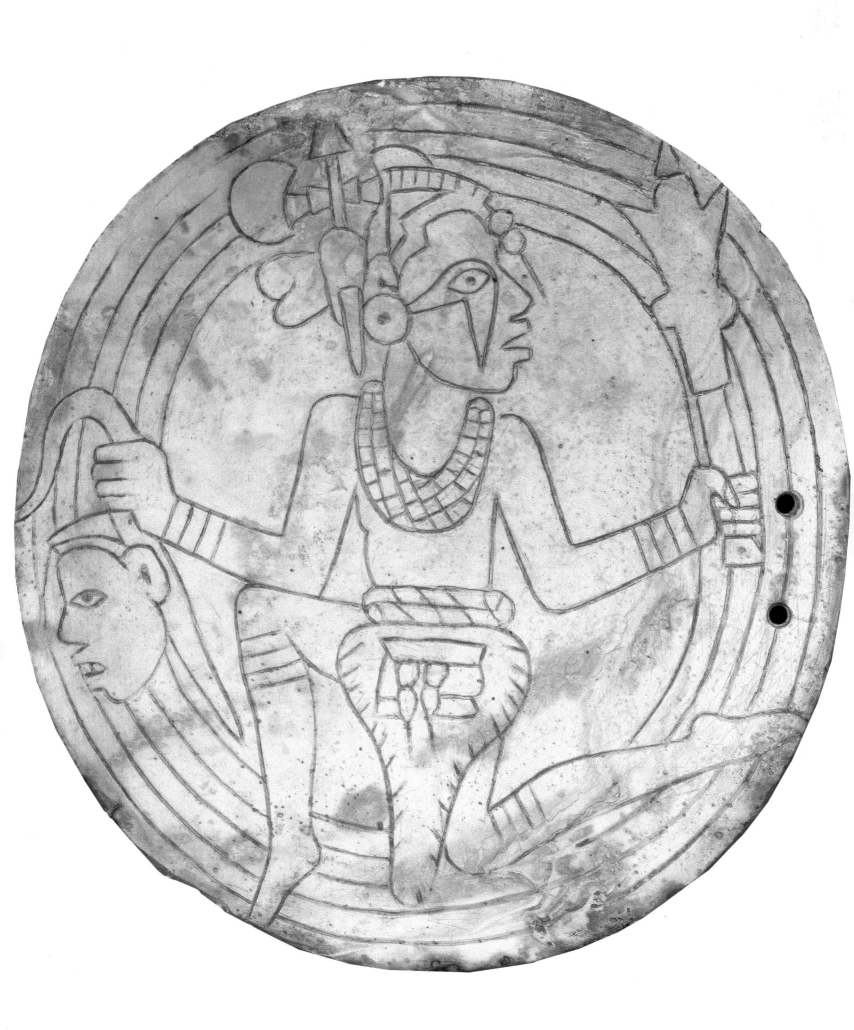

FALCON MAN GORGET

1250–1300, Mississippian culture, Sumner
County, Tennessee.
Seashell, diameter 10.2 cm (4 in).
National Museum of the American Indian, New York.

CARVED AND ENGRAVED GORGET

1200–1450, Etowah culture,
Bartow County, Georgia.
Seashell, diameter 15 cm (5 7/8 in).
Etowah Mounds Archaeological Area, Georgia
Department of Natural Resources, Etowah.

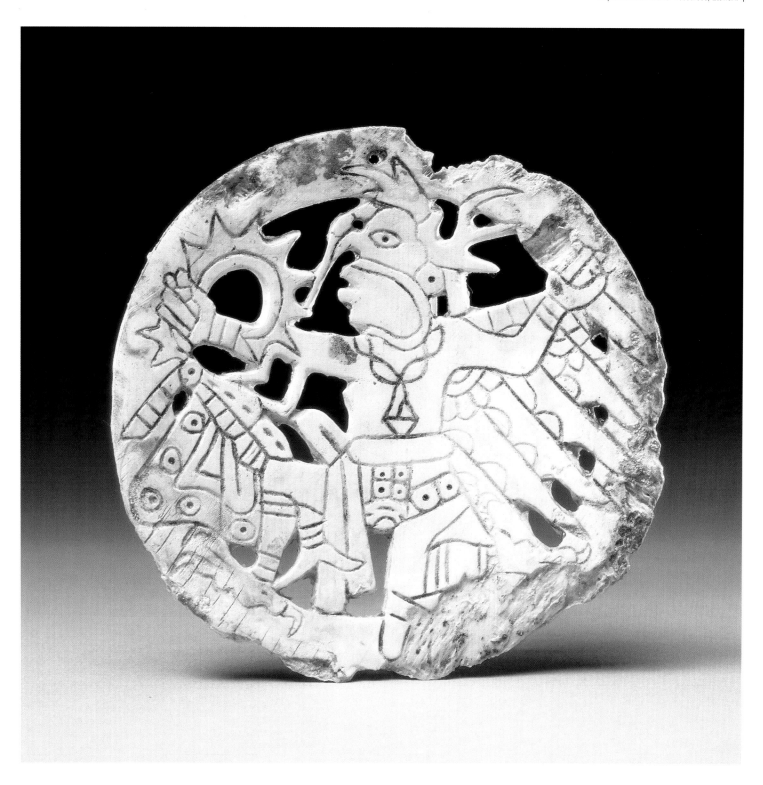

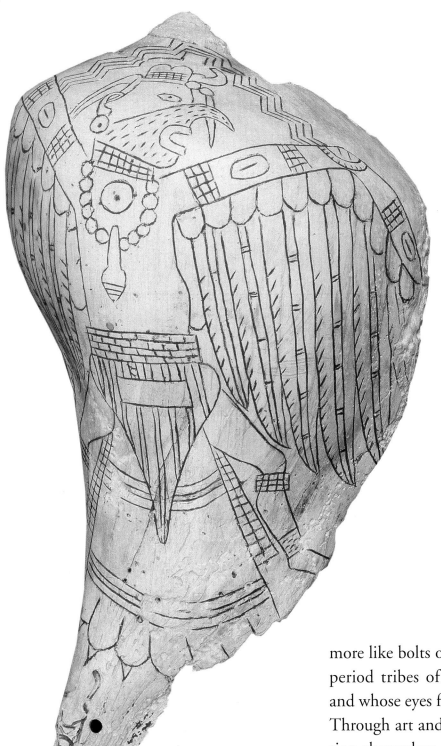

ENGRAVED EAGLE-MAN CUP
1100–1300, Caddoan culture,
Spiro site, Oklahoma.
Seashell, length 33 cm (13 in).
National Museum of the American Indian, New York.

BIRGER FIGURINE
1000–1250, Cahokia culture, Madison
County, Illinois.
Bauxite, height 21 cm (8 3/8 in).
Illinois Archaeological Survey, Springfield.

more like bolts of lightning, recalling descriptions from historic period tribes of thunder birds whose wings flapped thunder and whose eyes flashed lightning.

Through art and ritual, the Mississippian chiefs sought to position themselves at the centre of this traditional cosmology, so that their followers would see them as supernatural beings controlling vast spiritual powers. The well-being of society thus depended upon them, as a bauxite sculpture found near Cahokia confirms. A kneeling woman works the earth with a hoe; the earth is represented as a massive coiled serpent, whose tail becomes a vine climbing up the woman's back, sprouting bottle gourds. The successful cultivation of food is a gift from the spirit world – from the earth beneath our feet and the dome of the sky overhead (sun and rain). The chiefly families used their

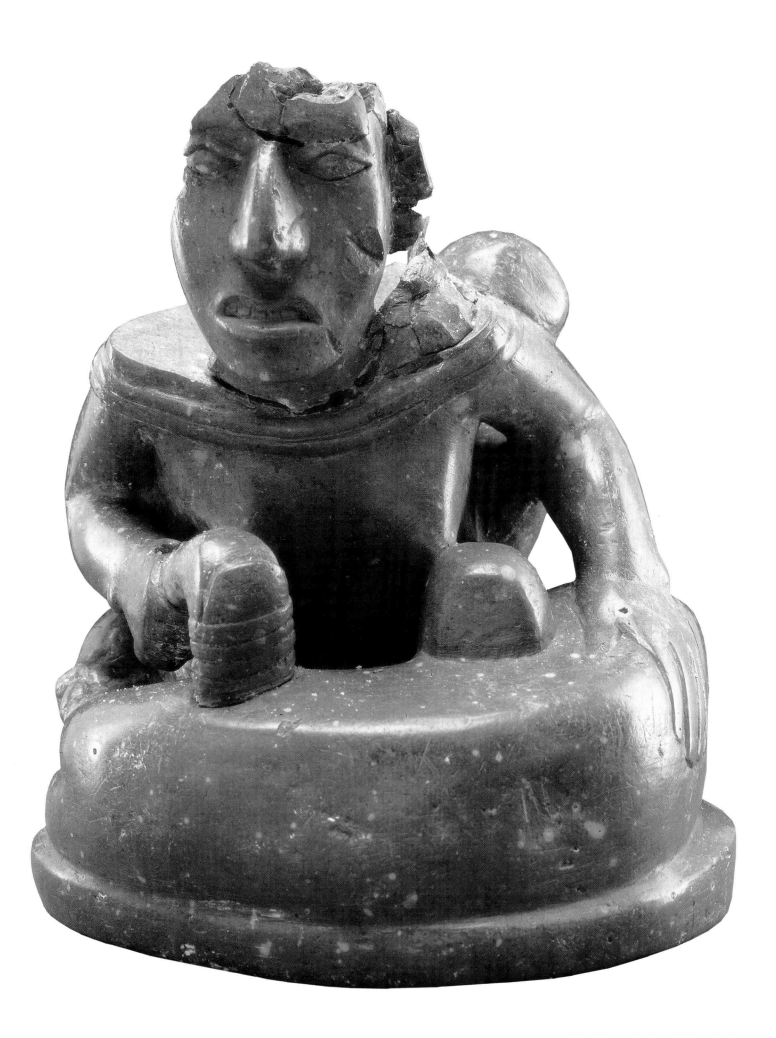

ancestral connections with the spirit realm to ensure that these blessings would continue.

Pottery jars and bottles, manufactured in far larger numbers than shell or copper ornaments, were also placed with the dead. These fine, highly decorated wares have been recovered from the mound burials of the Mississippian elite, and also from the cemeteries where humbler people were laid to rest. The designs often borrow the chiefly symbols, showing sun disks, serpent spirals and a vast array of effigy forms. In the Late Mississippian period, jars appear in the central Mississippi valley modelled in the form of a seated hunchback with emaciated chest and withered limbs. Modern physicians have pointed out that the figure's condition resembles a form of tuberculosis that is related to vitamin deficiencies and general malnutrition.

HODGES ENGRAVED BOTTLE
1300–1500, Caddoan culture,
Ouachita County, Arkansas.
Fired clay, height 23.5 cm (9 1/4 in),
diameter 18 cm (7 in).
The Detroit Institute of Arts, Detroit.

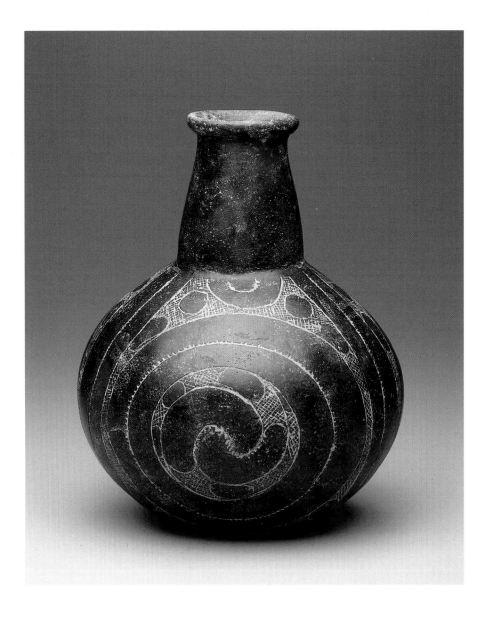

Evidently, the expansion of Mississippian culture eventually outstripped the land's ability to support it. Archaeological evidence shows a sharp reduction in the population of the Mississippi valley in the 1400s, when many towns were abandoned. The final blow came the following century, with the arrival of the Europeans and the microbes they brought with them. The population of the South-East is estimated to have fallen by nearly ninety percent due to devastating epidemics of influenza and dysentery that swept through the region during the 1500s. Some Mississippian chiefdoms survived, particularly among the Algonquian speakers of the eastern seaboard, but in the Mississippi valley itself only the Natchez, the Karoa and the Taensa remained. The Creek, Chickasaw and Choctaw who dominated the South-East after the 1500s amalgamated from

BIRD EFFIGY BOWL
1300–1500, Mississippian culture,
Missouri or Arkansas.
Fired clay, 18.5 x 19 cm
(7 3/8 x 7 1/2 in).
The Detroit Institute of Arts, Detroit.

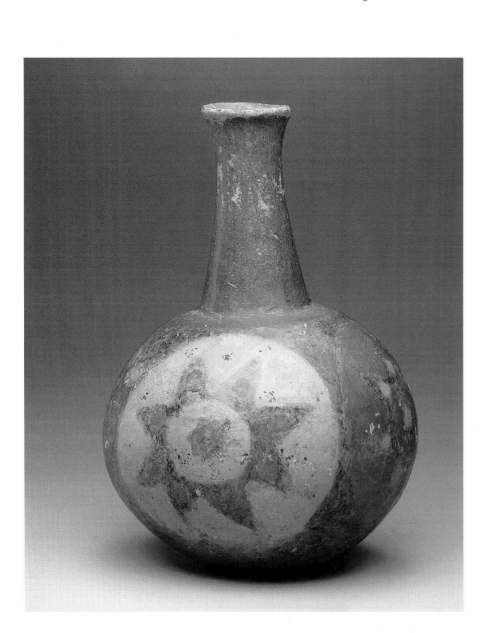

AVENUE POLYCHROME BOTTLE
1400–1600, Quapaw culture,
Arkansas.
Fired clay, height 25.5 cm (10 in),
diameter 18 cm (7 1/8 in).
The Detroit Institute of Arts, Detroit.

surviving Mississippian populations, but they reorganized into a far more egalitarian society. The legacy of the Mississippian chiefdoms lived on, however, in myriad concepts, ritual details and visual symbols that were to enrich the cultures which took their place.

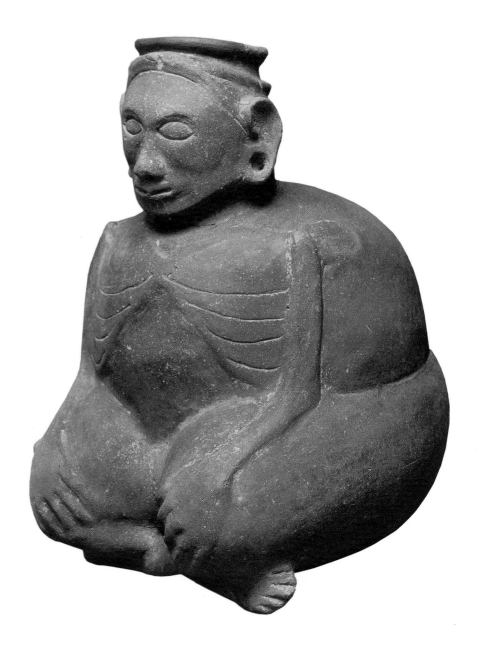

HUMAN EFFIGY BOTTLE
1300–1400, Mississippian culture,
Arkansas or Missouri.
Fired clay, height 20 cm (7 7/8 in).
National Museum of the American Indian, New York.

3. From the Eastern Woodlands to the Great Plains

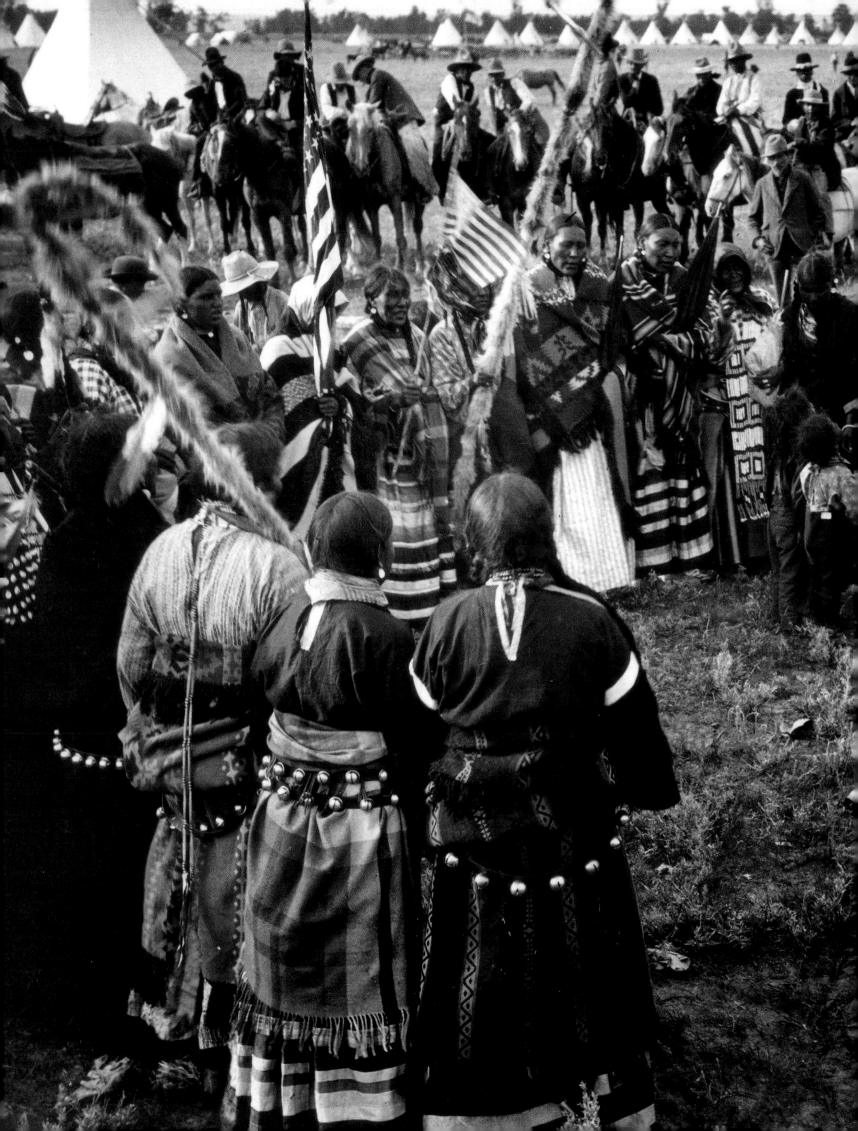

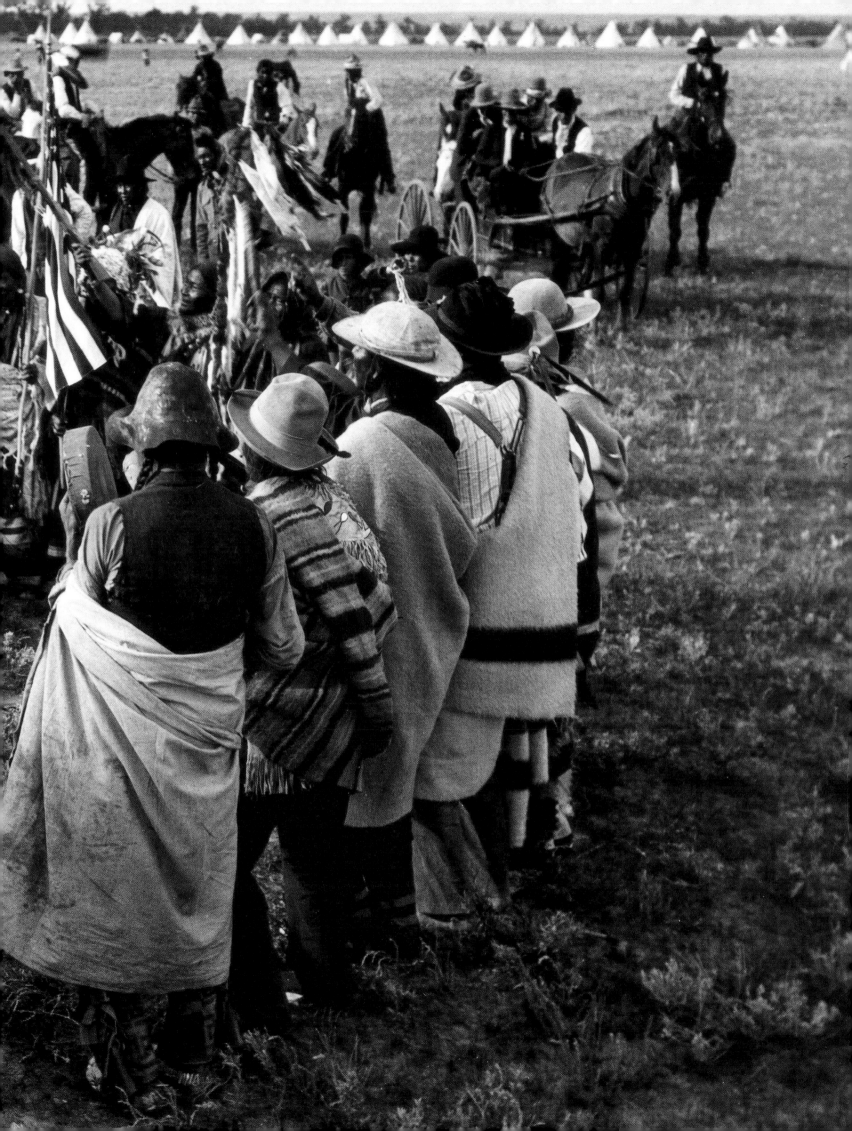

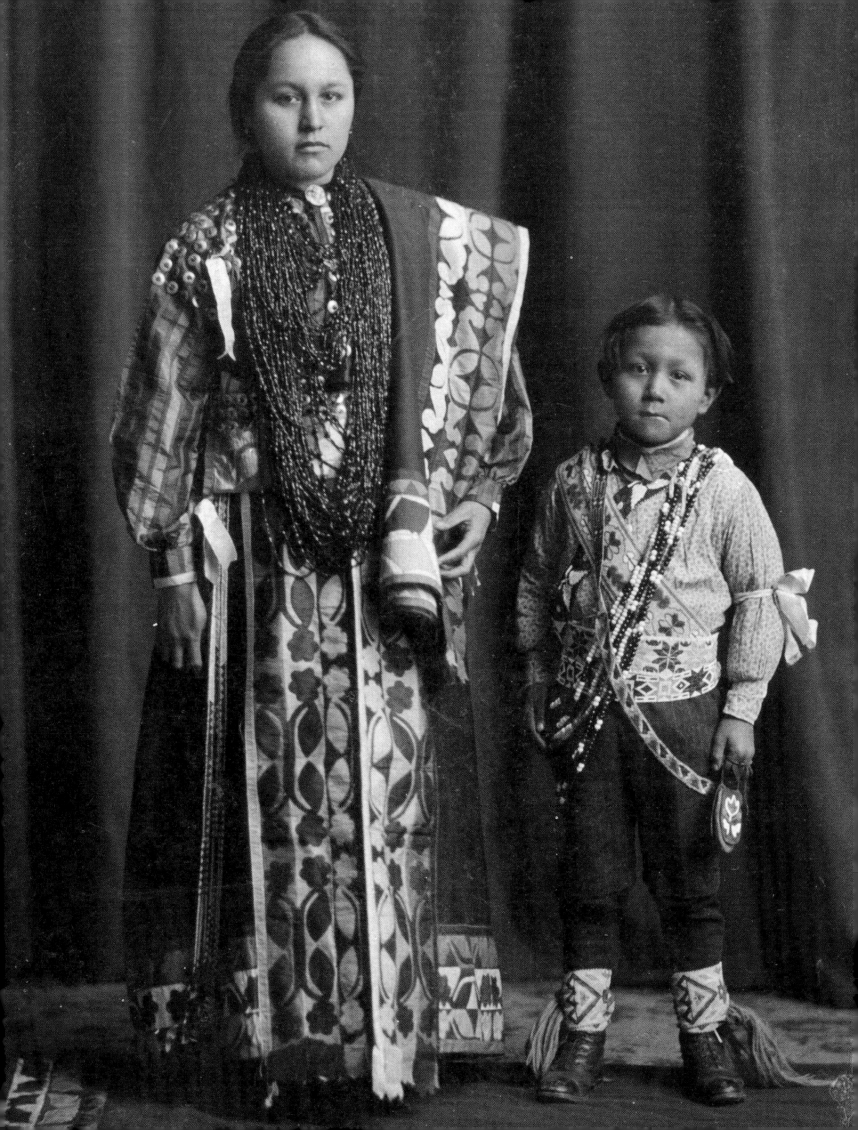

ust as sculpture and painting were traditionally activities reserved for men, so women too had their own specific domains, including craft work and the making of regalia and textiles. As in most traditional societies, the roles of the two sexes were perceived as quite distinct, yet complementary. Men were responsible for a wide range of everyday productive chores: preparing poles and bark for building lodges (though the women did the building), constructing canoes and hollowing out dugouts. They were the hunters and, in times of conflict, the warriors too. Women, for their part, would tend the fields, prepare food and make clothes from the hides of animals.

All young women learned these crafts as part of their education, just as young men learned theirs. As a result, the works produced by each group addressed very different cultural concerns and employed different kinds of expressive language.

Dress-making: the domain of women

Formal clothing and ornaments represent one of the highest forms of artistic expression among the peoples of the eastern woodlands and Plains. From an early age, young women learned how to dress hides, weave textiles and embroider decorations. These skills were integral to a woman's social identity and accomplished craftswomen were highly esteemed. These formal clothes were made not only for families and relations, but also for trade. They were not everyday wear, but were reserved for special occasions such as social events, ceremonies, councils, and formal visits. Wearing such garments honoured the event and the other participants. It was a way of expressing an individual's personal wealth and accomplishment, his or her spiritual well-being; it was also an assertion of community identity. The style of such clothes changed over time to reflect the historical experiences of those who made and wore them. Each generation renewed the traditions they inherited from their elders, and introduced innovations relevant to their own cultural concerns.

It is rare that textiles and animal hides survive from pre-colonial times, and when they do, they are only fragments and in poor condition. Instead, we have to rely on the collections assembled by the first European visitors, whether souvenir hunters or would-be ethnographers. The earliest collections came about by

| Pages 54–55
WOMEN DANCING
Gros Ventre and Assiniboine tribes, 1905, Fort Belknap Indian reservation, Montana.

POTAWATOMI YOUNG GIRL AND BOY
Late 19th century, Mayeta, Kansas.
Richard and Marion Pohrt collection, Flint.

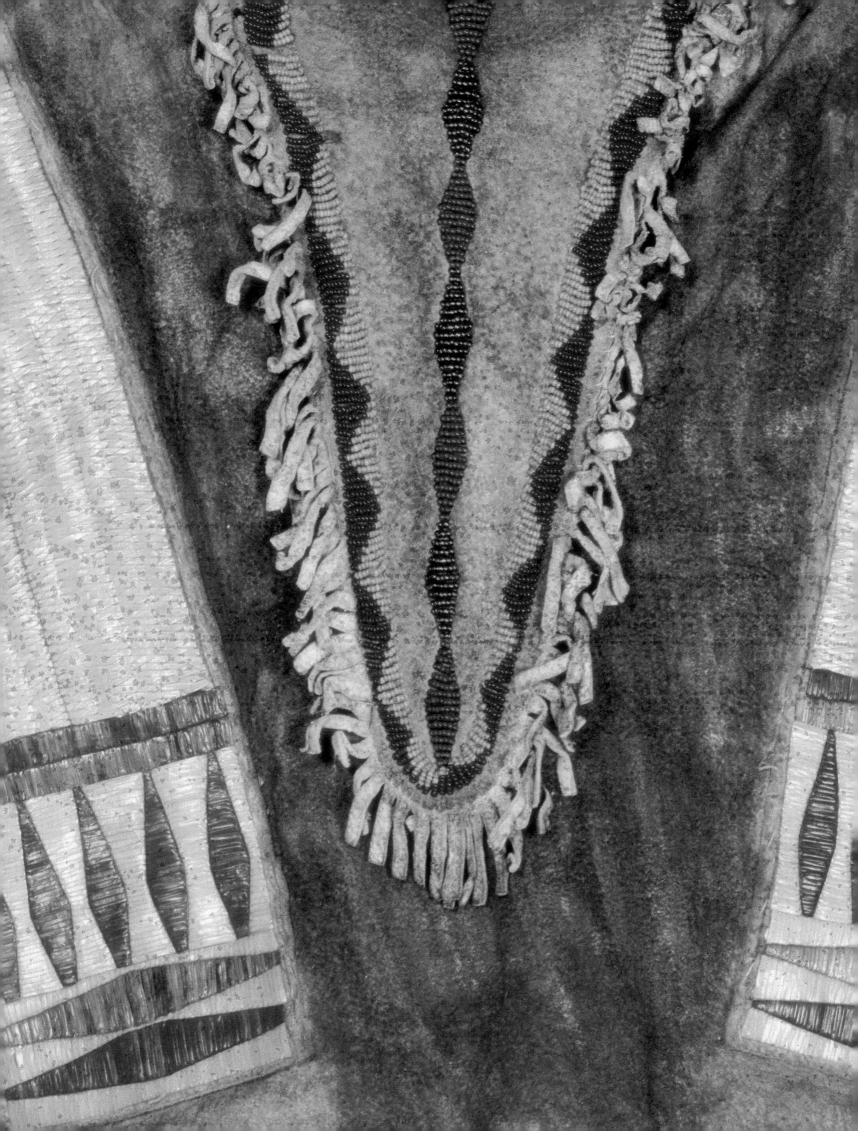

chance, as visitors returned from their travels laden with 'curiosities', and large-scale collections only began to be put together by anthropologists during the final decades of the 19th century. A reliable corpus of formal clothing extends back only to the mid-19th century, and very few items made before 1800 have come down to us intact.

From the very first, relations between Native and European peoples were shaped by the economic opportunities of trade. European visitors sought the pelts of fur-bearing animals (beaver in the north, deerskins in the south-east). In return, they offered Native people the products of European factories. In many cases, these trade goods possessed a practical utility: steel blades for knives and axes, copper kettles, fire arms. Nevertheless, items and materials whose only use was in making clothes and personal ornaments came increasingly to dominate the fur trade as it developed into the 17th and 18th centuries. Wool blankets for robes, printed cotton cloth for shirts and blouses, glass beads for embroidered decoration, silk ribbon for appliqué, silver ear pendants, arm bands, pectorals, and all kinds of other materials, were grist to the mill of Native women artists. Sported on formal occasions, such items served to indicate fur trade 'wealth', and testified to the success and well-being of those who wore them. During the 18th and 19th centuries, Native women thus explored and elaborated a wide range of original techniques and styles in response to these new materials.

Fur trade fashion was an addition to traditional regalia styles, not a replacement for them. Among the Iroquois of New York State and their Algonquian-speaking neighbours of the Great Lakes region, women customarily employed finely-tanned deerskin for shirts, leggings, moccasins and pouches of different descriptions. They used a dye made by boiling black walnut hulls to stain the deerskin a deep brown. Porcupine quills, softened, dyed various colours, and stitched to the surface of the skin as a kind of appliqué, provided colourful decoration. Women would flatten the porcupine-quills and fold them back and forth to fill in narrow bands of colour, or wrap the quills around a length of sinew to create the thin lines of their designs. Using variants of these basic techniques, they would decorate blackened deerskin garments and pouches with intricate patterns. Fringes wrapped with

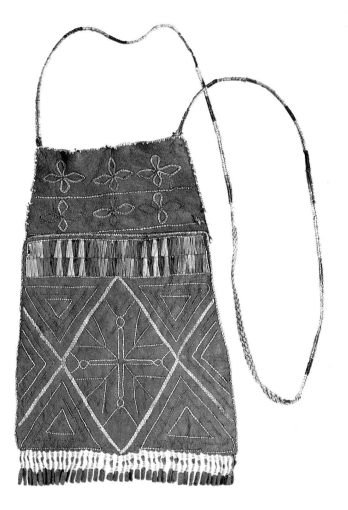

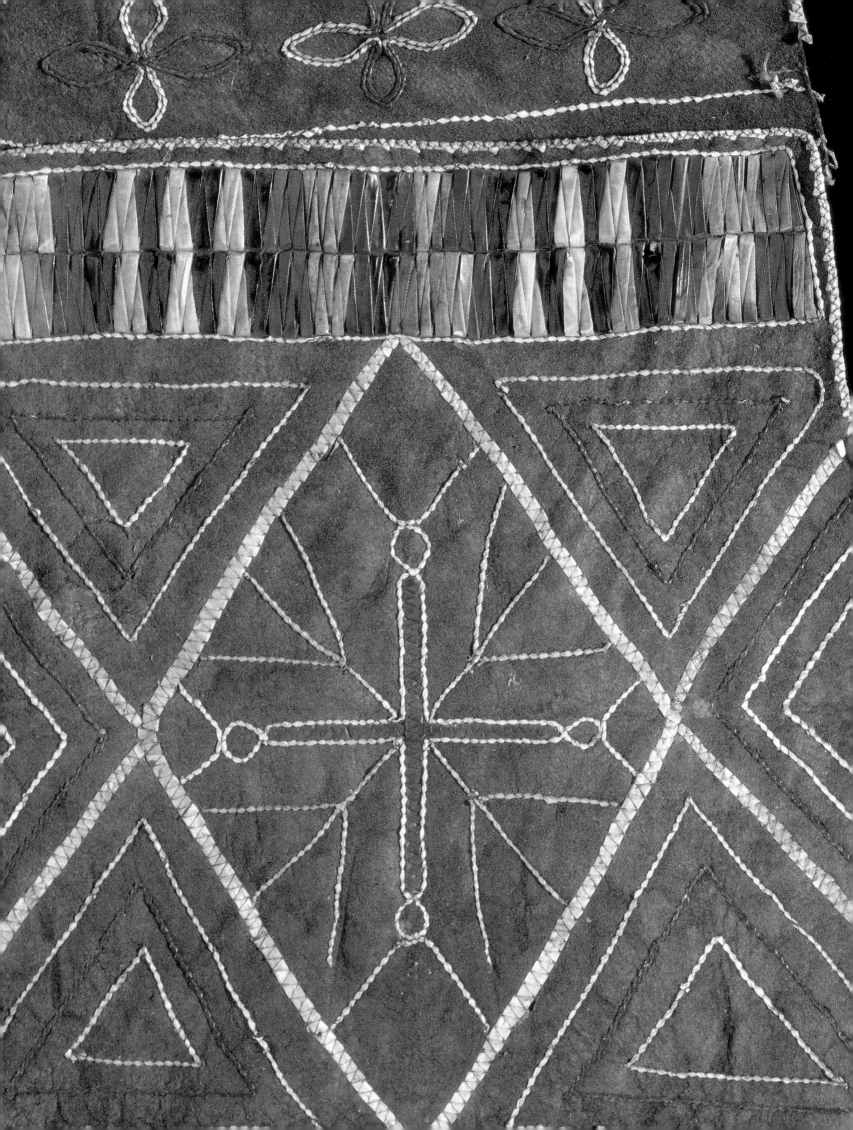

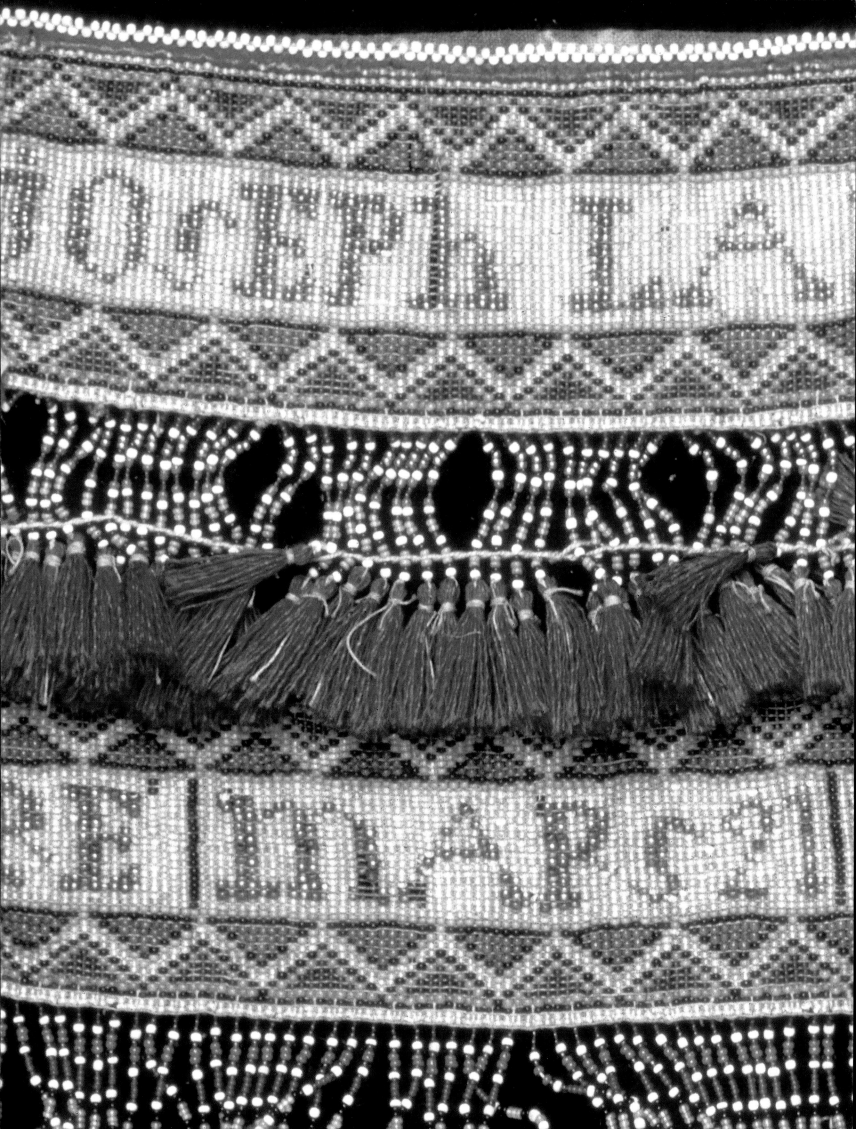

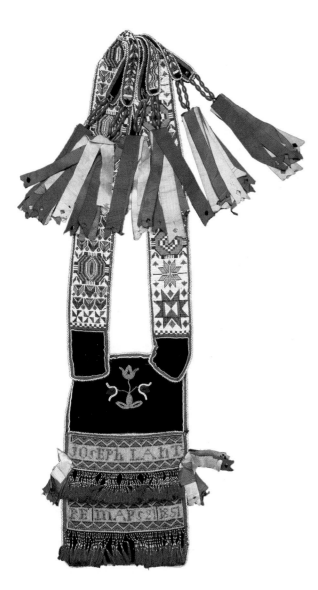

OJIBWA SHOULDER BAG

1851, Michigan or Minnesota.
Wool fabric and yarn, cotton fabric
and thread, silk ribbon, glass and
metallic beads,
79.4 x 17.8 cm (31 1/4 x 7 in).
Detroit Historical Museum, Detroit.

| Page 61
OJIBWA SHOULDER BAG
| Detail.

POTAWATOMI SKIRT

1860–1880, Wisconsin.
Wool cloth, silk ribbon, cotton thread,
116.8 x 82.5 cm (46 x 32 1/2 in).
Field Museum of Natural History, Chicago.

porcupine-quills and dangling pendants made from deer hoof with tufts of red-dyed deer hair added a kinetic dimension to regalia, responding sensitively to every movement of the wearer. With the arrival of fur trade goods, women sewed glass beads to deerskin and trade cloth, expanding upon the customary porcupine-quill designs. Wool yarn strung with glass beads took the place of quill-wrapped fringe and rolled copper or tin cones substituted for deer-hoof pendants. Trade materials did not entirely replace indigenous media; they simply enlarged and multiplied the artistic possibilities.

At the same time, women were adapting the methods of European weaving and needle work. With simple box looms, heddles, wool yarn, and linen or cotton thread, Great Lakes women of the early 1800s used weaving techniques to make sashes, garters (tied around the leg just below the knee) and shoulder straps or 'bandoliers' for pouches. As they strung glass beads on wefts of cotton threads, they arranged the colours to create intricate, geometric patterns known today as 'woven beadwork'. By the mid-1800s, Ojibwa women were making ambitious and complex shoulder bags, using long, oblong panels of woven beadwork for the decorative facing of the shoulder straps and pouch. To decorate robes, skirts and leggings, they would cut silk ribbon into imaginative shapes and sew them to the garments with needles and cotton thread as appliqué. Later in the 1800s, ribbon-work designs were first traced on paper, then cut out to serve as templates. Families passed these paper patterns down through the generations, from mother to daughter.

The designs these women devised were rooted in Native cosmology. The Earth was conceived as a disk oriented to the four cardinal directions, suspended between the dome of the sky-world above and the watery underworld below. An equal-armed cross, often set within a circle or a diamond, signifies the cardinal directions of the Earth and its surrounding horizon. Pin-wheels and X-and-cross patterns – frequently used for woven beadwork – can be understood as elaborate variants on the equal-armed cross, and allusions to the sacred number four, which connotes the four quarters of the world.

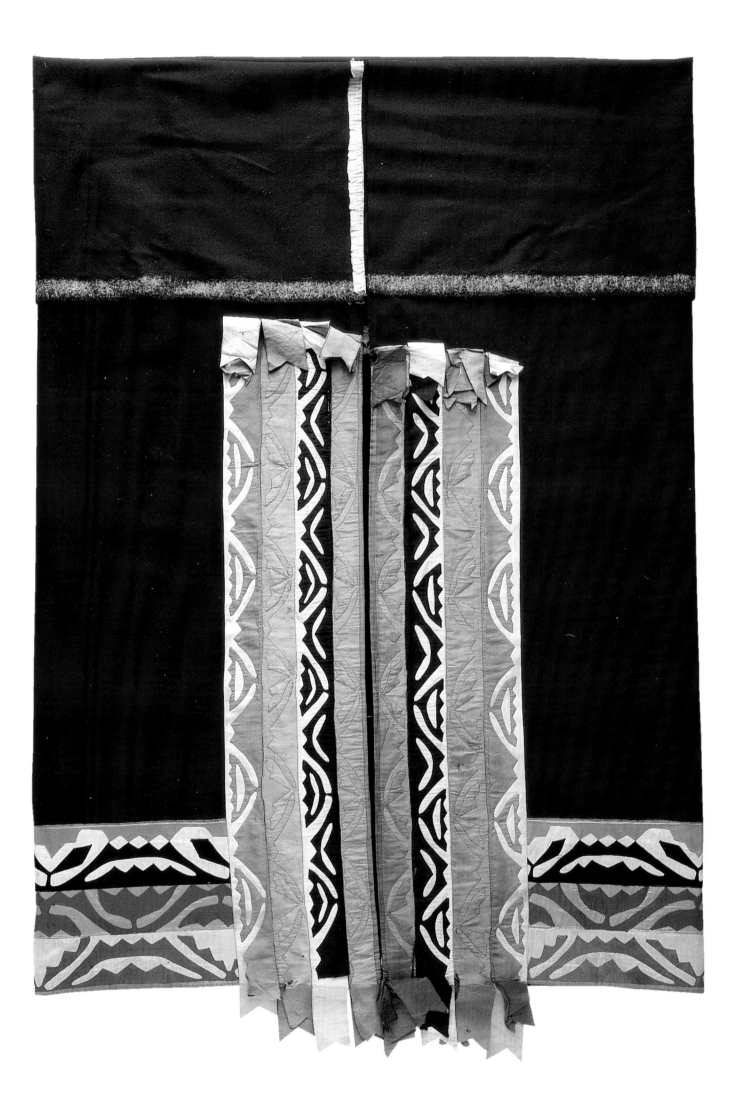

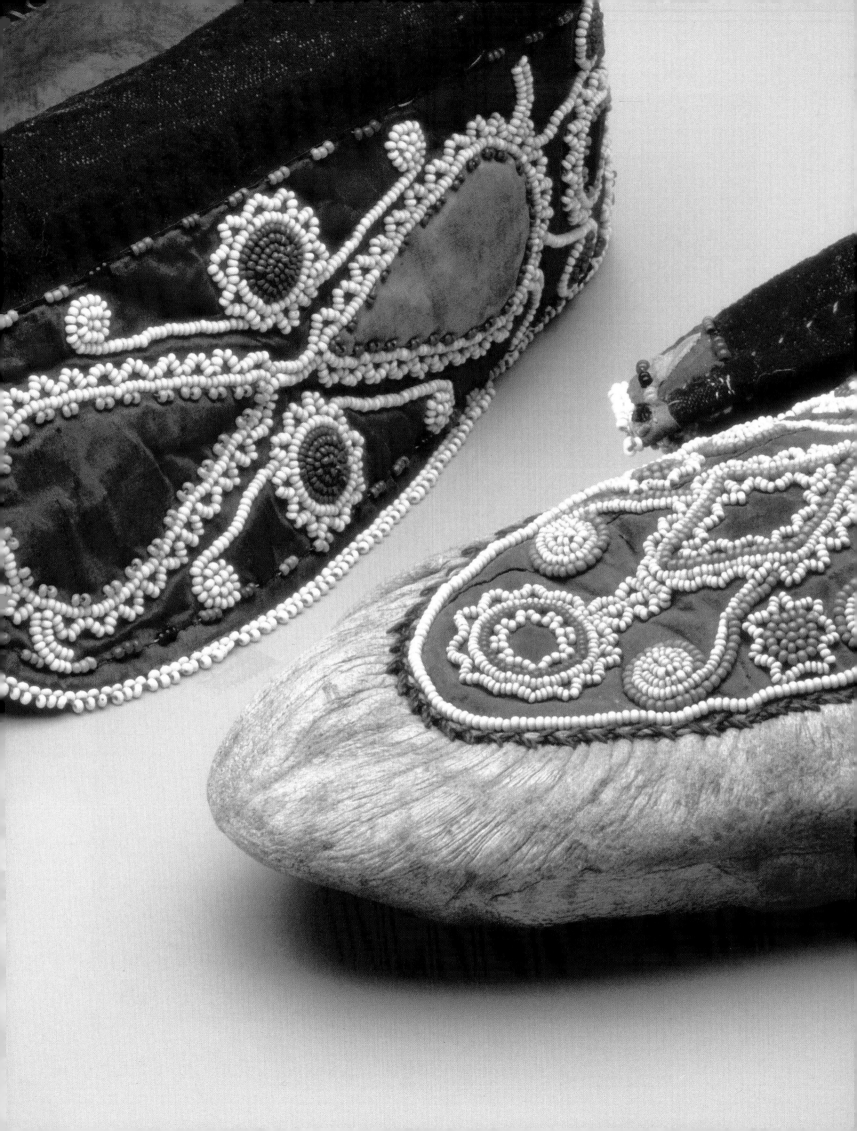

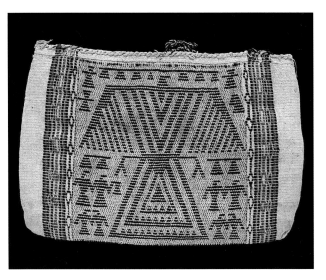

POTAWATOMI BAG
1840–1880, Wisconsin.
Cotton twine, wool yarn,
43.2 x 64.8 cm (17 x 25 1/2 in).
The Detroit Institute of Arts, Detroit.

Bags of twined nettle fibre and animal wool made by women of the Great Lakes peoples often feature images of the thunder bird on one face of the bag and the horned serpent (underwater panther) on the other. As such, the bags represent a kind of cosmological diagram. Between these symbols of the sky-world and the underworld lie the sacred contents of the bag, which are intended for ritual use here on earth. The cosmological principle of balancing antithetical elements is also hinted at subtly in the asymmetrical use of colour in decorative designs on formal clothing. Contrasting colours may be used on either side of otherwise symmetrical designs, or pairs of designs may alternate colours. The figures used on shoulder bag straps, moccasins, cuffs, or even pairs of leggings, may also show asymmetrical contrasts. Even the most basic decorative principles are informed by an underlying cosmological structure.

During the first decades of the 1800s, as American settlers pushed west, the economy of the fur trade began to collapse. Instead, European Americans bartered for land rights in return for annual payments called annuities, often distributed in the currency of fur trade goods. Impatient with Indian peoples as impediments to 'progress', President Andrew Jackson signed the Indian Removal Act in 1830, requiring all Native peoples east of the Mississippi to leave their homelands and relocate in 'Indian Territory' to the west. During the three decades that followed, the authorities rounded up members of the eastern woodlands tribes and forced them to march west to reservations in Kansas, Nebraska, and Oklahoma. Many died *en route*. Others escaped to Canada, sought refuge in the forests of Wisconsin, as in the case of the Potawatomi, or in the swamps of Florida, in the case of the Seminole. The Michigan Ottawa signed away their federal recognition as a tribe in order to escape removal, and have only recently regained it. Those who made it to Kansas and Oklahoma found themselves in strange new surroundings with new neighbours.

| Pages 64–65
OTTAWA MOCCASINS
1830–1840, Cross Village, Michigan.
Deerskin, cotton fabric, silk ribbon, glass beads,
length 27.9 cm (11 in).
The Detroit Institute of Arts, Detroit.

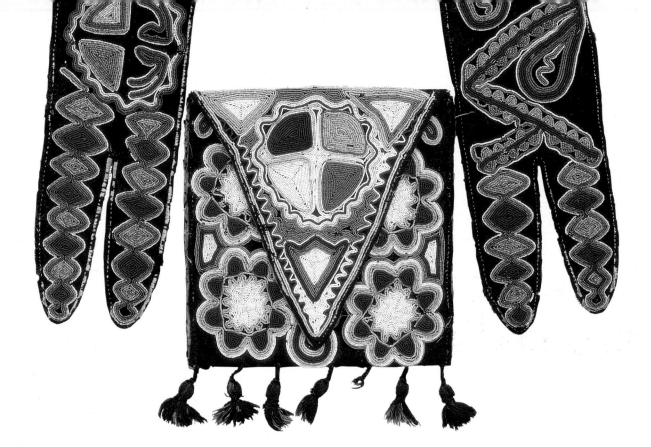

During the 1860s, a new style of regalia decoration began to emerge on the reservations of the west. Prairie style, as it is known today, combined the curvilinear patterns of Creek and Cherokee designs with the more stolid and structured designs of the Great Lakes peoples. Employing mainly glass-bead embroidery and ribbon-work, it emphasized hot colour combinations and florid designs contrasted against dark blue or black wool fabric. The traditional principles of radial symmetry and bifurcated colour found new expression in these abstract-floral patterns, which in many instances suggest images of flowers, yet resist identification with any particular flower. Prairie style was pan-tribal; the residents of western reservations exchanged their design ideas at dances and ceremonies. Winnebago, Mesquakie, Delaware, Potawatomi, Iowa and Oto women all contributed to this new fashion.

Floral designs entered into the repertoire of Great Lakes women through the patterns they saw on printed cotton trade cloths, as well as through Mission school teaching. A highly pictorial kind of floral style was developed by Ojibwa and Cree women living west of Lake Superior, in Minnesota and Manitoba. There were a large number of Metis, or mixed-blood, families in that region (French, Scots, or English Canadian men married to Native women), many of whom were Catholic, and whose children

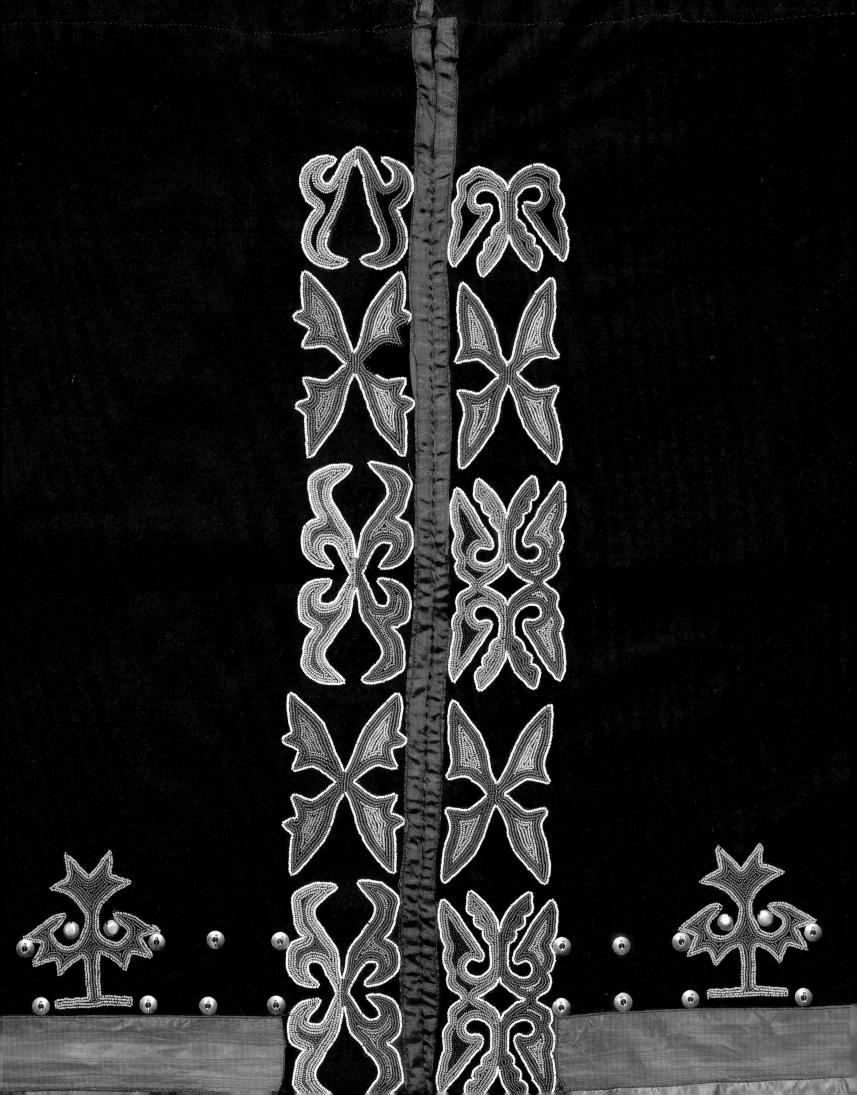

were educated in Mission schools. There, young women were taught the domestic skills expected of Christian wives, which included silk-thread embroidery for linens, tablecloths and napkins, using floral patterns drawn from popular European-style decorative arts. These designs were soon appropriated for the Native tradition, and adapted to the techniques of glass-bead embroidery for the decoration of leggings, shoulder bags, shirts and other items of formal regalia. Their natural imagery fitted easily into the larger context of Indian cosmology.

Early examples of formal clothing made by women of the Great Plains tribes are rare today. Explorers and traders only began to penetrate this vast region in the late 1700s. By then the Plains were home to peoples who pursued buffalo on horseback, a way of life that was less than a century old. The Caddo, Arikara, Pawnee, Hidatsa and Mandan still lived the ancient agricultural life, building earth lodges in the fertile river valleys and growing corn, beans and squash. They had been joined, however, by large bands of newcomers whose mobile camps followed the buffalo herds in their migrations. Their horses were descended from those brought by the Spanish to their colonies in New Mexico. These animals had travelled northwards through the trade between the Native peoples of these two regions, and by the 1700s the Plains tribes possessed large numbers of them. Thus provided, the Lakota, Cheyenne, Arapaho, Gros Ventre and Blackfeet pressed west into the Dakotas, Wyoming and Montana. The Nez Percé, Salish and Shoshone carved out hunting territories east of their homelands in the western mountains. The Kiowa and Comanche occupied the southern plains. The Crow broke away from their village-dwelling Hidatsa relations and turned equestrian buffalo hunters in Wyoming and Montana. Early traders who travelled up the Missouri river from St Louis to seek buffalo hides found that the agricultural villages they encountered along the way were also thriving trade centers for the itinerant bands of hunters. Entire communities visited periodically, arriving in great formal processions to trade hides, meat, and horses for produce and craft goods. Traders set up shops in the villages of the Arikara, Manda and Hidatsa, bringing their goods upriver and sending buffalo hides down to St Louis by boat. Many of the surviving examples of formal clothing from

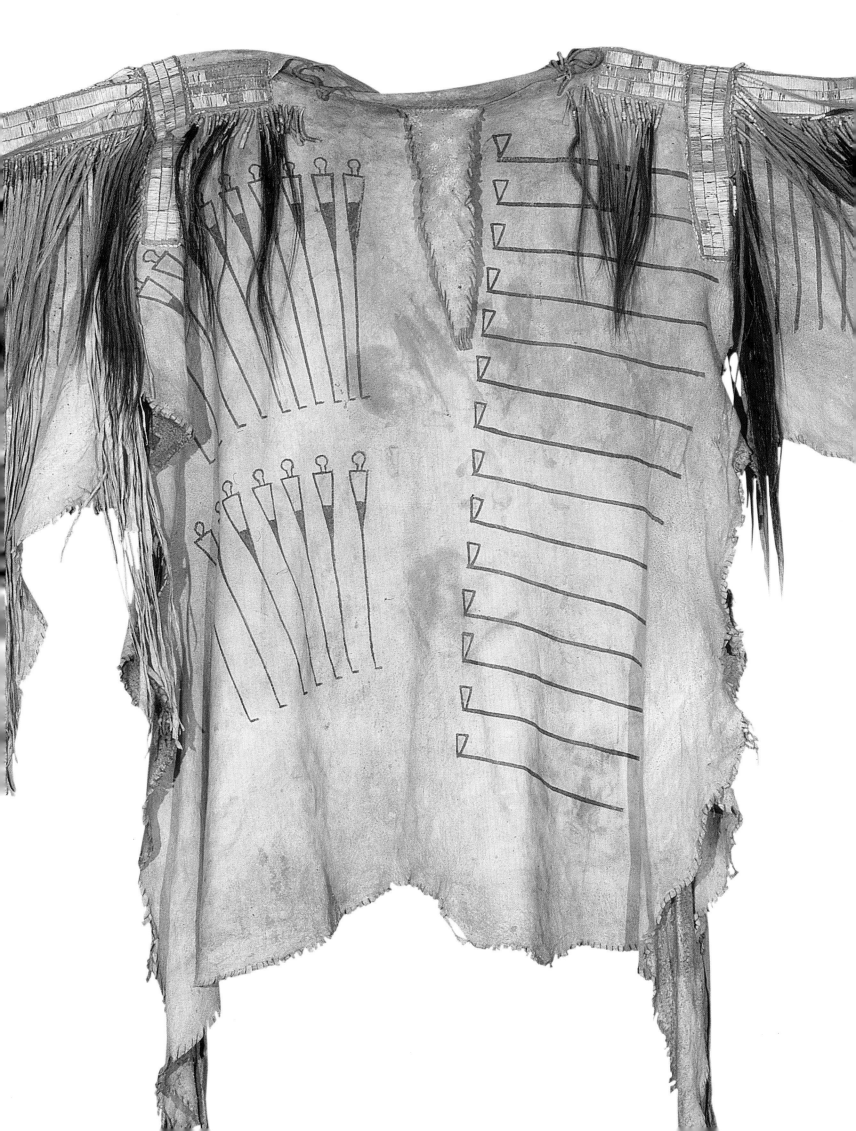

this era (1800 to 1850) were collected at the Missouri river trading posts.

The water colours of Karl Bodmer are one of the best documentary sources for the regalia of the upper Missouri tribes during the heyday of the buffalo hide trade. Bodmer accompanied Prince Maximillian zu Wied, an amateur naturalist and ethnographer, on an expedition up the Missouri river in 1833 and 1834. Maximillian had commissioned Bodmer to provide illustrations for the expedition report, which was published in 1843. Bodmer's portraits of the Native people they met with are rendered with great attention to detail, emphasizing the importance of regalia as an expression of dignity and social status.

The men would wear large, loose-fitting shirts made of the hides of deer or bighorn sheep. The women used two hides to make each shirt, one for the front and the other for the back, while the hind portions of the skins were used for the sleeves. The shirt fitted over the head like a tunic, hanging well below the waist, with long pendants made from the forelegs of the animal skin dangling to front and back. A large hide might provide enough material for a triangular neck-flap, or 'bib', at front and back, or the woman might just add these pieces on. She laced the sleeves with fringe of deerskin along the length of the arms, or used narrow bundles of long flowing human hair, as a sign that the man who wore the shirt had killed an enemy in battle. Women also added narrow strips of buffalo hide across the shoulders and down the arms, embroidered with porcupine-quills or with glass beads received from traders. Shirts were worn with a breech clout and hide leggings, also decorated with embroidered strips of buffalo hide, and quilled or beaded moccasins. Women wore dresses made of three hides, one for the front, another for the back, and the third for the 'yoke' or bodice. The bodice was often elaborately decorated with glass beads. Women's leggings were shorter, extending up the calf of the leg. Both men and women wore robes made of buffalo hides, painted or decorated with a horizontal 'blanket strip' decorated with porcupine-quills or glass beads. The women who made the regalia were as highly esteemed as male warriors. As men stood up in ceremony to recount their heroic exploits in battle, so too the women would stand up and enumerate the buffalo hides they had tanned.

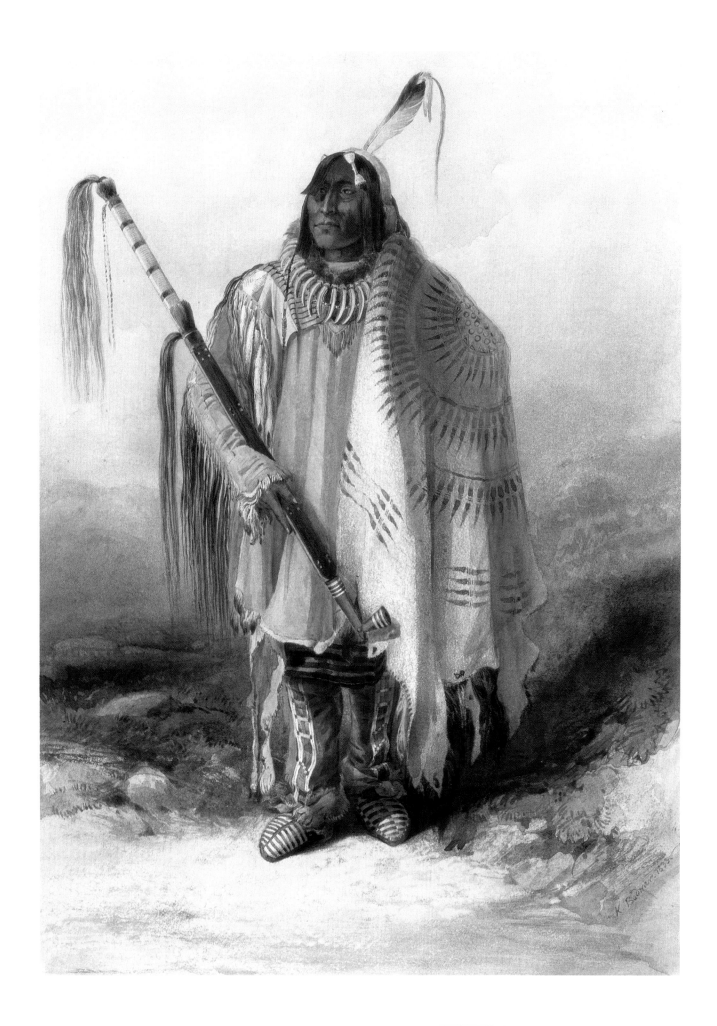

LAKOTA DOUBLE SADDLE BAG
Circa 1880, North or South Dakota.
Deerskin, glass beads, sinew, wool fabric,
length 169.2 cm (66 5/8 in).
The Detroit Institute of Arts, Detroit.

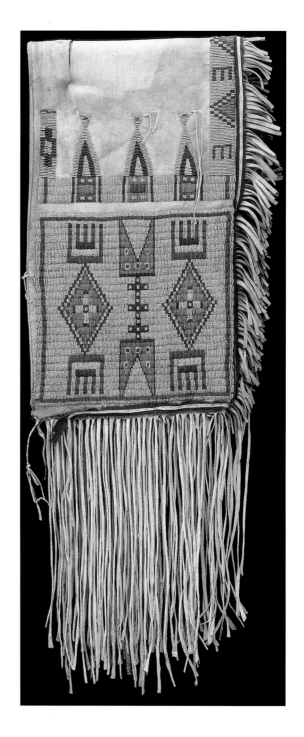

Before 1850, traders of the Missouri region imported glass beads of a distinctively large size, known today as pony beads. They came in a limited range of colours, predominantly blue and white, with some black, red and, rarely, yellow. Women used them to create broad panels or stripes of colour in shirts, dresses, leggings, moccasins and other items. It is often difficult to be sure of the origins of these garments from the upper Missouri region, as the designs, also incorporating porcupine-quill embroidery, are too generalized to identify particular tribal styles. The upper Missouri tribes traded finished garments among one another, and so their generic decoration may have been deliberate.

With the discovery of gold in California in 1849, the pace of European American migration across the Plains quickened. The Fort Laramie Treaty of 1851 sought to ease potential conflicts between the Plains tribes and the emigrants and to establish the locations of tribal territories for future administration. The livelihood of the equestrian buffalo hunter could not be contained within boundaries, however, and the 1860s and 1870s roiled with conflicts as the Plains tribes skirmished with one another for access to prime hunting grounds. They also resisted the encroachments of American soldiers, who were struggling to keep the roads to the West open. By the late 1870s, the crisis had come to a head. The southern buffalo herds were hunted to extinction by professional white hunters. The northern herds of Montana fared a little better, but the last viable summer hunt there took place in 1881. After that, the remaining animals could no longer sustain the people. With the buffalo gone, the Plains tribes were forced to live on reservations, relying on the meagre rations distributed by unreliable and frequently corrupt government officials.

During the 1850s and 1860s, traders provided women with small 'seed beads', which were available in a much broader range of colours than pony beads. Distinctive techniques for embroi-

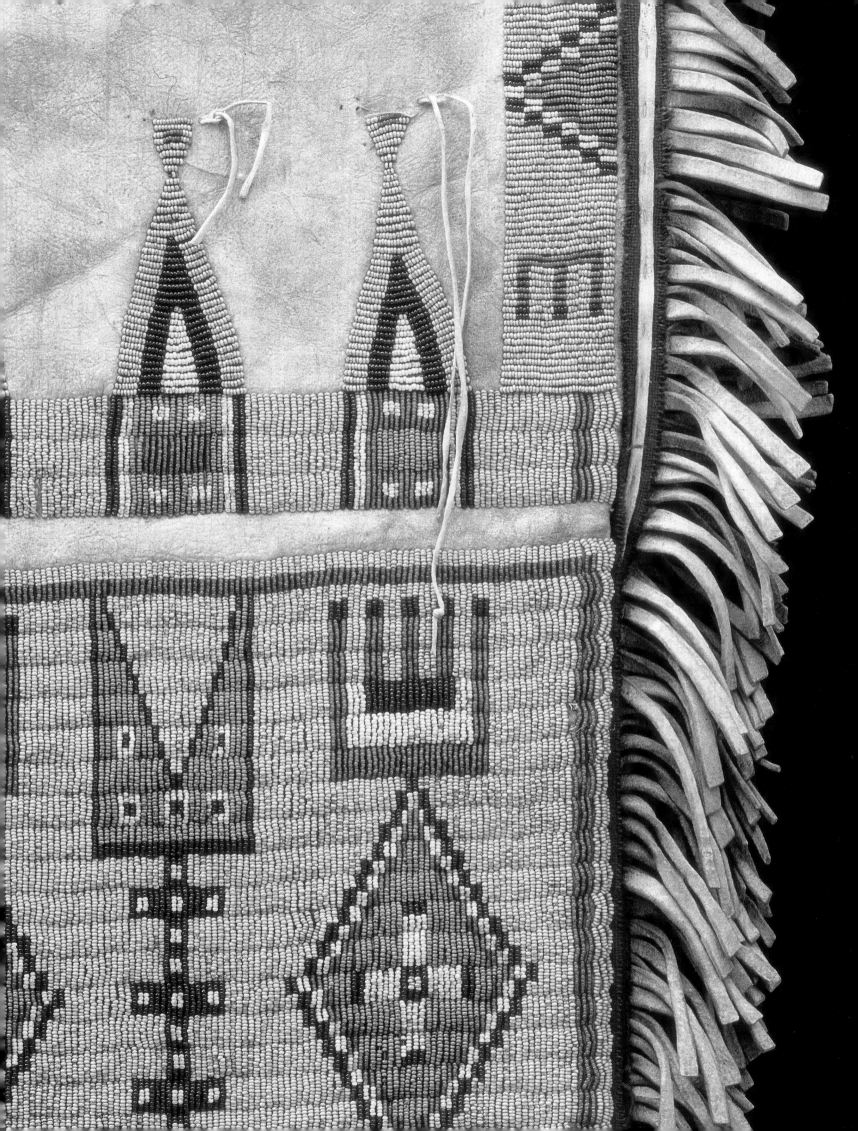

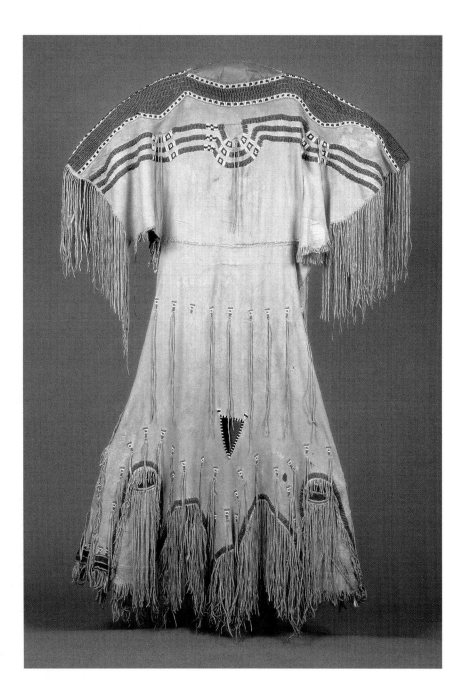

LAKOTA DRESS
Circa 1840, Dakota.
Deerskin, glass beads,
wool fabric.
National Museum of the American Indian, New York.

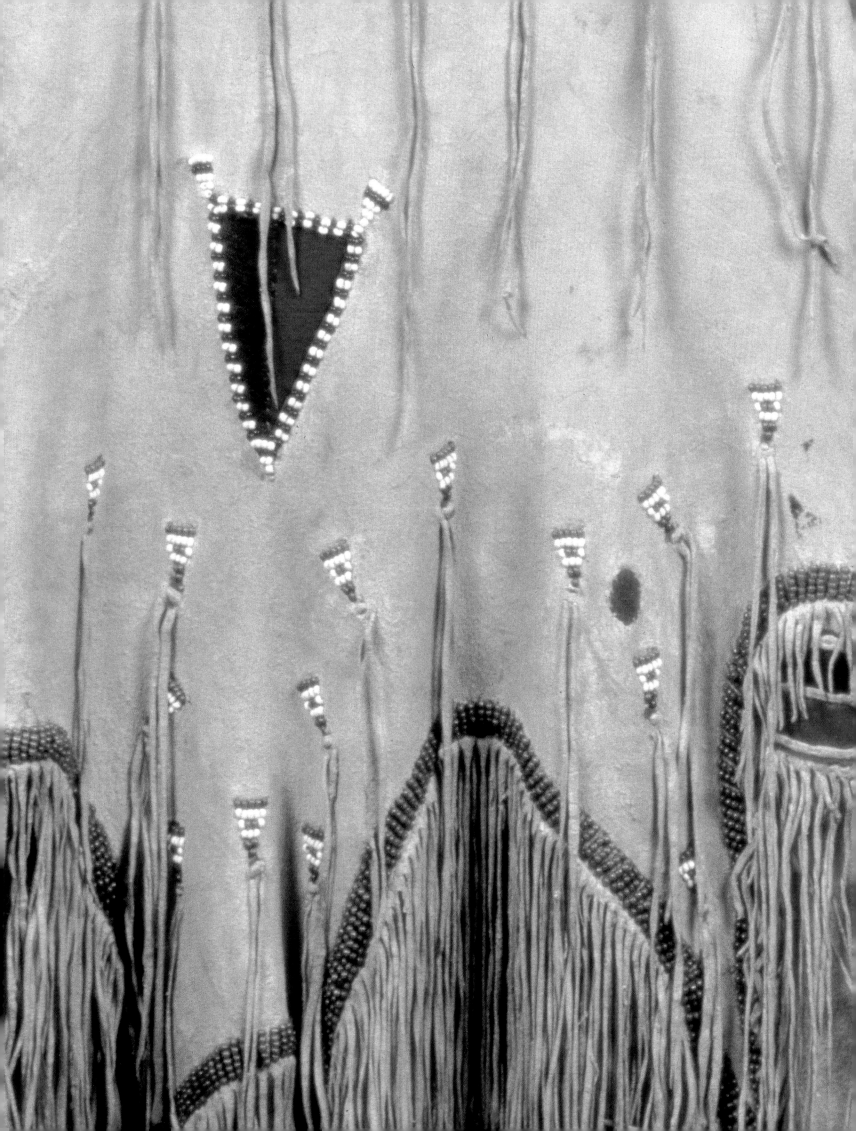

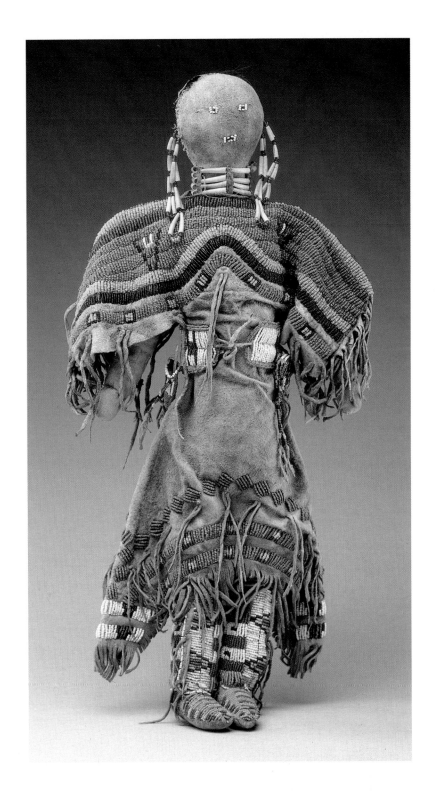

LAKOTA DOLL

Circa 1890, South Dakota.
Tanned cow hide, glass beads,
muslin fabric, dentalium shells,
50.5 x 35.6 cm (19 7/8 x 14 in).

Richard and Marion Pohrt Collection, Flint.

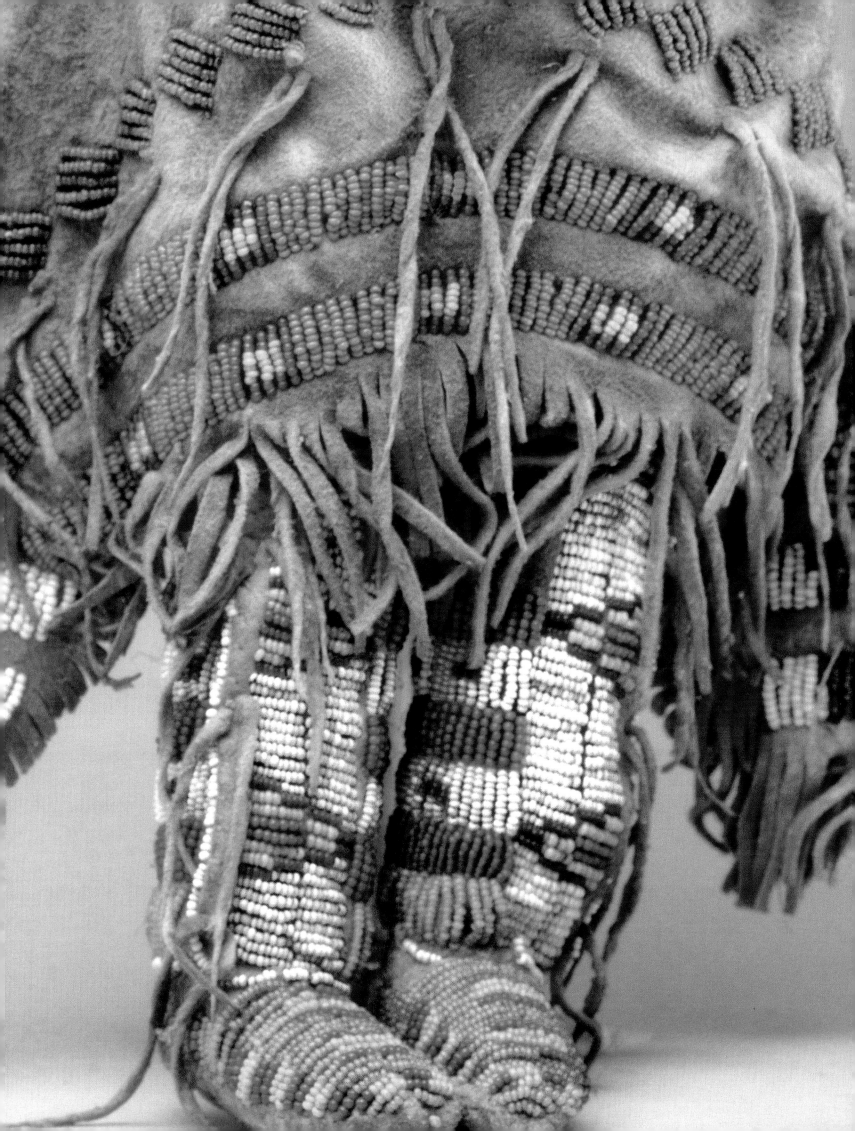

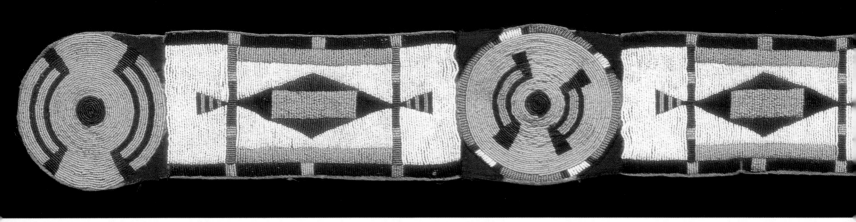

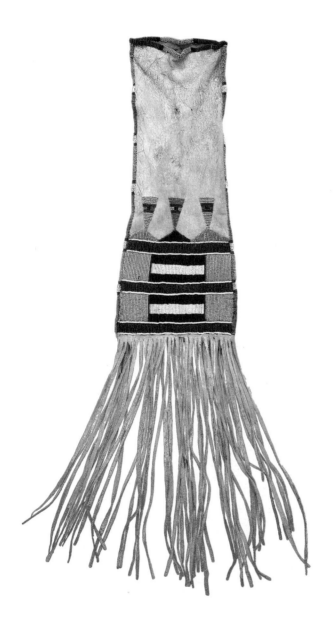

dering glass beads to garments, strong colour preferences and characteristic design forms began to define consistent tribal styles. Women of the Lakota and Cheyenne, for example, who as allies often camped together, preferred to stitch beads in parallel lanes when filling in areas of colour, a technique known today as 'parallel stitch' or 'lazy stitch'. On the other hand, Blackfeet and Cree women used 'flat stitch', also called 'spot stitch', where the beads are applied without using lanes. As for colour preferences, Crow women enjoyed pale blues and a hot pink, with strong contrasts of red, navy blue and yellow. Lakota women, on the other hand, preferred to use strong primary colours in equal weight: sky blue, white, red, navy blue, yellow and green. Cheyenne bead-work designs often included bars and bands that derive from porcupine-quill embroidery, while Crow women experimented with more expansive, geometric patterns closely related to the designs they painted on the raw-hide containers known as 'parfleches'.

It is no coincidence that these tribal styles emerged among the Plains tribes just as the tribes' survival was under threat. They served to assert both the cultural value of craft work in general, and the ethnic identity of a particular people. The role of clothing in the expression of traditional values grew during the later decades of the 1800s. From the 1880s onwards, social dances, religious ceremonies and sham battles helped brighten up reservation life and provided occasions to wear traditional regalia, whose decoration became ever more extravagant. Beginning in the 1890s, Plains women produced elaborately ornamented

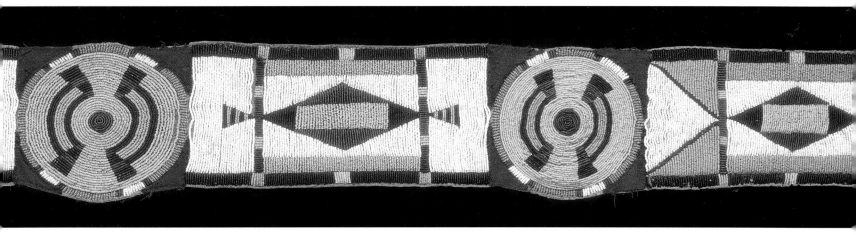

garments covered from top to bottom with bead-work embroidery. The 'powwow' regalia of the present day derives directly from garments made for social dances during the early reservation period.

CROW BLANKET STRIP
1870–1880, Wyoming and Montana.
Buffalo hide, glass beads, wool cloth, sinew,
160 x 14 cm (63 x 5 1/2 in).
Richard and Marion Pohrt Collection, Flint.

Sculpture: the domain of men

For carving wood, the Native men of eastern North America employed a crooked knife: a kind of one-handed drawknife with a blade hafted to a wooden handle. In many cases, the handles themselves were deftly carved with figures, animals, or other decorative patterns. Men used the curved blade to hollow out bowls and spoons. Burls wedged off maple or ash trees made fine bowls, since the tight concentric grain did not split and presented a pleasing pattern.

When attending a feast, a guest brought his or her own utensils: a wooden spoon, cup or bowl. Some of these were carved with images identified with the owner and referring to personal spirit protectors or sources of spirit power. This is particularly true of utensils brought to the feasts that accompanied religious ceremonies. Spoons were carved with broad spatulate bowls and long tapering handles hooked at the end to rest securely on the edge of a serving bowl. The host served from a large feast bowl, which sometimes had animal heads rising from either side of the rim. The birds, animals or human-like heads carved on bowls and spoons are never rendered in great descriptive detail. Their reductive forms suggest without specifying their spiritual pow-

CROW TOBACCO BAG
Circa 1890, Montana.
Deerskin, glass beads,
76.2 x 17.8 cm (30 x 7 in) with fringe.
Richard and Marion Pohrt Collection, Flint.

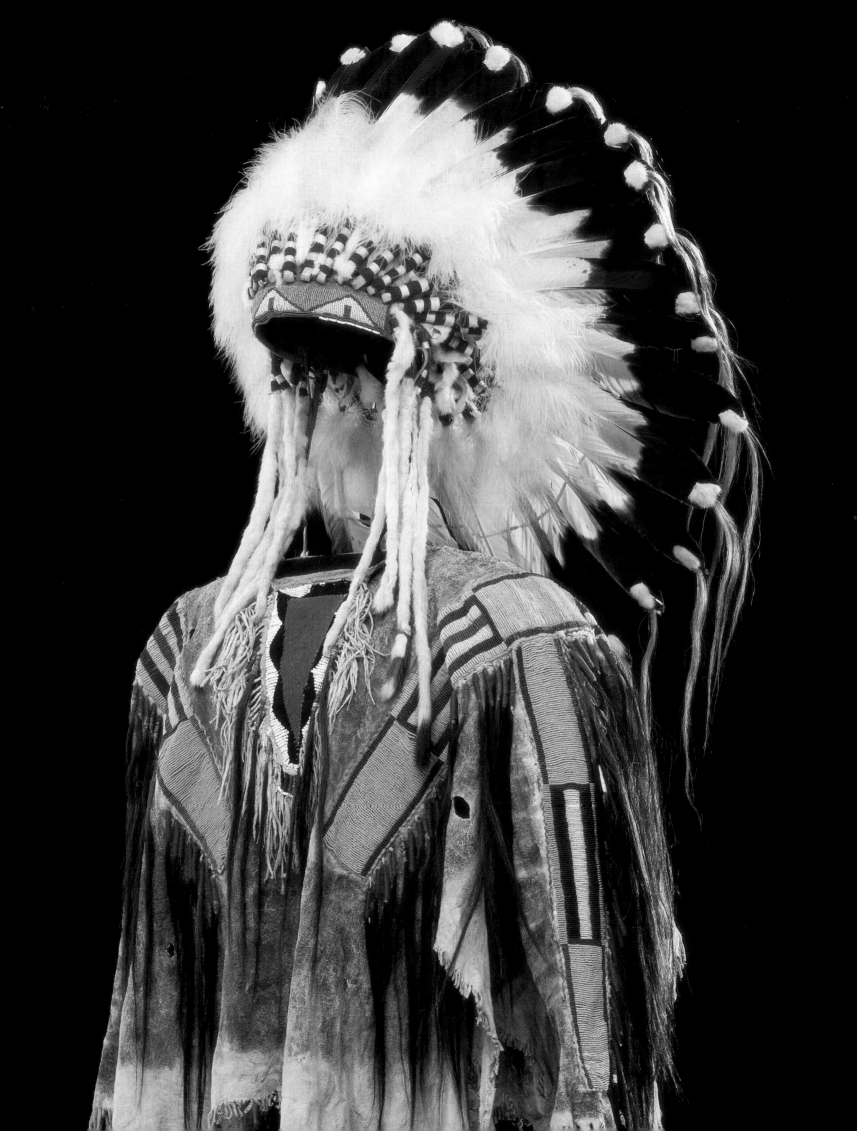

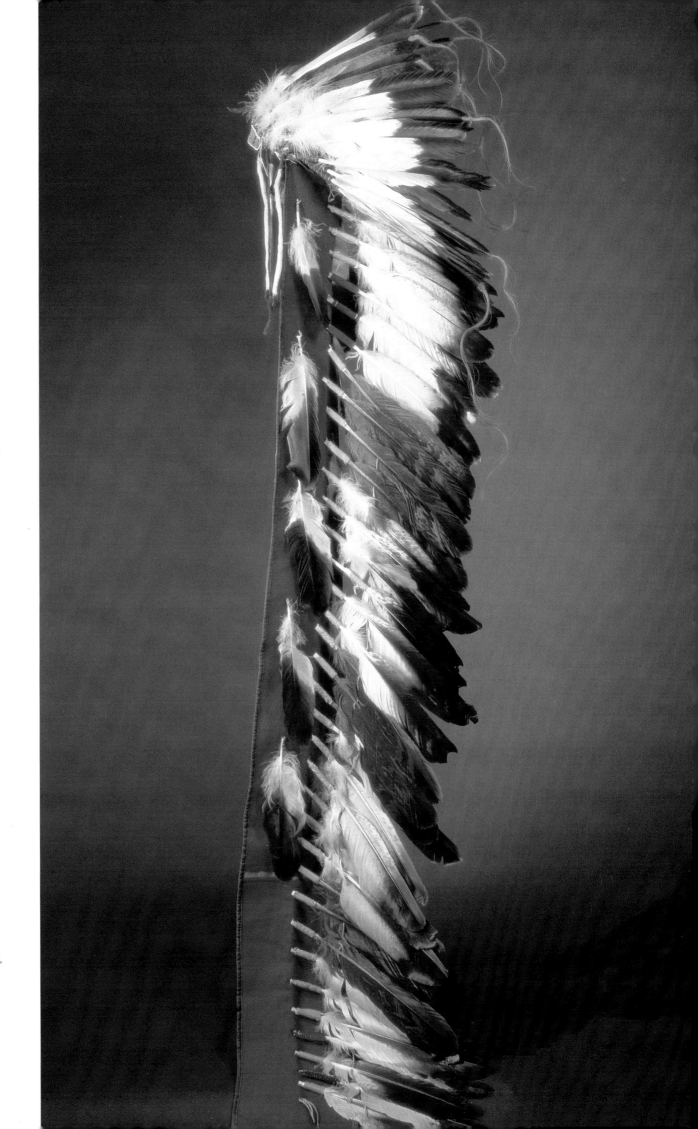

CHEYENNE HEADDRESS

1880s, Oklahoma.
Eagle feathers,
deerskin,
cotton fabric,
glass beads,
height 180 cm (71 in).
National Museum of the
American Indian, New York.

**CROW SHIRT AND FEATHER
BONNET**

Circa 1860 for the shirt,
circa 1900 for the
bonnet, Wyoming and
Montana.
Shirt: deerskin, buffalo
hide, human hair, glass
beads, porcupine-quills,
wool fabric and yarn,
68.6 x 160 cm
(27 x 63 in).
Bonnet: eagle feathers,
ermine skin, glass beads,
cow tail, wool fabric,
length 43.2 cm (17 in).
The Detroit Institute of Arts,
Detroit.

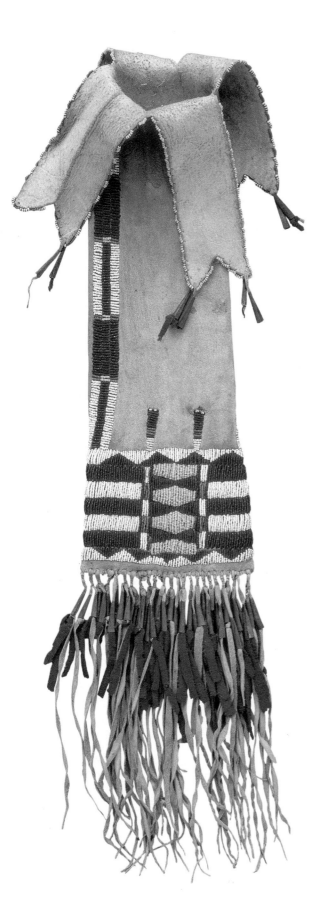

ers. Their presence during ritual feasts sanctioned the prayers offered by the participants.

In a similar vein, healers used small medicine bowls carved with spirit figures to serve their patients restorative mixtures of medicinal herbs. The figures along the edges of the bowl – or the bowl itself carved in the form of an animal – witnessed to and fortified the medicine's power. Before serving the patient, the healer sprinkled tobacco dust on the liquid in the bowl to determine the efficacy of his potion, indicated by the swirling patterns of dust on the liquid's surface.

Smoking tobacco in pipes was often an act of prayer. The tobacco is offered to spirit beings in thanks for the blessing of their powers. The bowls of tobacco pipes are often carved with images of animals and human heads or faces. These images are not manifestations of the spirit beings, but metaphorical expressions of the powers that prayers were intended to address. Pipestone National Monument in south-west Minnesota was the source of a distinctive red stone used by pipe carvers from many different tribes. Called catlinite, after the frontier artist and memoirist George Catlin, a seam of this deep red stone runs just

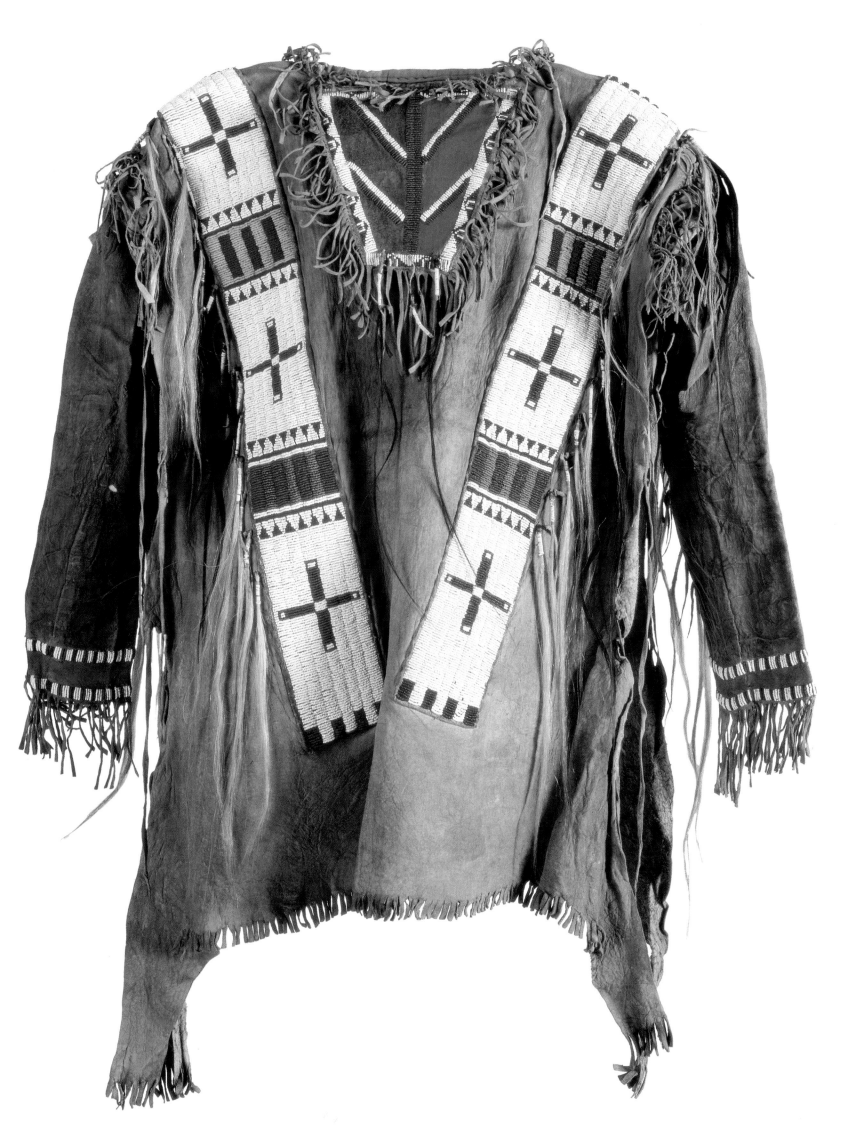

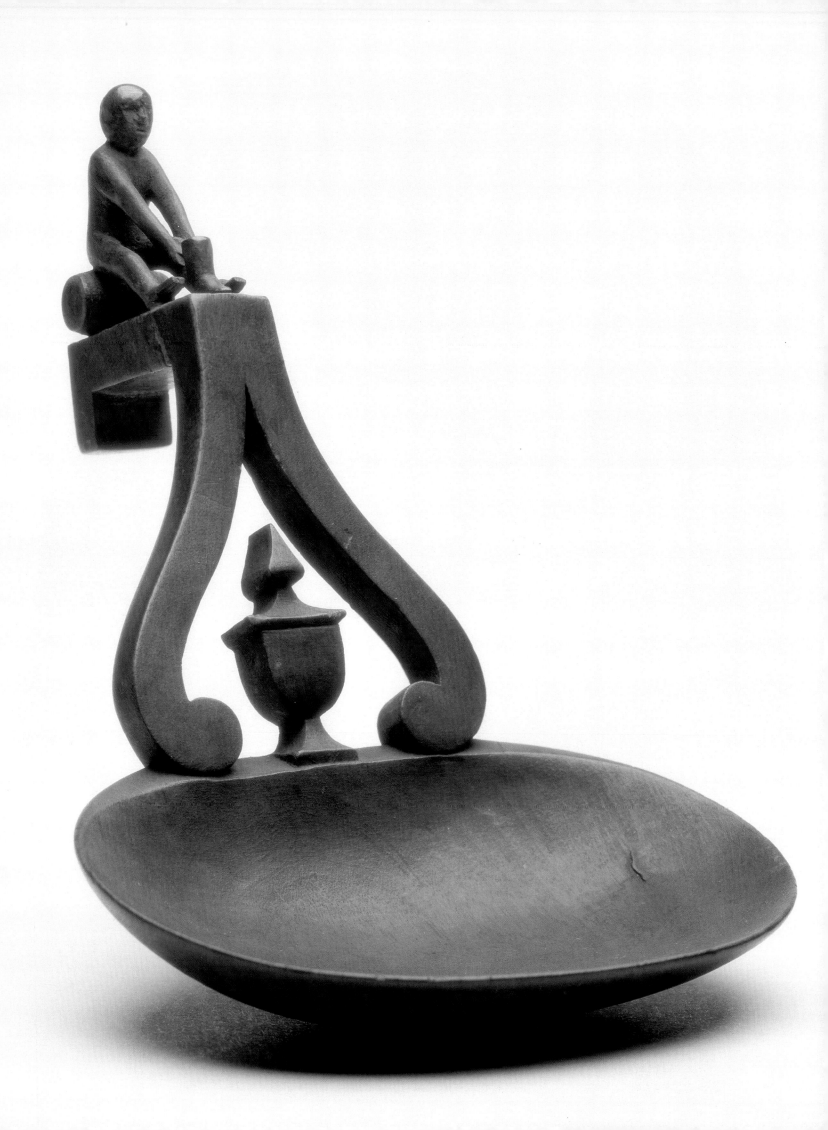

below the surface of the broad valley floor. Those who came for the stone prepared themselves by fasting and offered prayers before digging a shallow pit. Red catlinite was the material most coveted by pipe makers from the Plains and western woodlands, because the colour red symbolized the active principle in all spiritual power.

Woodlands and Plains men rarely carved free-standing figural sculpture, and when they did, such figures were invariably instrumental, not decorative. They were intended to perform certain ritual tasks. A small wooden Potawatomi figure dressed in woollen leggings like a doll would be used

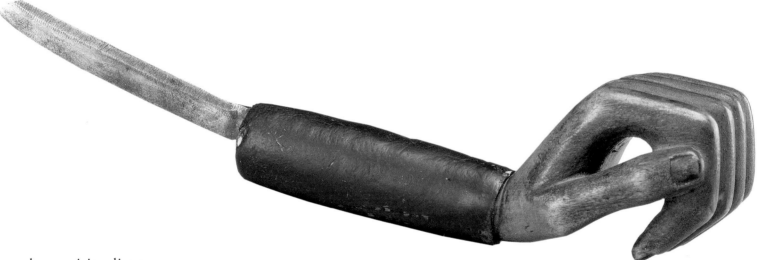

by a spiritualist to coerce love from an unwilling victim at the behest of a client. Spiritualists who performed such services were considered dangerous and treated as social outcasts by the community. Inflicting 'love medicine' on others was seen as an act of rape. Nevertheless, some religious practitioners pursued such sorcery in secret, inflicting disease and even death on others.

Other carved figures were included among the many esoteric components of 'sacred bundles', assemblages of sacred objects employed by their owners or 'keepers' to harness the spirit powers. Ambitious men would seek out relationships with spirit beings through 'vision quests' and fasts. A spirit being might appear to its human partner in dreams or reveal itself in visions. The 'tree dweller', for instance, was sometimes encountered by the Dakota in the forests of Minnesota. It lived in the stumps of dead trees and it was said that if one laid eyes on one while hunt-

CROOKED KNIFE
Late 19th century, Great Lakes region.
Wood, steel blade, rawhide, length 23.5 cm (9 1/4 in).
The Detroit Institute of Arts, Detroit.

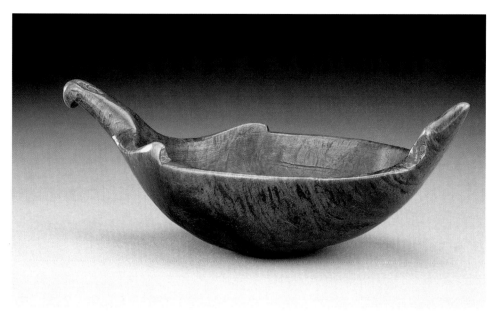

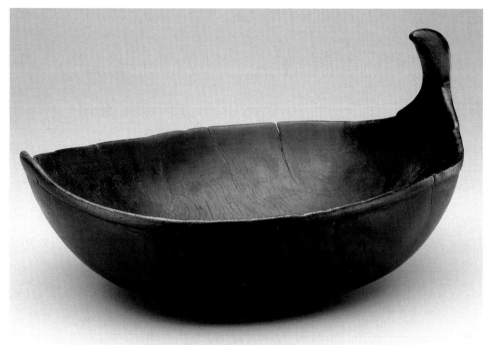

MESQUAKIE FEAST BOWL

19th century, Tama, Iowa.
Maple, height 35.9, diameter 42.5 cm
(14 1/8 x 16 3/4 in).
The Detroit Institute of Arts, Detroit.

| Above

WINNEBAGO BIRD EFFIGY MEDICINE BOWL

19th century, Wisconsin.
Maple, height 5.4, diameter 16.5 cm
(2 1/8 x 6 1/2 in).
The Detroit Institute of Arts, Detroit.

ing alone in the forest, one would go mad and wander about lost forever. Bundles that stemmed from a tree dweller's blessings would include a wooden image of its eerie, other worldly form. Encounters with spirit beings often took place in the forest, far from the centre of community life. The Big House ceremony of the Delaware stems from such a meeting between two young hunters and the Great Stone Face.

Long ago, it is said, the Delaware were stricken with famine. Two boys resolved to ease their community's suffering and trav-

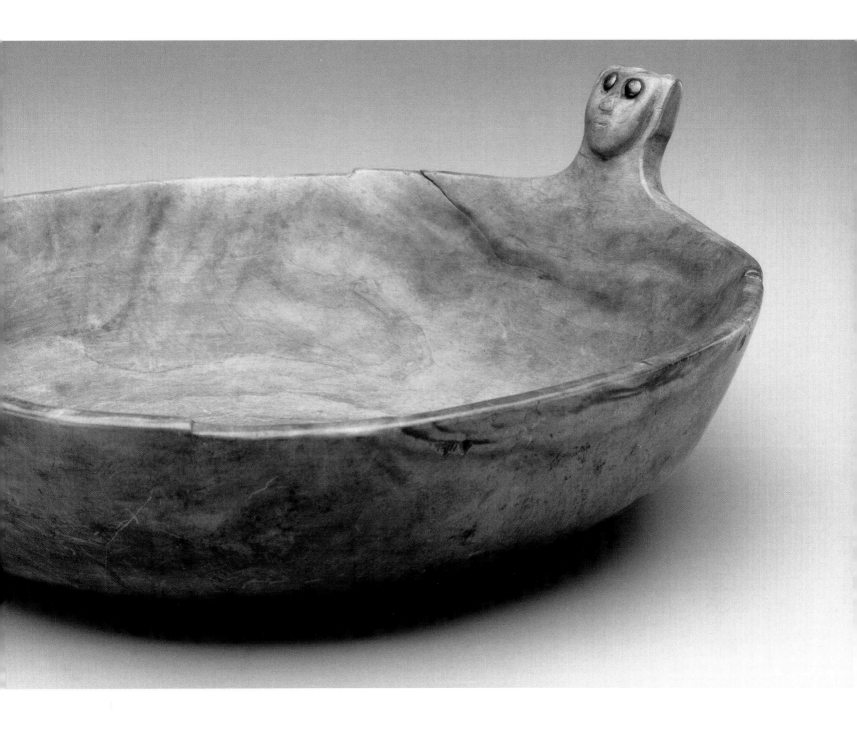

elled deep into the forest in search of game. Far from their customary hunting grounds, they met a fearsome supernatural being who called himself the Great Stone Face. He taught the boys how to conduct an elaborate twelve-day ritual. He promised that he would provide their community with abundant game if they performed the ceremony to honour him on a regular basis. With this gift of sacred knowledge, the young hunters returned to their village and organized the ritual that came to be known as the Big House ceremony.

YANKTON OR YANKTONAI (NAKOTA) FEAST BOWL
Circa 1850, Minnesota or South Dakota.
Maple, brass tacks, height 13,
diameter 34 cm (5 1/8 x 13 3/8 in).
The Detroit Institute of Arts, Detroit.

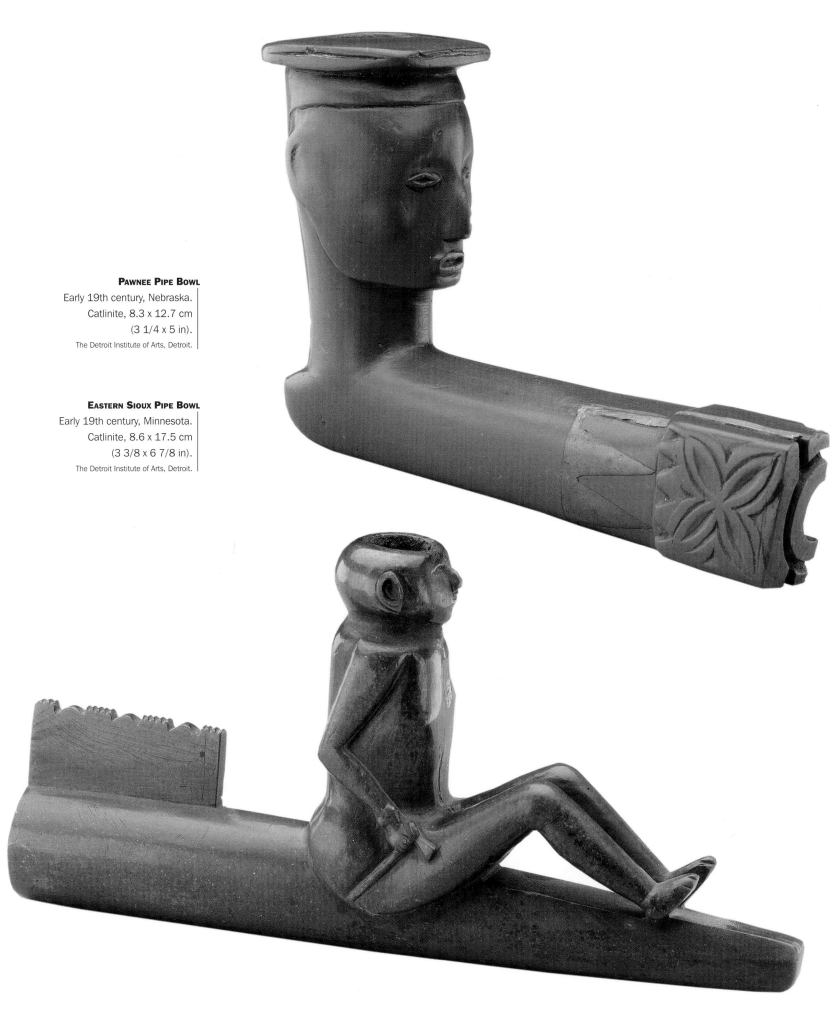

PAWNEE PIPE BOWL
Early 19th century, Nebraska.
Catlinite, 8.3 x 12.7 cm
(3 1/4 x 5 in).
The Detroit Institute of Arts, Detroit.

EASTERN SIOUX PIPE BOWL
Early 19th century, Minnesota.
Catlinite, 8.6 x 17.5 cm
(3 3/8 x 6 7/8 in).
The Detroit Institute of Arts, Detroit.

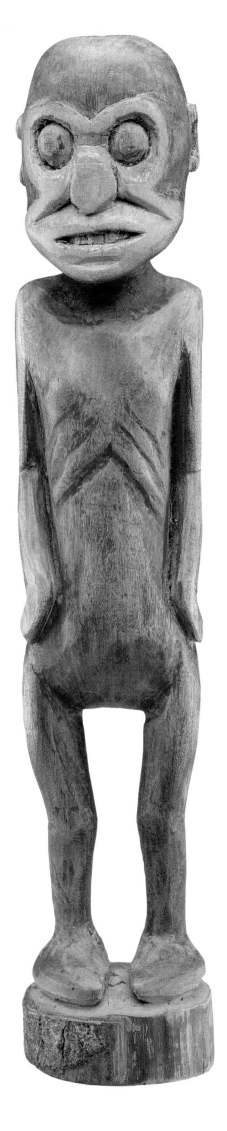

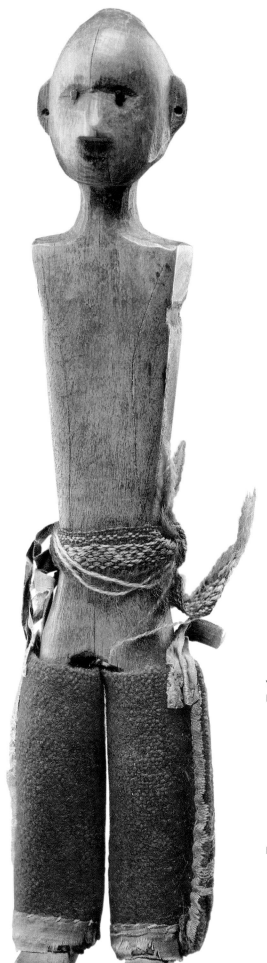

| Left
YANKTON TREE DWELLER FIGURE

19th century, Minnesota or South Dakota.
Wood, height 24.1 cm (9 1/2 in).
The Detroit Institute of Arts, Detroit.

| Right
POTAWATOMI MALE FIGURE

1800–1860, Crandon, Wisconsin.
Wood, wool fabric and yarn, cotton braid, metal, height 22.9 cm (9 in).
Cranbrook Institute of Sciende, Bloomfield Hills.

The Big House where the ceremony takes place is a communal structure built far away from the village. For twelve days, dances alternate with feasting, all in honour of the spirit who helped the Delaware survive. At a certain point, the Great Stone Face himself appears as a masked figure wearing a suit made of bearskin. The ritual is divided into four sequences of three days each. During the last and most sacred sequence, the dances are accompanied by drumming using special drumsticks carved with faces, one male and one female, out of respect for the necessary and complementary relations between the genders. Their faces are painted half red and half black, to represent dawn and dusk, birth and death, or more simply, the cycle of life that animates all things.

Pictographs and paintings: the memory of the tribes

Men of the Woodlands and Plains tribes used 'pictographs' to record and convey certain kinds of information. Such symbols differ from systems of writing in that their content is often specific to a particular functional context. They are aides to memory rather than systems of notation. For example, Potawatomi herbalists, healers who employed medicinal plants for their cures, would engrave wooden tablets with signs representing the different plants required to treat specific ailments. The herbalist would use the 'prescription stick' as a mnemonic and heuristic device, to remember the recipes and to teach others, but only he and those he taught could 'read' the message it carried. In this way, knowledge was simultaneously preserved and yet concealed from those who did not have the right to it.

The spiritual structure of the larger cosmos was often expressed in the pared-down imagery of pictographs. The tablet-like lid of an Eastern Sioux box, in which eagle feathers used in a headdress were stored, carries an elaborate cosmological diagram. The scheme is divided into three sections. The central section contains four circles with equal-armed crosses in each, the ancient symbol for the four cardinal directions of the Earth and the encircling horizon. To one side are four underworld creatures, two bears and two underwater panthers. On the other side are two hourglass shapes, representing the breast and tail feathers of

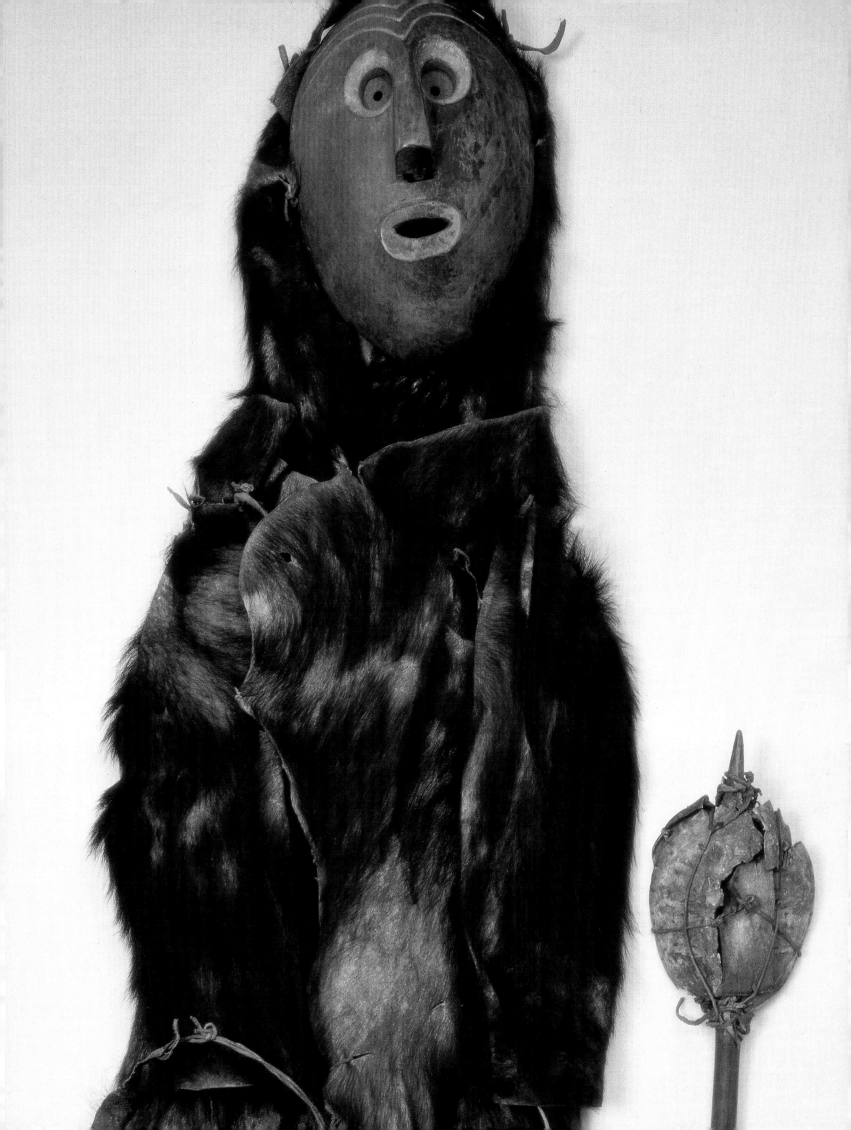

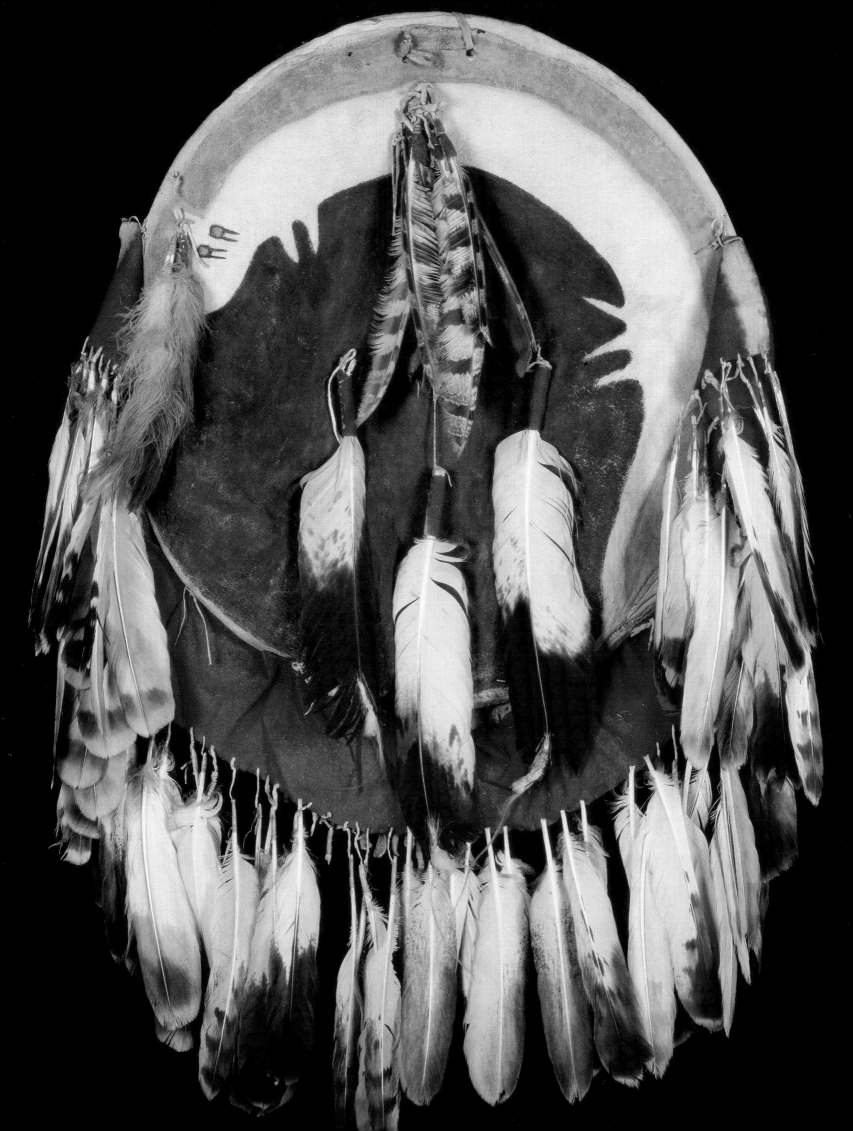

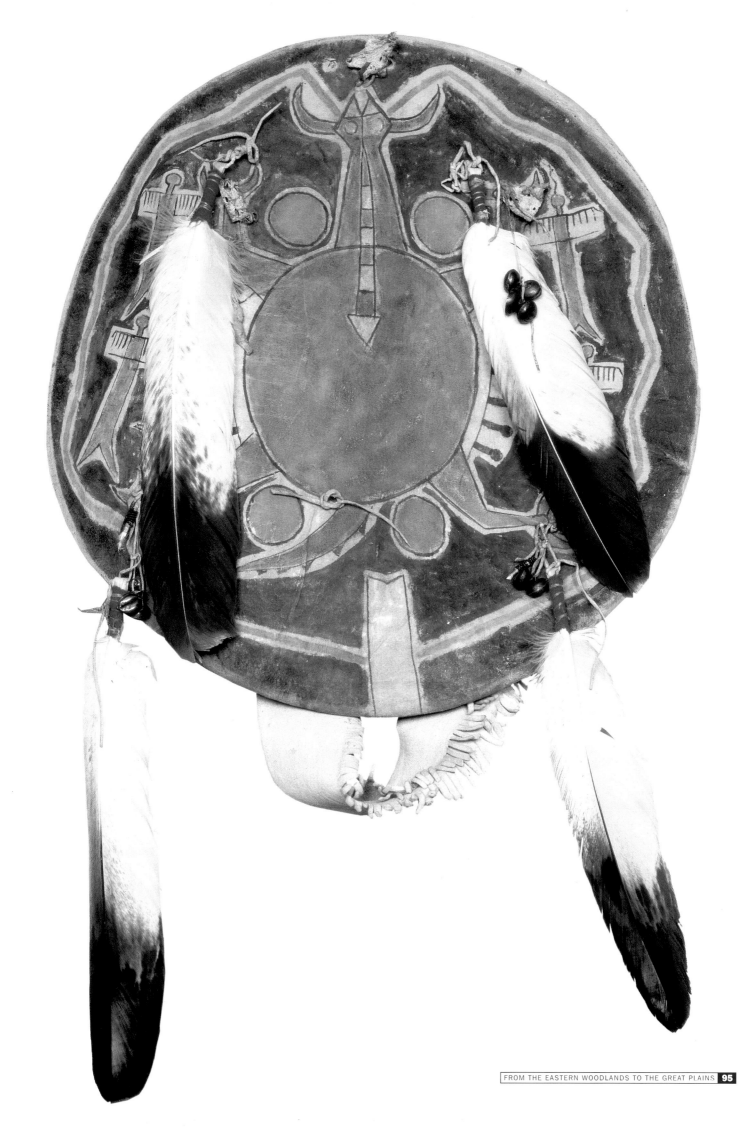

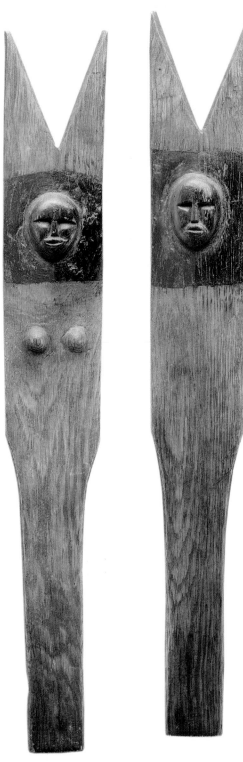

the thunder bird, with further feathered appendages. The design thus describes the terrestrial Earth bracketed on either side by the mighty spirit beings of the underworld and sky-world, the sources of all spiritual power.

The pictographic images engraved on some Ojibwa war clubs from the upper Great Lakes region contain explicit references to the spiritual and military biographies of their owners. 'Gunstock' clubs, with their distinctive angled shape, are actually images of lightning bolts, the deadly power of thunder beings. One such club is carved with an image that recounts how in a dream the owner ascended high into the sky-world where he saw a thunder bird seated on her nest. This image, in a reduced pictographic form, is inscribed on the face of the club: a large bird rendered in profile contained within a half-circle, representing the nest.

Plains warriors painted forceful images of their visionary experiences on their war shields, most often on a soft deerskin cover. These pictures are broadly metaphorical renderings of dream imagery, symbols of spirit powers or depictions of spirit beings themselves. Some warriors received visions in which their spirit protectors showed them the designs they should paint. The shields themselves, made of double thicknesses of buffalo

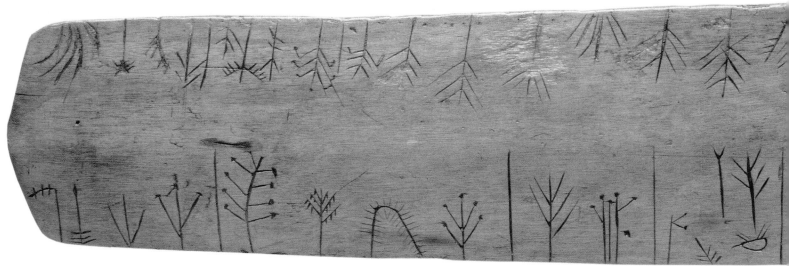

rawhide, protected their owners not only physically but spiritually. Bull Lodge, a Gros Ventre holy man, was told in a vision that his shield kept harm away not only from himself but from his entire war party.

Men painted images derived from visions and dreams on many other kinds of objects, too. The images themselves were gifts of power from the spirit world and their display was an exclusive right and privilege. Some men were given lodge or tipi designs by their spiritual protectors. A particularly famous painted tipi photographed at the Fort Belknap reservation shows a cosmological diagram like that seen on the feather-box lid, this time with horned monsters encircling the lower portion of the tipi and the rising thunder bird with a rainbow near the top. Similar paintings drawn from visionary experiences can be found on the lodges of the Blackfeet, Kiowa and other Plains tribes. In some cases, the right to paint such designs on tipis was handed down through the generations as an exclusive family prerogative, stemming from the visionary experience of an ancestor who had received the gift of the design from a spirit being. Such experiences were a constant source of spiritual imagery. During the late 1880s, a Paiute prophet named Wovoka began to have the visions that later formed the foundation for the pan-tribal

PAIR OF DELAWARE DRUMSTICKS FOR THE BIG HOUSE CEREMONY
Late 19th century, Oklahoma.
Wood, paint, length 49.8 cm
(19 5/8 in).
The Detroit Institute of Arts, Detroit.

POTAWATOMI PRESCRIPTION STICK
Circa 1860, Kansas.
Wood, length 32.4 cm (12 3/4 in).
The Detroit Institute of Arts, Detroit.

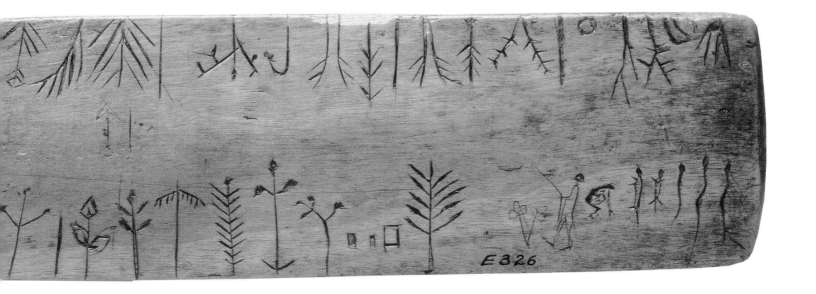

religious revival known as the Ghost Dance. The Ghost Dance promised the restoration of the buffalo and a return to the ways of life traditional before the advent of the white man. Wovoka had received this vision while visiting the ancestors in the land of the dead. Religious leaders from reservations throughout the Plains visited him and brought his teachings back to their communities. The Arapaho of Oklahoma painted special garments combining Ghost Dance symbolism, such as the crow and western magpie, with traditional Arapaho symbols like the cedar tree. The crow is a messenger from the dead, while the western magpie was Wovoka's spirit guardian. The cedar tree, however, is the Arapaho symbol for the world centre and for everlasting life. The circles, crescents and stars visible on most Arapaho Ghost Dance garments represent both the heavens and the new world that the Ghost Dance promised.

Men also used pictographic images to record their battle honours. In the Woodlands region, a kind of shorthand notation was favoured, painted or drawn in a prominent location like a cliff face or the prepared surface of a large tree. On it were recorded the results of expeditions: the number of warriors in the party, the name of the leader, the number of enemies killed. On the Plains, men used a similar graphic system to represent their fighting experience on clothing such as war shirts or buffalo robes. An exceptionally early and elaborately painted buffalo robe was collected at a Mandan village during the Lewis and Clark expedition up the Missouri in 1804. It illustrates a great battle that took place in 1797 between the Mandan and their Hidatsa allies on one side, and their enemies the Lakota and the Arikaras on the other. The combatants are simple stick figures, distinguished only by their headdress, weaponry and fate. The expansive composition breaks down into innumerable face-to-face encounters. What seems like a formless mêlée is in fact a carefully rendered summation of many individual Mandan experiences during the battle: the enemies Mandan warriors killed or the wounds Mandan men suffered. For those who participated in the battle, or who heard the story afterward, every participant could be identified, every event confirmed by witnesses. Provided with the bare bones, memory would supply the missing details.

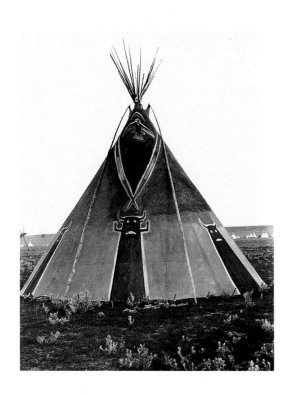

MEDICINE TIPI
1905, Fort Belknap, Montana.
Milwaukee Public Museum, Milwaukee.

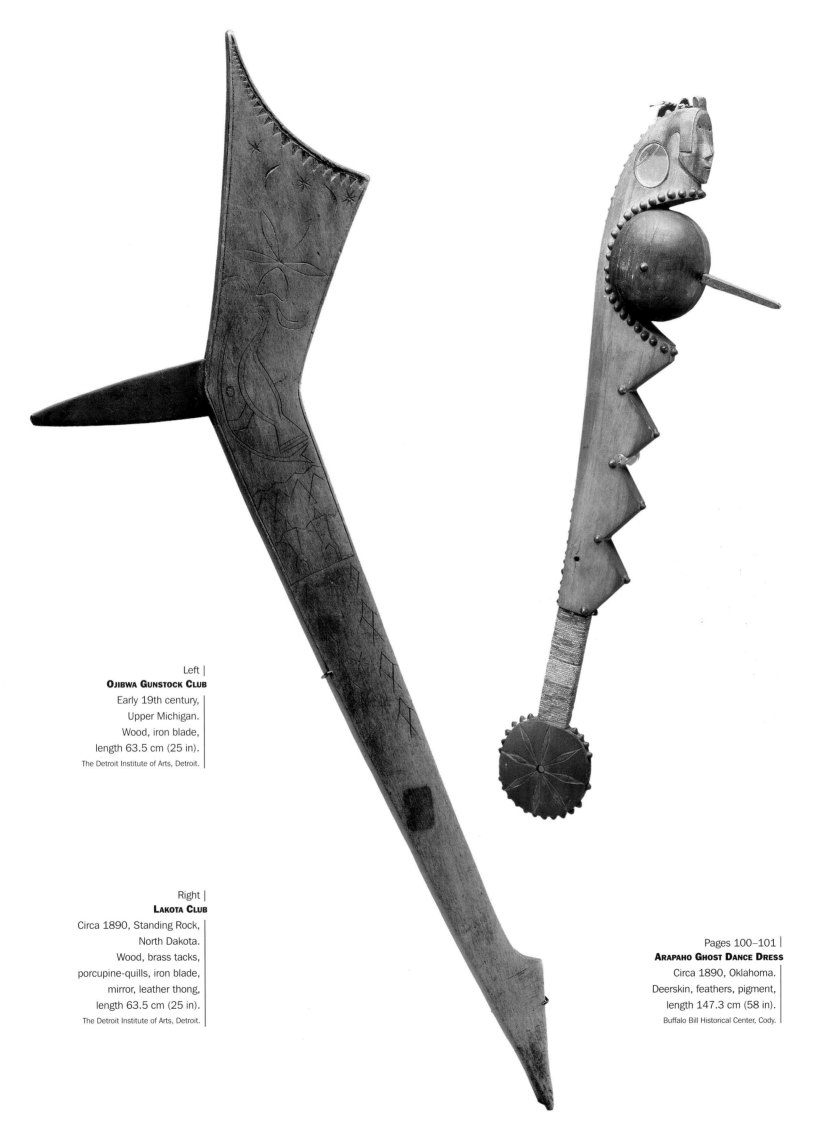

Left |
OJIBWA GUNSTOCK CLUB
Early 19th century,
Upper Michigan.
Wood, iron blade,
length 63.5 cm (25 in).
The Detroit Institute of Arts, Detroit.

Right |
LAKOTA CLUB
Circa 1890, Standing Rock,
North Dakota.
Wood, brass tacks,
porcupine-quills, iron blade,
mirror, leather thong,
length 63.5 cm (25 in).
The Detroit Institute of Arts, Detroit.

Pages 100–101 |
ARAPAHO GHOST DANCE DRESS
Circa 1890, Oklahoma.
Deerskin, feathers, pigment,
length 147.3 cm (58 in).
Buffalo Bill Historical Center, Cody.

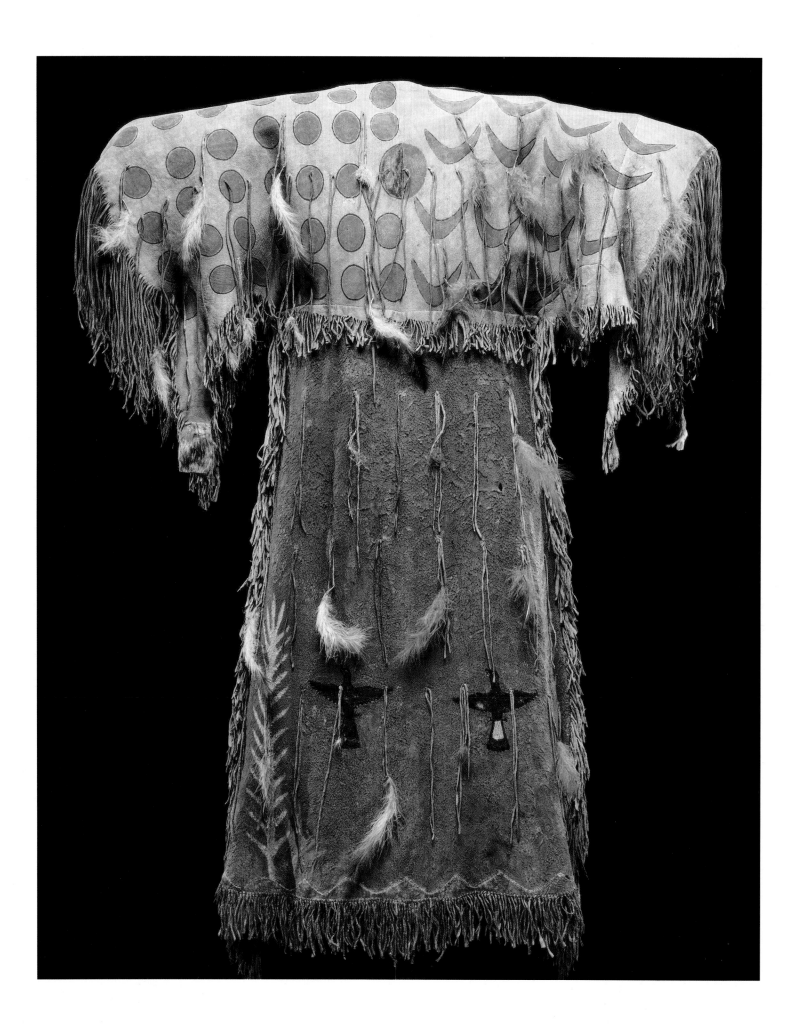

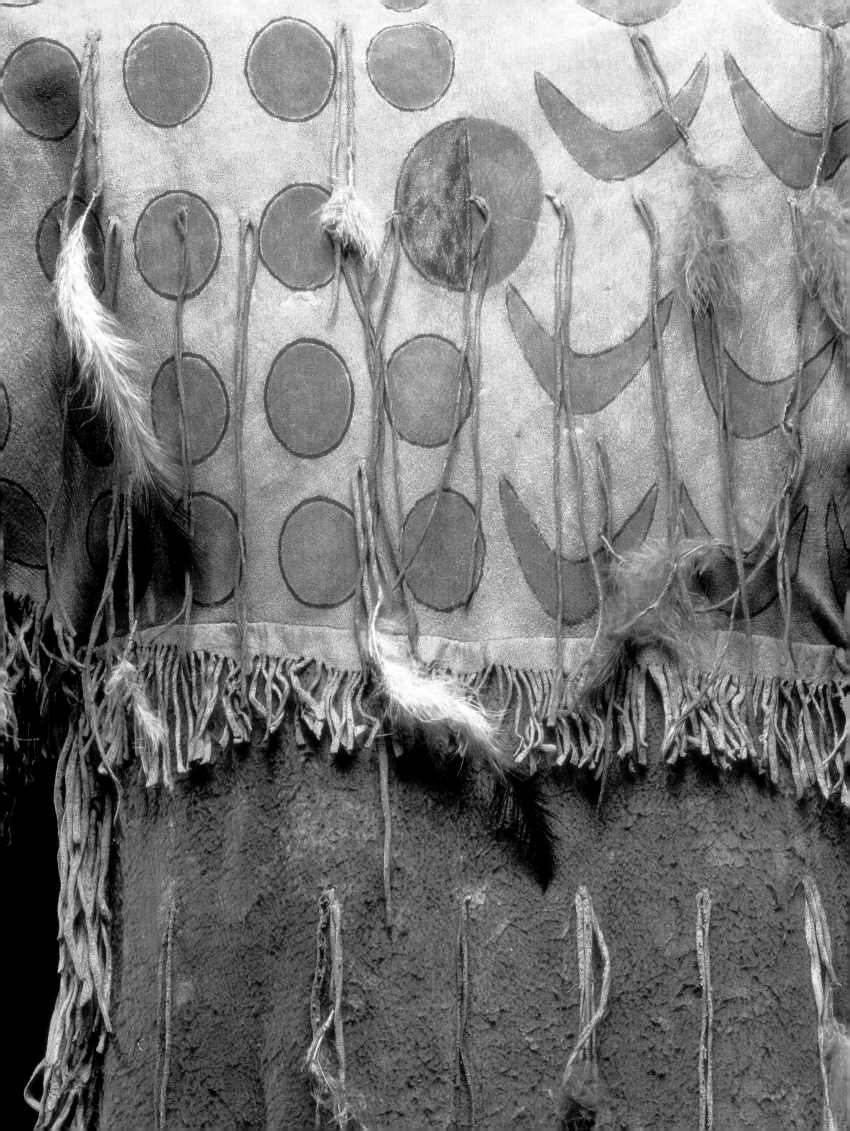

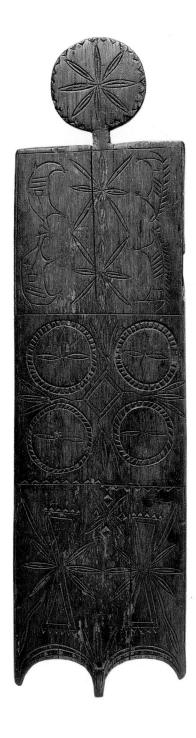

EASTERN SIOUX FEATHER BOX LID
1800–1860, Minnesota.
Wood, 44.4 x 12.1 cm
(17 1/2 x 4 3/4 in).
The Detroit Institute of Arts, Detroit.

Another early item, collected possibly in the 1830s in the upper Missouri region, is a war shirt illustrating the visual structure of pictographic battle pictures. The painter shows three separate events across the torso of the shirt. In the first, on top, the protagonist in red (probably the shirt-owner himself) levels his rifle at an enemy who is holding a shield and has raised his war axe to strike. Behind the hero is a second wounded enemy, who has dropped his rifle. In the second encounter, the same red warrior is now wearing a feathered headdress; he is shooting a yellow warrior, who also holds a rifle. Blood spurts from the enemy's wounds. In the third action, at the bottom, the red warrior is chasing a fleeing enemy and firing arrows after him. These three events were probably widely separated in time. Two more episodes of combat are shown on the back of the shirt. The shirt owner painted black stripes on the sleeves as a sign that he had killed enemies in battle. The red stripes with horse tracks at the bottom of the shirt probably represent expeditions when horses had been captured. In traditional Plains Indian society, where social rank depended on deeds, not on birthright, these kinds of accomplishment spoke eloquently of a man who had proved himself.

By the 1860s, Plains men had adopted the habit of recording their deeds of war in ledger books or account books, which they had traded or captured. They used pencil, pen-and-ink, and watercolours or other pigments. Their figures were fleshed out with more descriptive detail, influenced, no doubt, by the conventions of illustrations they had seen in magazines and other sources garnered from whites. A large number of the ledger-book drawings were produced by warriors newly confined to reservations during the 1880s and 1890s as pictorial histories, summarizing their experiences during the Plains wars. A drawing by the Cheyenne warrior Yellow Nose, for example, shows a moment during the Battle of the Little Big Horn, when George Armstrong Custer and five companies of his Seventh Cavalry were killed to a man. Yellow Nose has ridden among the dismounted troopers with a captured flag and is striking the soldiers with it, oblivious to the bullets flying all around him. The drawing was produced many years after the event as part of a sequence of pictures illustrating significant episodes from the

MANDAN ROBE PAINTED WITH EPISODES FROM A BATTLE OF 1797

Probably collected in 1804–1805 by Lewis and Clark.

Buffalo hide, painting, length 240 cm (94 1/2 in).

Peabody Museum, University of Harvard, Cambridge.

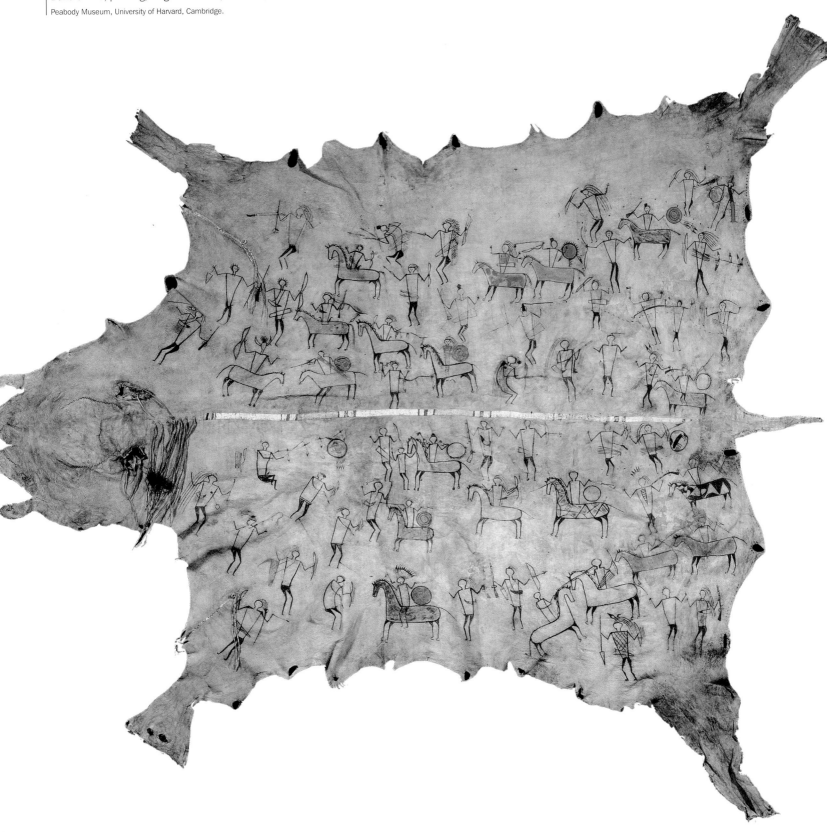

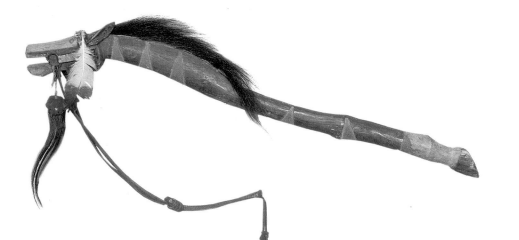

**FRONT AND BACK
OF WARRIOR'S SHIRT**
1830s, Upper Missouri region.
Deerskin, porcupine-quills,
horse hair, paint,
length 87.9 cm (34 5/8 in).
National Museum of Natural History,
Washington, DC.

| No Two Horns
DANCE STICK
1880s, Lakota, Standing Rock
reservation, North Dakota.
Wood, horse tail, hide, feathers,
paint, 88.9 x 8.9 cm
(35 x 3 1/2 in).
National Museum of the American Indian,
New York.

battle, all of them shown from the artist's own point of view as participant.

No Two Horns, a Lakota warrior, commemorated the bravery of his horse during the same battle in a series of drawings and sculptures. His blue roan was wounded five times before falling in battle. Besides several drawings depicting this event, he also carved a series of dance sticks with the horse's head at one end, a single hoof at the other, and the five wounds in red along the shaft. A 'dance stick' or 'dance club' is an elaborately carved wand or club carried while dancing. Military dances like the Grass Dance enjoyed great popularity during the early days of the Lakota reservations because they extolled the traditional virtues of warriors. The old timers who were no longer permitted to fight could dance with the weapons and in full regalia. A popular form of dance club made at the Standing Rock reservation featured the head of a Crow warrior, recognizable by his distinctive hair style. The Crow were historical enemies of the Lakota; the head on the end of the club was a kind of sculptural equivalent to the pictographic sign for a Crow killed in battle.

The depiction of battle honours in pictographic drawings was traditionally the province of men, but after the 1880s, some women artists of the Lakota began to include pictographic images in their beadwork designs. As a rule, these images represented warriors on horseback with weapons or holding American flags; there was no reference to specific events. The images glorified traditional values in a more generalized way, by incorporating them into the regalia worn for public and ceremonial events. On rare occasions, though, a beaded pictograph did refer

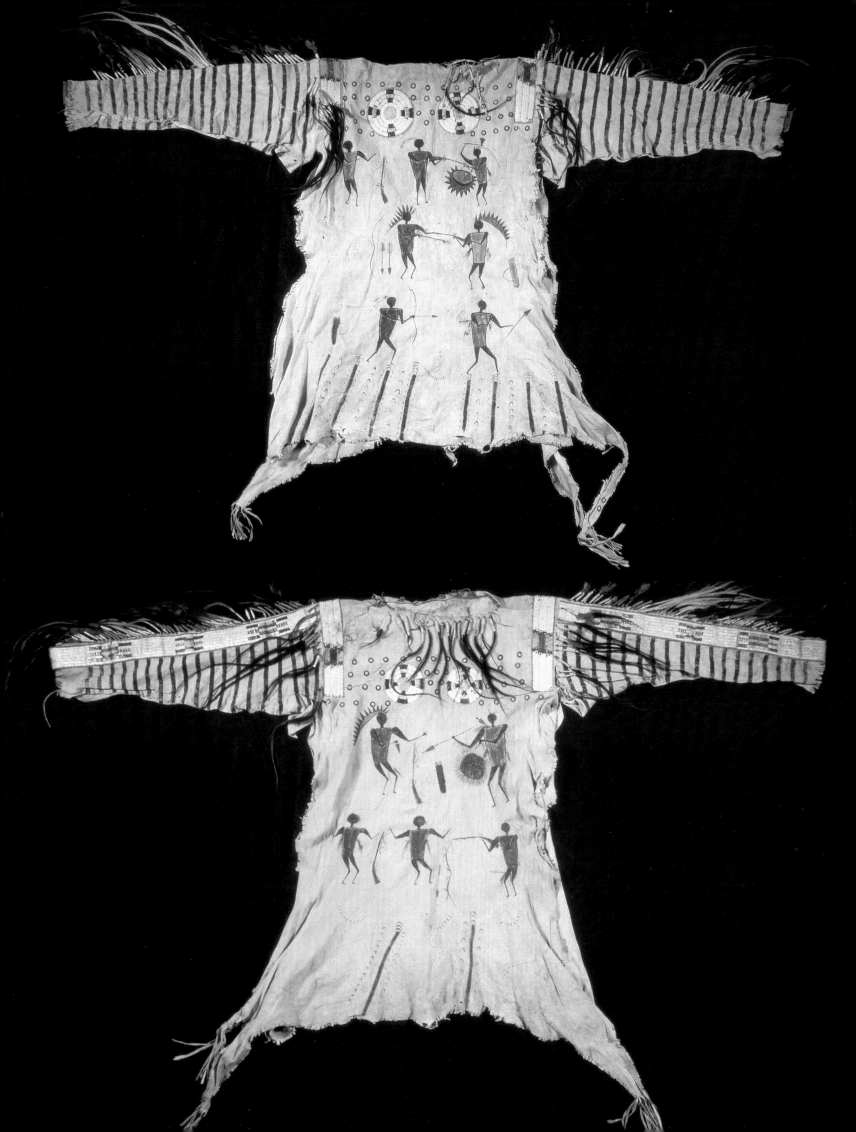

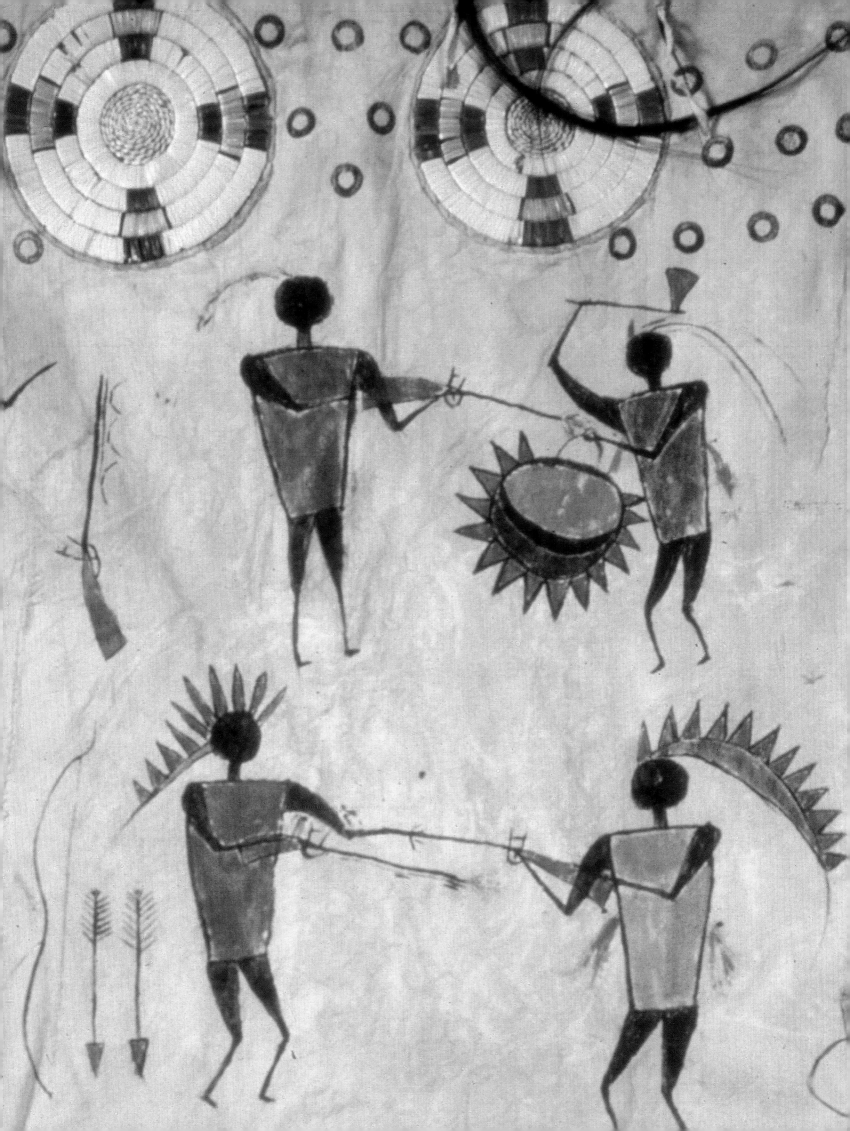

to a specific battle. Thus, there is a small group of pipe bags and storage bags illustrating the exploits in battle of White Swan, a Minniconjou Lakota war chief (c. 1866–1900). One of the bags shows White Swan identified by a 'name glyph', the image of a white swan-like bird. Seated with one hand raised, he seems to be recounting his deeds of valour. Behind him, as if to illustrate his narrative, is the herd of horses he successfully stole from a Crow tipi camp. The heads of three bearded whites and four Crow warriors symbolize the enemies he defeated in battle. Dennis Lessard has speculated that objects such as this figuring White Swan's war record may have been given away to the guests at his funeral feast in 1900.

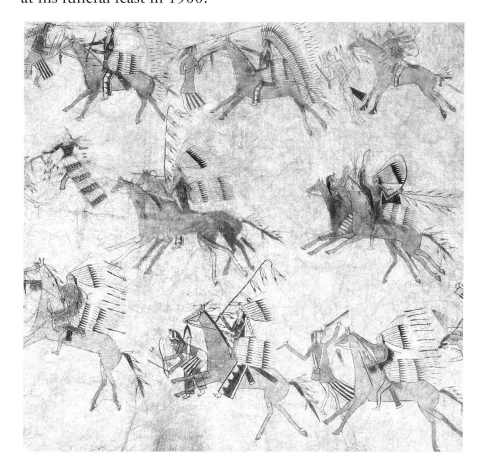

Young Man Afraid of His Horse
PICTOGRAPHIC PAINTINGS ON A ROBE
1880s, Lakota, Plains region.
Buffalo hide, 223.5 x 175.3 cm (88 x 69 in).
National Museum of the American Indian, New York.

With the drastic changes brought about by reservation life, the subject matter of Plains art shifted during the 1880s and 1890s. Instead of depicting individual battle honours, artists began to draw pictures representing the social and ceremonial life of the tribe. Many of these drawings were produced by a younger generation who had never experienced Plains warfare. They sensed that their traditional way of life was threatened by the modern world and they drew in order to create a lasting

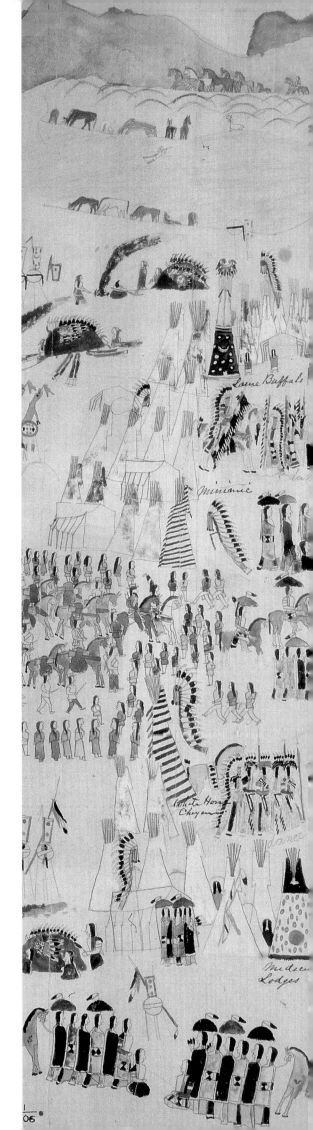

Little Chief |
Sun Dance
1880s or 1890s, Cheyenne, Oklahoma.
Paint, pencil, ink on paper,
59.5 x 65.8 cm (23 1/2 x 26 in).
National Museum of the American Indian, New York.

record of tribal ways. The Sun Dance was a favourite theme, being both the most sacred of the Plains Indian religious rituals, and the most at risk of repression by reservation officials. Little Chief, a Cheyenne, treated many of the episodes of the four-day ceremony in one broad and busy panorama.

Plains Indian drawing has often been characterized as pictorial history. It is rooted in factual content, so as to preserve historical events for posterity. A 'winter count', for example, was organized precisely as a historical image, a pictorial procession of the years. It was the practice of several Plains tribes to name the years, which ran from winter to winter, after notable events they had witnessed. So one would say, "I was born in the year they left the bad corn standing", meaning the year the Yanktonai took part in a raid against the Arikara and took the corn from their fields, leaving the 'bad' or spoiled corn standing (i.e. 1823). In a 'winter count', the names of each year are given a pictorial equivalent and the pictographs are arranged in sequence, as a spiral or a grid, on a hide or muslin cloth. The names were agreed upon in council, but several individuals kept 'counts' of the names, often incorporating earlier counts with their own to create a chronicle spanning several generations. The winter count illustrated here begins with the year 'they left the bad corn standing' and ends with the year 1911. It can be read as an overview of Yanktonai history: skirmishes with enemies; exceptional acts of bravery; scandalous crimes; the construction of the first trading post; the harrowing small pox epidemics of 1837 and 1838; and finally, confinement to the reservation with its log cabins.

Through pictographs, men not only made visual records of their personal experiences, they also created a visual language that reinforced the cultural values specific to their sex. With the onset of the reservation period, many male artists turned to the pictographic tradition to create a permanent record of a tribal life

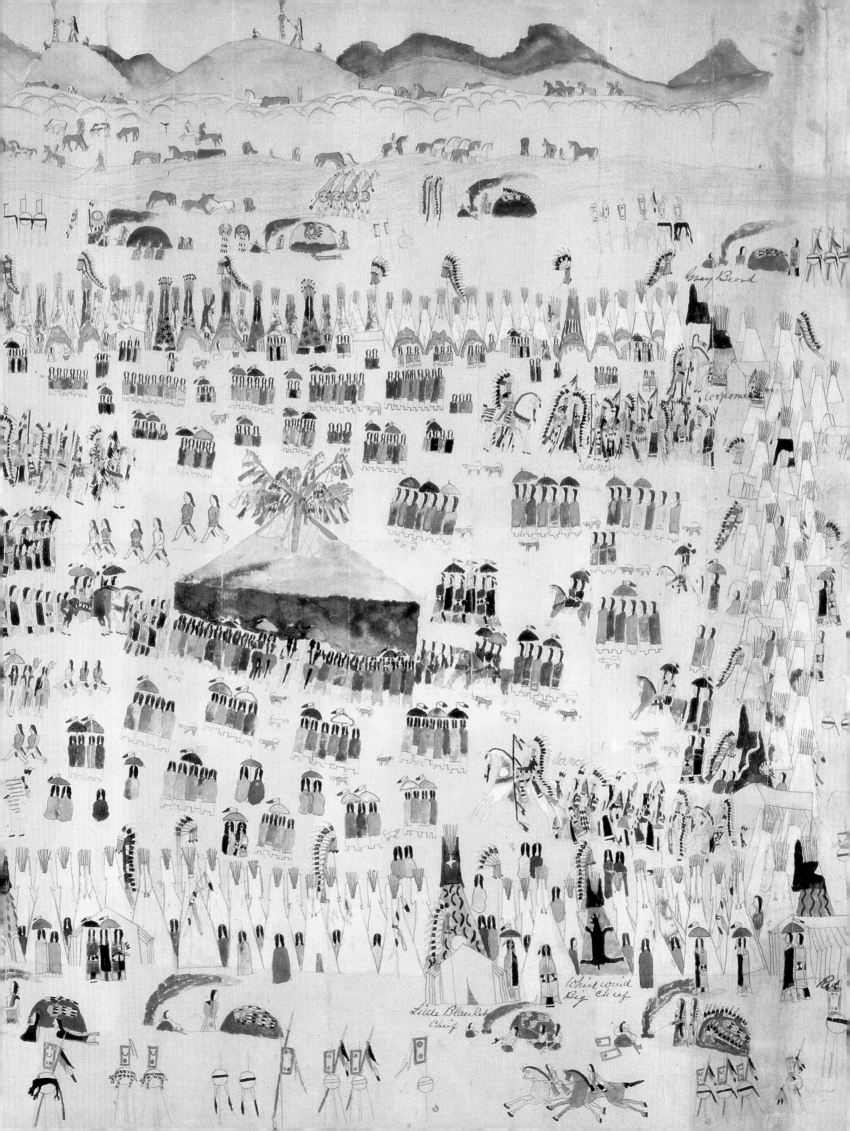

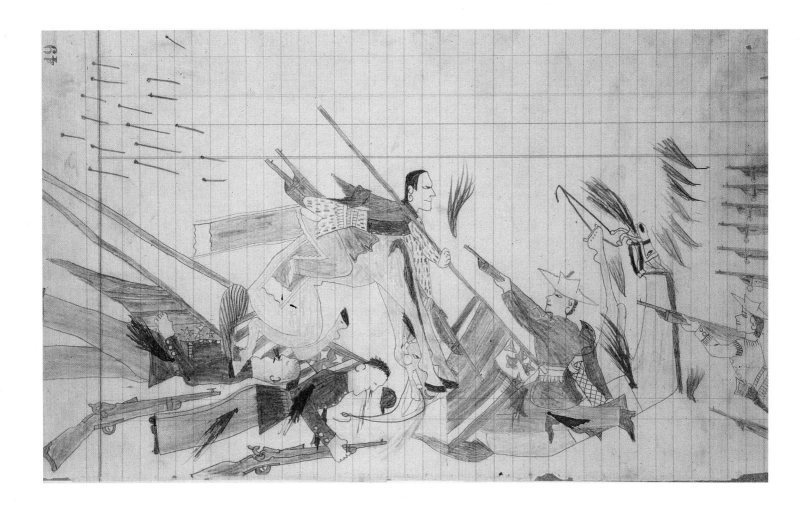

| Yellow Nose
THE BATTLE OF LITTLE BIG HORN

Circa 1885, Cheyenne reservation,
Oklahoma.
Lined paper, coloured pencils,
length 31 cm (12 1/4 in).
National Museum of Natural History,
Washington, DC.

YANKTONAI WINTER COUNT
Circa 1915, Fort Toten reservation,
North Dakota.
Ink on cotton muslin, 103.5 x 89.5 cm
(40 3/4 x 35 1/4 in).
The Detroit Institute of Arts, Detroit.

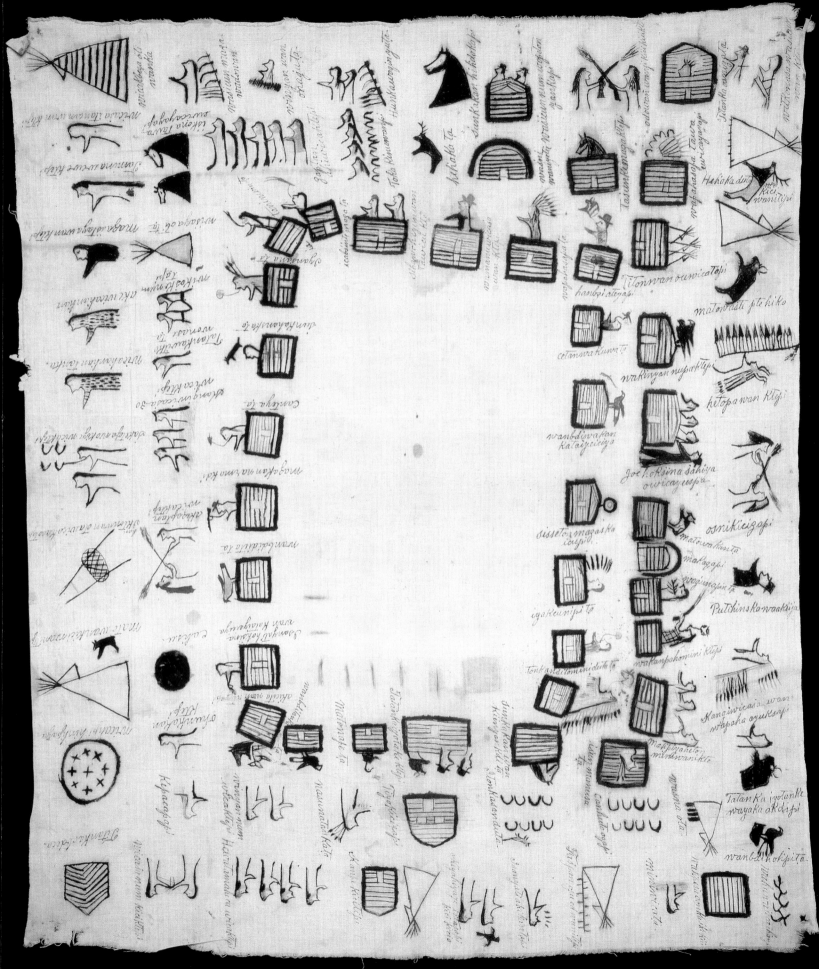

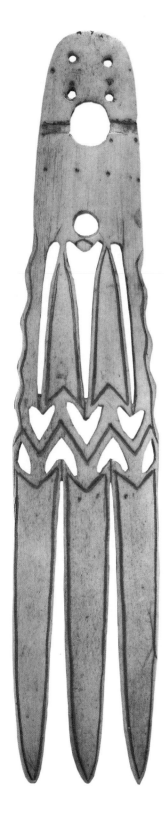

whose extinction they feared. Many of the drawings produced during the first decades of confinement were commissioned by Indian agents and officials. The 'Indian wars' of the Plains were a subject of great nostalgic interest to whites, once they were over, and the drawings were coveted by collectors as romantic chronicles of a bygone age. Their sale also brought much needed income into the reservations. Throughout North America at the turn of the century, arts and crafts provided one avenue of entry into the cash economy that was being imposed on Indian people by the outside world. The pictographic traditions of Plains Indian drawing laid the groundwork for the first generations of American Indians who thought of themselves as 'artists' in the modern sense of the term, and who would create a modern 'American Indian art' during the first decades of the 20th century. We will pick up their story in the final chapter of this book.

MESQUAKIE ROACH SPREADER
Circa 1860, Tama, Iowa.
Horn, height 22.2 cm
(8 3/4 in).
The Detroit Institute of Arts, Detroit.

4. Canyons and Deserts of the South-West

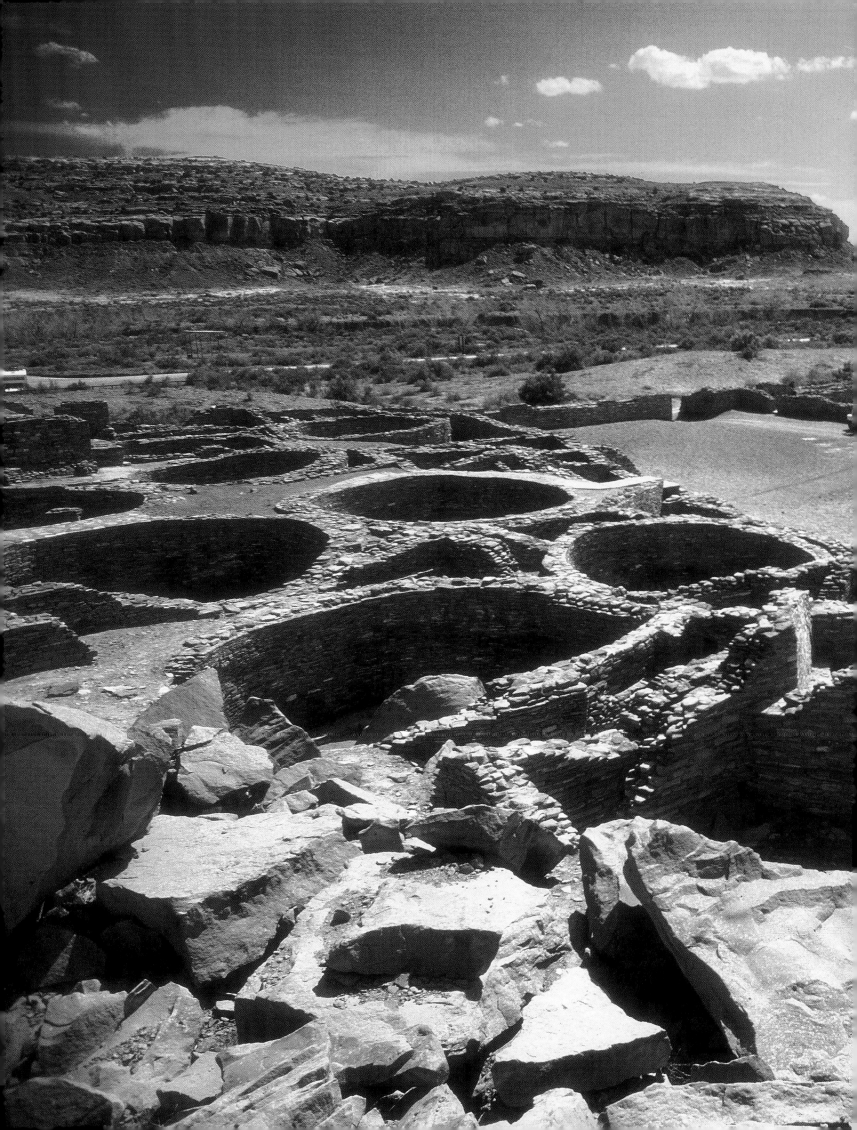

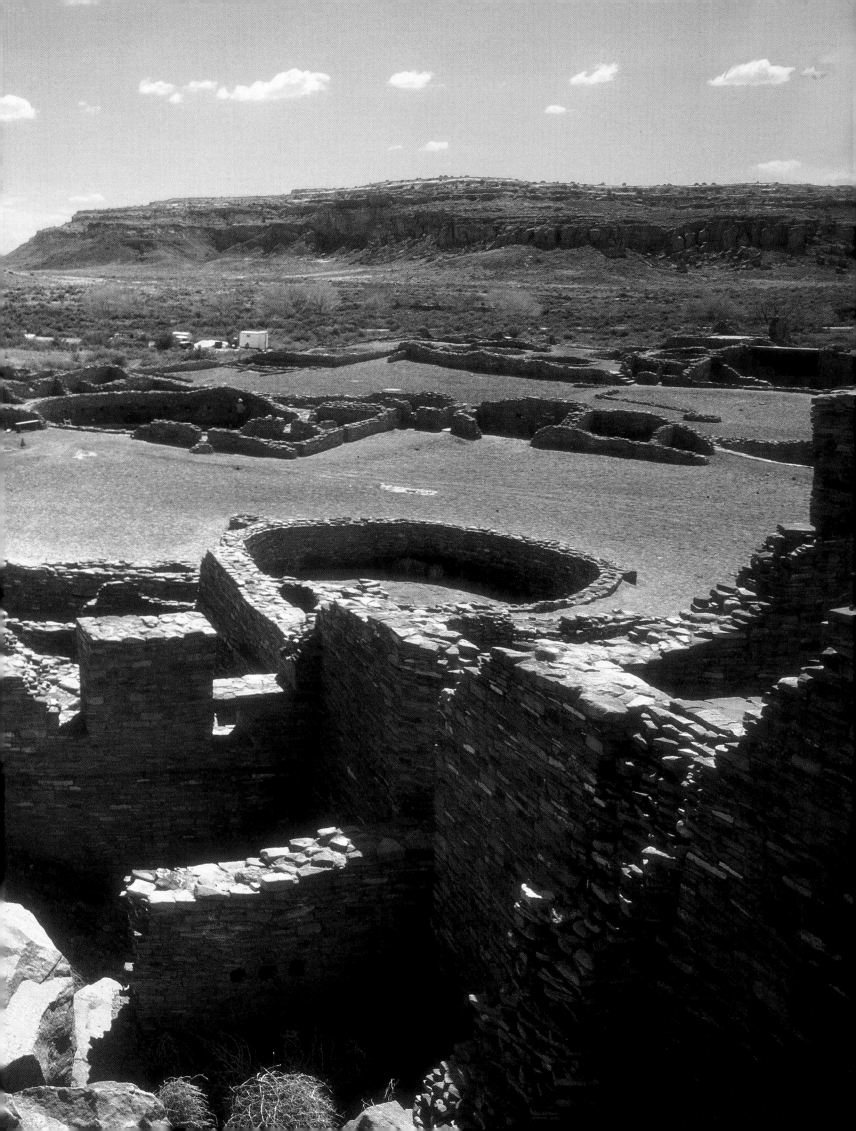

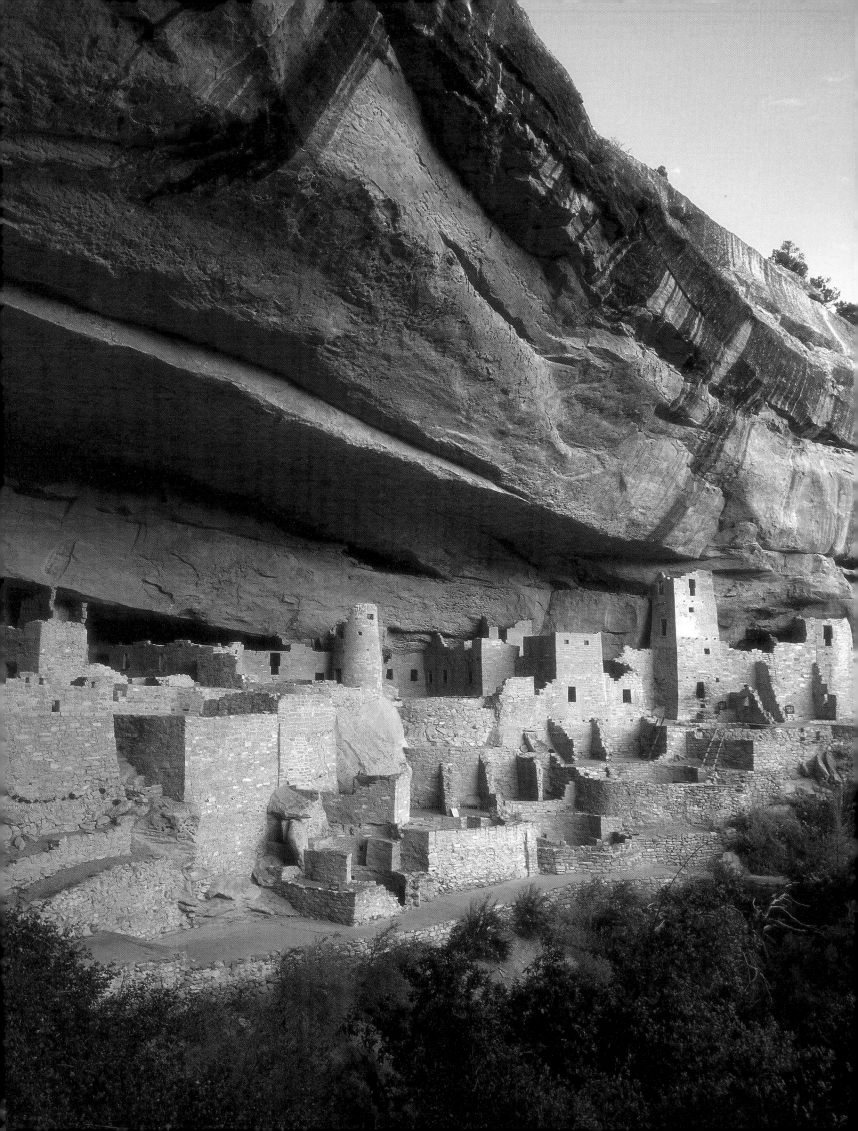

| Pages 114–115
PUEBLO BONITO
| 850–1150, Anasazi.
| New Mexico.

In the popular imagination, the South-West is an integral part of American Indian culture. Yet the Native Americans of this region lived largely in isolation from the great civilizations to the east. The first peoples of the South-West – the Hohokam, the Anasazi and the Mogollon – looked rather to the south, to Mexico, for their cultural origins. To the north of their territory, the land rises gradually towards a chaos of mountains and canyons. To the west, the canyons of the Colorado river give way to the Pacific cordillera of southern California. To the south, the vast Sonoran desert stretches out into northern Mexico. Only to the east are there isolated passes leading to the southern Plains, through which visitors, immigrants and trade could move. Although geographically isolated, the communities of the South-West maintained relations with the outside world. They traded with the Utes of the northern Plateaux, the Comanche of the southern Plains, the villages near the Gulf of California and with Mexicans to the south. Their isolation contributed to the stability of their population. For thousands of years, the ancestors of present-day Pueblos have inhabited this very same region, where they slowly developed the arts of agricultural village life.

Those earliest ancestors hunted small game and gathered wild plants, moving from one area to another to harvest seasonal resources. By 300 BC they were cultivating early varieties of corn, but only in a casual way, and this cereal made up only a small portion of their diet. Over the next several hundred years, however, societies in the different parts of the South-West grew more and more dependent on corn and other domesticated food plants, and their communities were reorganized to facilitate the agricultural life.

It is difficult to establish precise connections between the ancient inhabitants of these regions and the modern Pueblo Indians who

CLIFF PALACE
| 1150–1300, Anasazi.
| Mesa Verde region, Colorado.

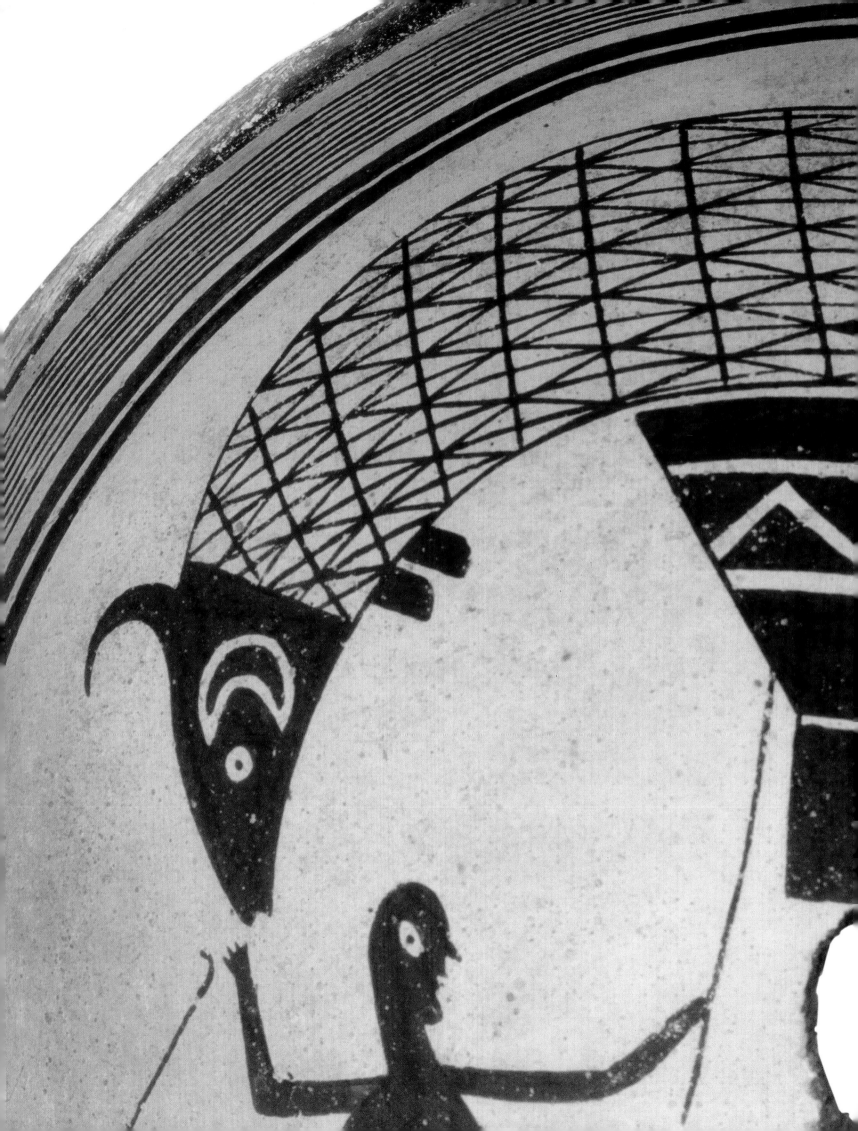

speak the Hopi, Zuni, Kersesan (Acoma, Laguna, Zia) and Tewa (Rio Grande Pueblos) languages. The difficulty is compounded because it is clear that communities speaking different languages often shared the same material traits, then as today. Yet however that may be, there are certainly ancestral links between the ancient Mogollon and Anasazi, and the Rio Grande and Western Pueblos of more recent times. For their part, the Hohokam are believed to be the ancestors of the Pima who still live today in southern Arizona.

Pottery: a thousand years of history

The Hohokam are the exception among the South-Western agricultural societies, since there is good evidence their ancestors migrated northward from Mexico. They settled in southern Arizona by AD 500 at the latest, and built their largest city, Snaketown, near present-day Phoenix. An adequate supply of water was the principle obstacle to agriculture in this region, and

MOGOLLON/MIMBRES BOWL
Detail. 1100–1400,
New Mexico.
Fired clay,
height 26.7 cm (10 1/2 in),
diameter 10.2 cm (4 in).
The Detroit Institute of Arts, Detroit.

HOHOKAM STORAGE JAR
900–1100, southern Arizona.
Fired clay, height 27.9 cm (11 in),
diameter 43.2 cm (17 in).
The Detroit Institute of Arts, Detroit.

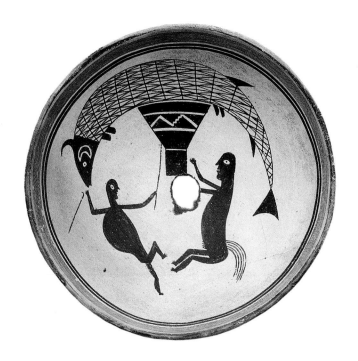

the Hohokam proved masters at engineering the necessary resources. They built many miles of canals to irrigate their fields with water from the Gila river. Snaketown may have supported as many as 1,000 inhabitants in a community which boasted Mexican-style civic features such as platform mounds and a ball court. Many other Hohokam lived in smaller homesteads spread throughout the adjacent region.

The decoration of Hohokam pottery from the Colonial Period (between AD 800 and 1000) illustrates a common theme in the art of the South-West – water. Thus a large bell-shaped storage jar is painted with a repetitive pattern in dusky red against a buff background. The design elements include spiral and diagonal lines, some straight, some zigzag or stepped, all arranged in a tight dynamic sequence. The spiral and stepped line represent two basic components of much South-West pottery design. In a world dominated by concern for water, they allude to its two main aspects: water that roils beneath the ground and water that falls from clouds in the sky. The spiral symbolizes the whirlpool of subterranean water, while the step-shape suggests the outline of a rising thunderhead, announcing the rainy season (May through July). Together, these two figures describe the continual circulation of this life-giving substance, from sky to earth and earth to sky.

MIMBRES POTTERY MOTIF

1100–1400, New Mexico.

Mineral pigment, length 7.2 cm (2 3/4 in).

National Museum of the American Indian, New York.

As the Hohokam founded Snaketown to the south, the inhabitants of the central South-West also adapted their communities to agricultural life. The early agriculturalists of the Mogollon tradition lived initially in pit-houses, small dwellings built over a floor dug several feet into the ground. The sunken walls provided excellent insulation. But between the years AD 700 and 900, these communities started to change. The Mogollon began to erect square-plan houses whose floors rested on the ground surface and which were linked together, each house sharing one or more walls with its neighbours. These extended 'apartment houses' were initially modest in size, but they soon grew larger. In the Mogollon heartland of the Mimbres valley, between the years AD 1000 and 1100, apartment complexes were raised with sixty to one hundred rooms gathered around open plazas. By this time the communities were intensively agricultural and had relocated to terraces above stream beds, so that they could plant the rich alluvial soils that retained the water of the rainy seasons. The inhabitants of the Mimbres valley towns created a unique kind of pottery vessel: a thin-walled, hemispherical bowl, whose inside was slipped with frosty white and painted with designs in a dense, black mineral paint. Archaeologists have discovered bowls like these inverted over the faces of the dead, who were buried beneath the floors of their homes. Some are

painted with geometric patterns, others with mysterious images found nowhere else. Against the clean white background, Mimbres artists depicted monstrous creatures, half-animal half-man, fantastic animals combining attributes of several species, or enigmatic tableaux in which figures of different descriptions enact some kind of narrative. This pictorial decoration contrasts strongly with the other pottery traditions of the South-West, which tend to be geometric and metaphorical in content, never narrative. Mimbres paintings are difficult to interpret, but some broad overall themes can be identified. Many of the animals represented can be associated with water (fish, snakes) or with the rainy season, when wildlife seems to spring forth from the earth: birds, butterflies, insects and hosts of other creatures. The narrative scenes may be episodes from the myths of the community.

ANASAZI SOCCORO WATER JAR
1100–1300, New Mexico.
Fired clay, height 40.6 cm (16 in),
diameter 35.5 cm (14 in).
Cranbrook Institute of Science,
Bloomfield Hills.

ANASAZI FOUR-MILE POLYCHROME JAR
1300–1500, New Mexico.
Fired clay, height 23.4 cm (9 1/4 in),
diameter 23.4 cm (9 1/4 in).
Cranbrook Institute of Science,
Bloomfield Hills.

Further to the north, up on the Colorado plateau of the Four Corners region (where Arizona, Utah, Colorado and New Mexico meet), is the ancestral homeland of the Anasazi. Like the Mogollon, the Anasazi gradually expanded their settlements after AD 700. Chaco Canyon became a centre for large-scale community development after AD 900, with the emergence of thirteen major sites and many smaller ones.

Pueblo Bonito is one of the largest of these, with five stories of over eight hundred rooms terraced back around the curved defensive wall of a D-shaped plan. The domiciles and storage rooms open on to a large communal plaza punctuated with circular-plan, subterranean religious structures called *kivas*. The Chaco Canyon Anasazi diverted run-off from rainfall down the Canyon arroyos to irrigate their carefully tended gardens, using canals, ditches, dams and sluice gates. Over a vast region of the northern South-West, Anasazi experimented with many different community locations, taking into account considerations such as the length of the growing season (which depends on altitude), the amount of rainfall and the possibilities for defence.

For example, the area of San Juan basin in southern Colorado, now known as the Mesa Verde region, saw dramatic growth of Anasazi settlements during the period between AD 1100 and 1300. It was then that the impressive Cliff Palace, with its more than two hundred rooms, was built. But by 1300, the Anasazi had left the San Juan basin, probably due to slow climatic changes which meant that their agriculture could no longer sustain large towns. They abandoned the Colorado plateau and shifted the focus of settlement south into the Rio Grande valley, where they became the ancestors of the Pueblo people who still live there today.

Anasazi women made a wide variety of pottery vessels for storage, culinary and ceremonial use. By AD 900, they were producing thin-walled grey wares slipped with white and painted with designs in black mineral paint. Anasazi black-on-white pottery reached its full flower of development during the period between AD 1100 and 1300, with a host of regional sub-styles.

ASHIWI POLYCHROME JAR
1720s, Zuni Pueblo, Arizona.
Fired clay, height 22.9 cm (9 in),
diameter 30.5 cm (12 in).
Thaw Collection, Fenimore House Museum,
Cooperstown.

Design ideas were disseminated through trade. A large group of particularly impressive water jars and hemispherical bowls known by the style-name 'Socorro black-on-white' have been recovered from the Rio Grande area of New Mexico. With their bold black painting and fine-line hatching, they would appear to have been strongly influenced by the designs of Chaco Canyon well to the north.

A red ware painted with black mineral paint was made by Anasazi women of the White Mountain region in the northern Arizona/New Mexico border area. These pots were traded widely and apparently many peoples coveted them for ceremonial use, since they have often been recovered from outdoor shrine sites. Curved-edge bowls and water jars are most characteristic of this style, and examples of effigy vessels are rare. Polychrome wares were introduced after 1300, the basic black-on-red being supplemented with a thick creamy white. One Four-Mile polychrome jar, for example, is painted with black stepped patterns resem-

ZUNI WATER JAR
Circa 1880, Zuni Pueblo, Arizona.
Fired clay, height 30.5 cm (12 in),
diameter 40.6 cm (16 in).
The Detroit Institute of Arts, Detroit.

ACOMA JAR
Detail. Late 19th century,
New Mexico.
Fired clay, height 27.2 cm (10 3/4 in).
National Museum of the American Indian,
New York.

bling thunderclouds with forked thunderbolts in wispy white, while butterflies, heralds of the rainy season, ring the shoulder and neck.

Each Pueblo community possesses its own unique pottery tradition based on local sources of clay and pigment and local production techniques. At Acoma, the local clays are a deep grey colour; at Zia they are a more sandy-textured reddish brown; at Hopi the clay is a greyish-yellow that fires a deeper yellow colour. The clay is mixed with temper: finely ground potsherds at Acoma and Zuni, sand and ground basalt at Zia. The temper gives the paste body when it is mixed with water. The pots are then put together by hand out of rolled 'ropes' of clay. The potter carefully smoothes the coils as she builds up the vessel walls. Once properly shaped, the vessels are allowed to dry to a leathery hardness and then burnished. The designs are painted before firing with mineral and vegetable pigments. The firing takes place outdoors, without a kiln; fuel is simply piled up around the vessels, and the fire carefully tended to maintain a consistent heat.

SANTA DOMINGO WATER JAR
Late 19th century, New Mexico.
Fired clay, height 25.4 cm (10 in),
diameter 29.8 cm (11 3/4 in).
The Detroit Institute of Arts, Detroit.

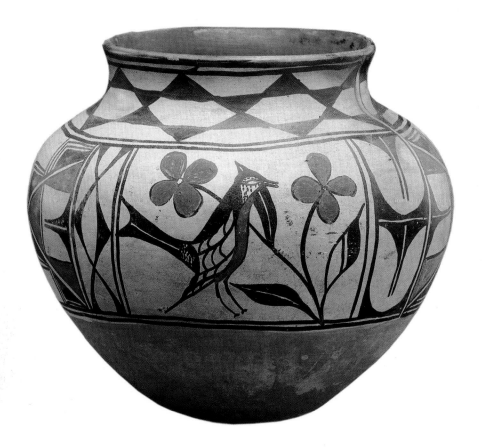

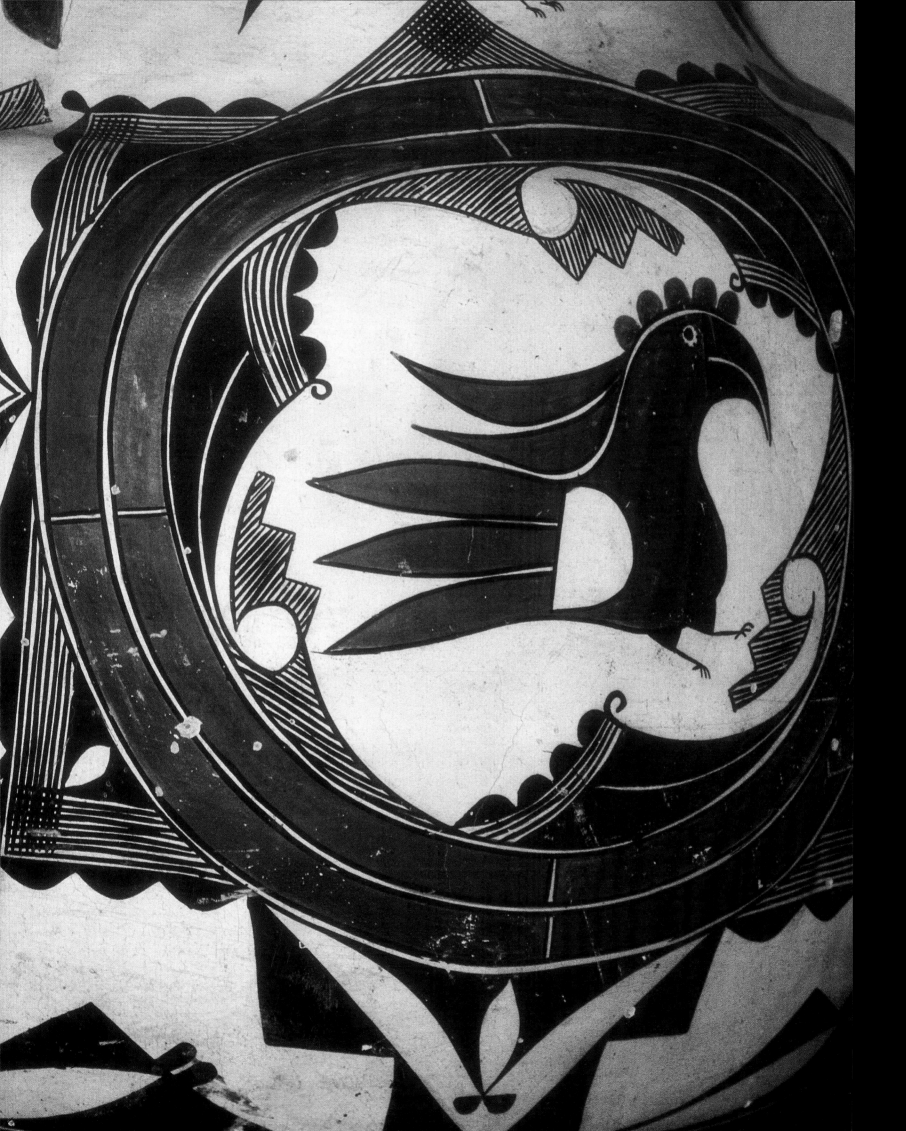

Girls are trained in the traditional techniques and forms of pot, but they are not told how to paint the designs. Instead, they are told to dream designs. Ruth Bunzel, an anthropologist, observed that Zuni girls tended to dream of Zuni pots and Hopi girls dreamed of Hopi ones. The community's collective notion of what is a proper pot is so strong that it determines even the sleepers' expectations, while 'dreaming' the designs allows the individual a certain expressive leeway within the parameters of the culture.

Through this dynamic, community styles slowly evolved. Jars made at Zuni during the 1700s were dramatically shaped with a conical base, a narrow bulging mid-section and an elongated gracefully tapering neck. On the particularly fine example illustrated here, the grey paste is slipped with white and red so as to distinguish the base from the upper portions of the jar. The white mineral slip provides a field for black and red designs. Note yet again the stepped patterns and their suggestions of lightning and cloud forms. A jar dating from over one hundred years later, in the 1800s, shows the same division – red-slipped conical base and white-slipped body and neck – but the base and neck have diminished, while the body portion is broader and squarer in shape. As with the earlier jar, the body and neck portions of the painted design are treated separately. The body is painted with spiral 'water bird' patterns, as the Zuni call them; a central band is filled with a tiny procession of what looks like horses. Encircling the neck above are repeated patterns that suggest feathers. Zuni pottery continues to develop to this day, as new generations of potters pick up and extend the tradition.

When the intercontinental railroad first reached the South-West homeland of the Pueblos in the 1880s, it created a new market for pottery that was to have a profound impact. The South-West became a tourist destination for eastern whites, who were drawn to the area's romantic mix of picturesque landscape, Hispanic legacy and American Indian culture. The old frontier that mod-

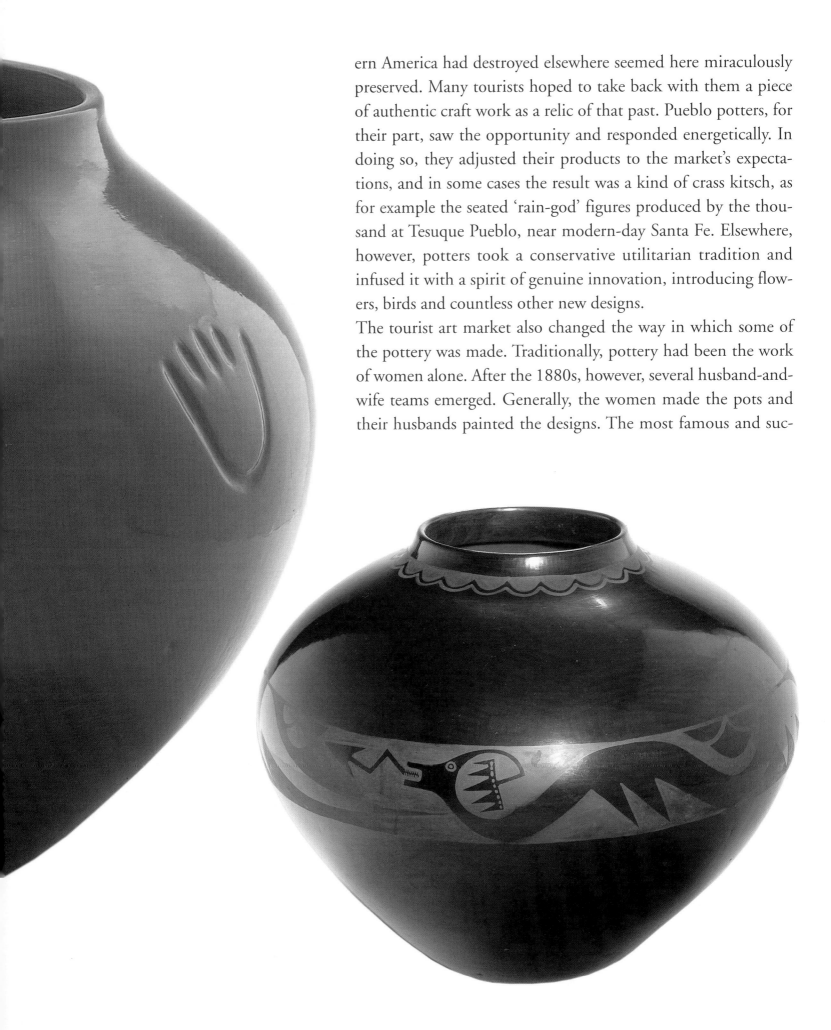

ern America had destroyed elsewhere seemed here miraculously preserved. Many tourists hoped to take back with them a piece of authentic craft work as a relic of that past. Pueblo potters, for their part, saw the opportunity and responded energetically. In doing so, they adjusted their products to the market's expectations, and in some cases the result was a kind of crass kitsch, as for example the seated 'rain-god' figures produced by the thousand at Tesuque Pueblo, near modern-day Santa Fe. Elsewhere, however, potters took a conservative utilitarian tradition and infused it with a spirit of genuine innovation, introducing flowers, birds and countless other new designs.

The tourist art market also changed the way in which some of the pottery was made. Traditionally, pottery had been the work of women alone. After the 1880s, however, several husband-and-wife teams emerged. Generally, the women made the pots and their husbands painted the designs. The most famous and suc-

cessful of such couples was Maria and Julian Martinez from San Ildefonso Pueblo, near Santa Fe. Maria and Julian first worked together in an innovative style called 'San Ildefonso polychrome', which was far more elaborate than the traditional black-on-red ware. Later, they experimented with black wares like those discovered in the excavations at Frijoles canyon. The result was their famous 'black-on-black' style, invented just before 1920, where the designs are painted matt black against a highly polished black ground. One of their designs comprises a horned serpent encompassing the pot. Maria and Julian's success revolutionized the economic life of San Ildefonso. They organized their extended family into a kind of pan-generational cottage industry, and by the 1930s a large portion of the village's income depended directly on trade craft work.

Julian and Maria Martinez soon discovered that their identification with their production increased its market value. They thus fashioned themselves into 'artists', as the modern world understands the term, and began to sign their pieces. Other potters also benefited from such personal recognition. Margaret Tofoya from Santa Clara Pueblo, assisted by her husband, is probably the best-known Native potter of the last hundred years. Her greatest artistic accomplishments are a series of oversize jars, beautifully shaped and immaculately polished black or ruddy orange, decorated with her simple trademark motif, a stylized bear paw design impressed into the gracefully sloping shoulder. The creation of fine arts pottery remains an important part of modern Pueblo cultural and economic life today. There are hundreds of active potters, and the best are very successful career-artists, who continue to innovate and renew the art through their skill in combining traditional knowledge with their own individual creative instincts.

Kachinas of the Hopi and Zuni

Kachinas are benevolent supernatural beings who visit the Hopi and Zuni Pueblos at certain periods of the year. They represent those who were left behind when, according to the origin stories, the Hopi and Zuni climbed out of the world below to the terrestrial world, at the behest of Father Sun. *Kachinas* are at once ancestors and clouds, bringing the pueblos life-giving blessings

| Margaret Tafoya
STORAGE JAR
Detail. 1930s, Santa Clara, New Mexico.
Fired clay, height 53.3 cm (21 in), diameter 48.3 cm (19 in).
Cranbrook Institute of Science, Bloomfield Hills.

| Maria and Julian Martinez
STORAGE JAR
1930s, San Ildefonso.
Fired clay, height 38.1 cm (15 in), diameter 49.9 cm (19 5/8 in).
Cranbrook Institute of Science, Bloomfield Hills.

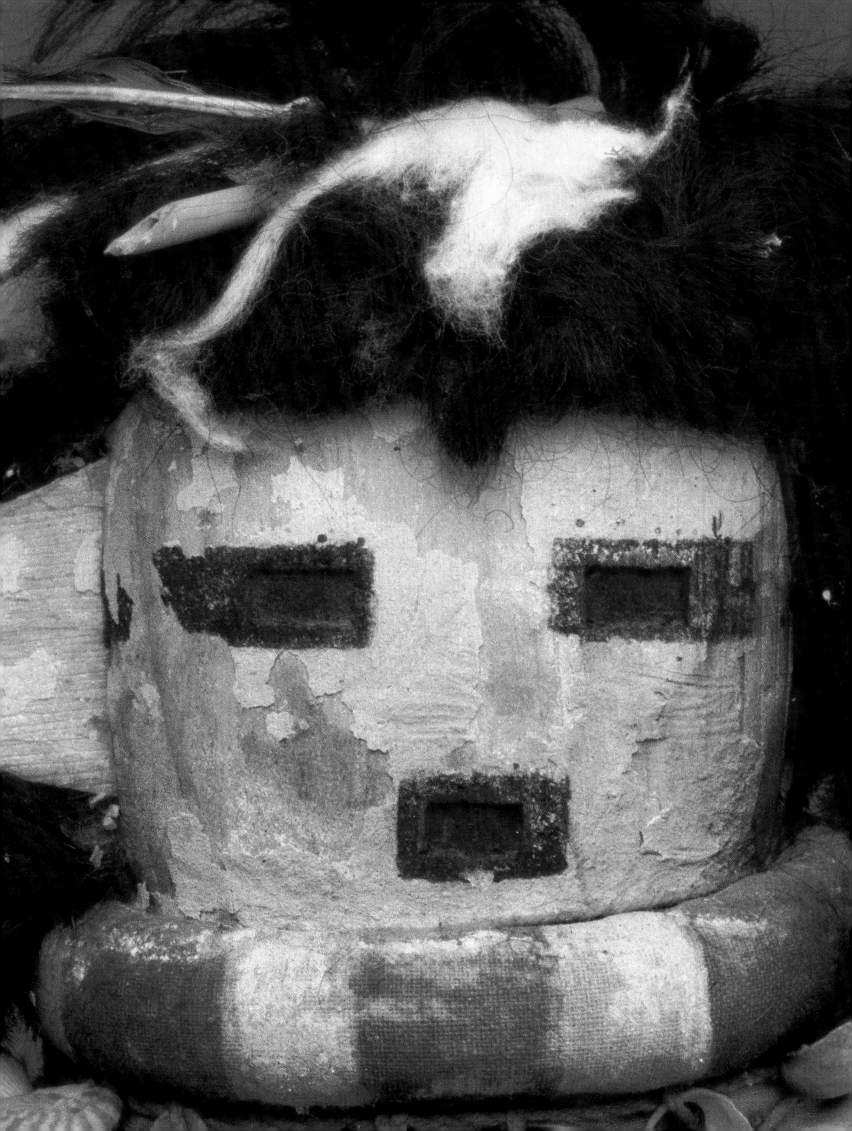

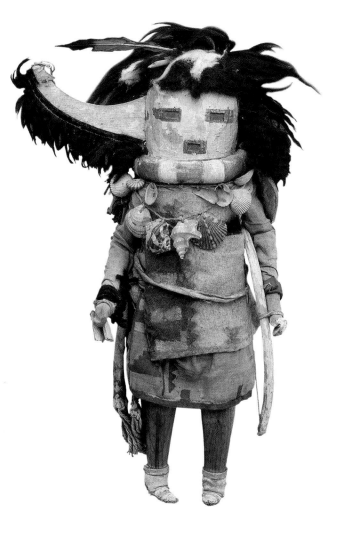

ZUNI 'ONE HORN' KACHINA DOLL
1930s, Zuni, Arizona.
Wood, cotton fabric, hair,
feathers, shell pendants,
height 38.1 cm (15 in).
The Detroit Institute of Arts, Detroit.

Page 134 |
HOPI 'HEMIS' KACHINA DOLL
1930s, Arizona.
Painted wood,
height 47.6 cm (18 3/4 in).
The Detroit Institute of Arts, Detroit.

Page 135 |
HOPI 'SHALAKO' KACHINA DOLL
1960s, Arizona.
Wood, feathers,
height 52.4 cm (20 5/8 in).
The Detroit Institute of Arts, Detroit.

of rain and fertility. It is said among the Zuni that when the *kachinas* used to visit in the past, some people would go back to the spirit world with them when they left, and their relations would mourn them. It was then agreed that the *kachinas* would stop coming if the Zuni held ceremonies every year to impersonate them. Societies called *kivas* stage the *kachina* ceremonies. The term *kiva* denotes both the organization and the sacred chamber where it meets and conducts its rites; it chooses the time of the ceremony and the dancers who are to perform. Traditionally, every member of the community belonged to a *kiva* and was required to participate in some way in its activities. The *kachina* ceremonies are closely tied to the agricultural year. In the Hopi Pueblos, the *kachinas* 'arrive' during the Powamuya ceremonies in February. A number of powerful and frightening *kachina* spirits circulate throughout the pueblo to ensure that people have conducted themselves properly and reverently throughout the previous year. They distribute gifts to the deserving, including bean sprouts cultivated in the *kivas,* which are presented to the senior woman of each household as a promise of the success of the year's farm work. Young children also receive gifts, including *kachina* dolls, small replicas of the various *kachina* beings made of painted wood. In the following months, the pace of *kachina* performances quickens: night dances in the *kivas* in March are followed by the appearance of the 'racer' and other *kachinas* during spring planting time, culminating in the *niman* or summer solstice dances. The *kachinas* bring life, pleasure, and blessings to the communities. Their masks and costumes symbolize water, fertility and growth.

Both Hopi and Zuni make *kachina* dolls. Their purpose is ostensibly to instruct young people in the intricacies of *kachina* identity. The Zuni and Hopi recognize hundreds of different *kachinas*, each with its own appearance and character. The dolls replicate the details of mask and costume design in great detail. The Zuni were always reluctant in the past to sell *kachina* dolls to outsiders, but the Hopi have been producing dolls for trade since at least the 1920s. The masks themselves, ceremonial altars and other *kiva* equipment are considered sacred and as such should never circulate outside the community. Zuni *kachina* dolls are carved in postures of movement, as if dancing, with

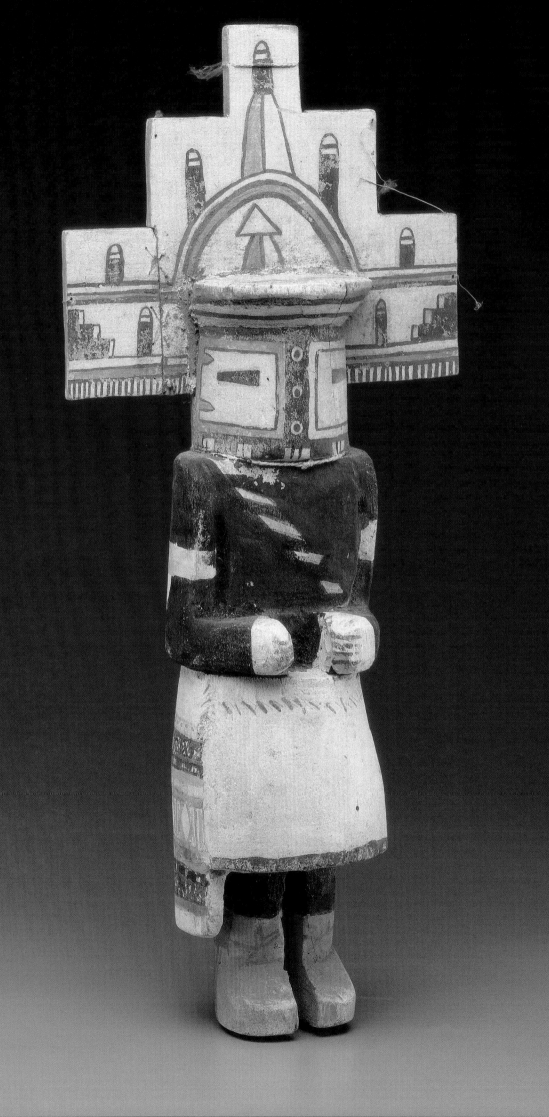

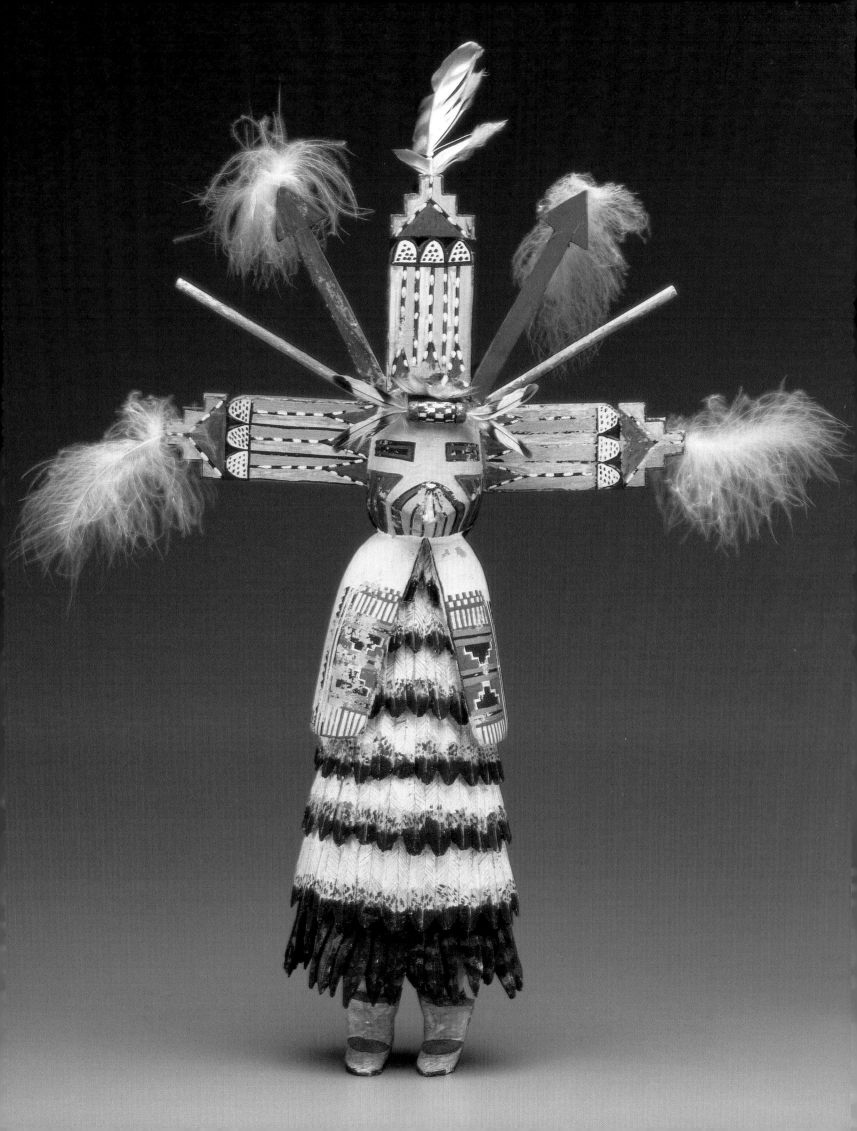

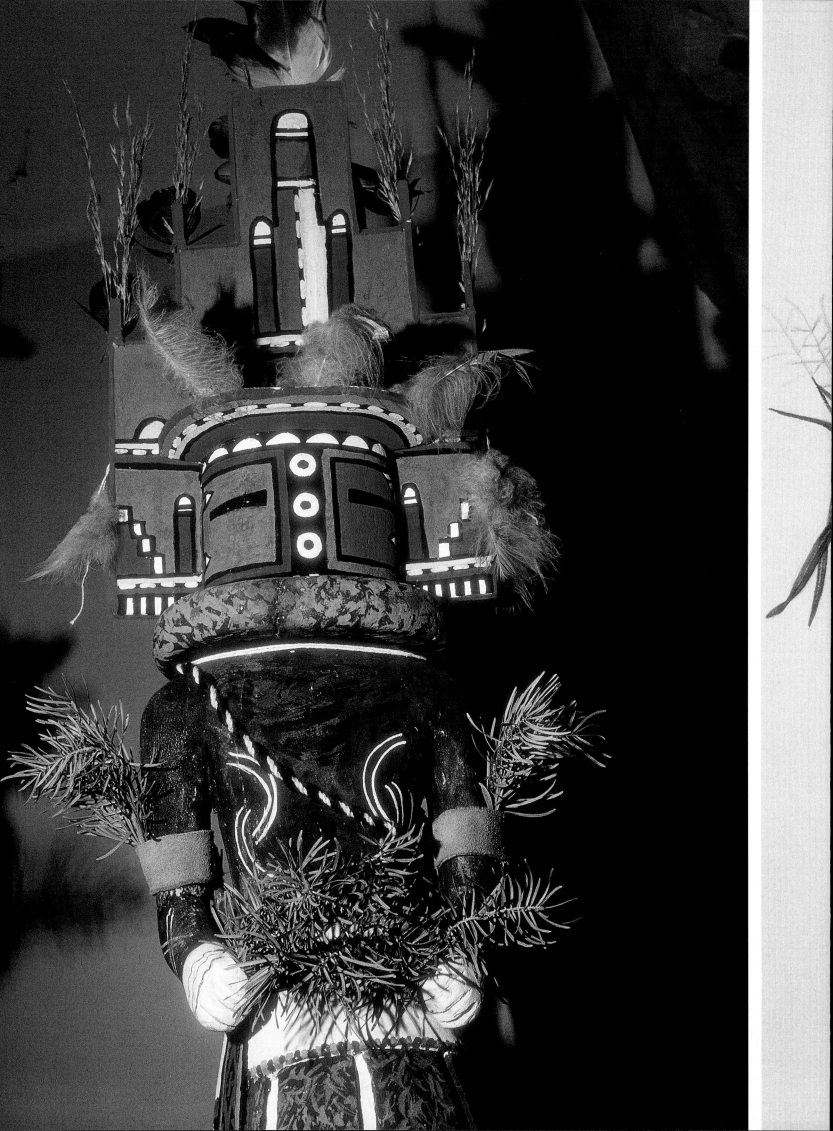

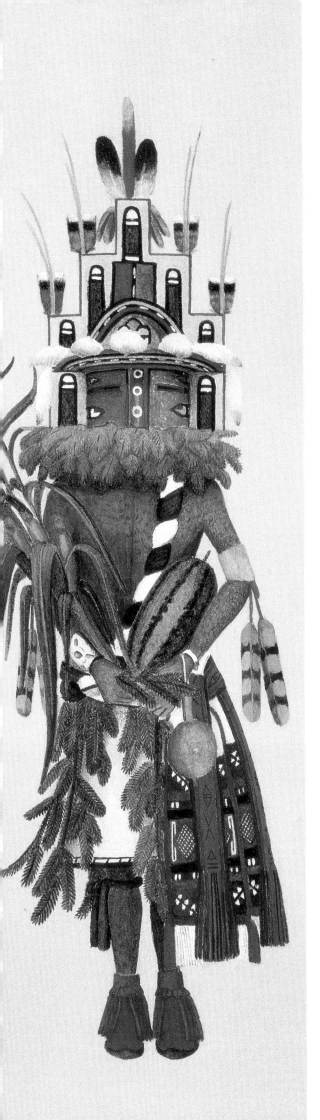

HOPI 'HEMIS' KACHINA DOLL
1920–1930, Arizona.
Painted wood, feathers and
pine branches,
height 46 cm (18 1/8 in).
Flagstaff Museum, Flagstaff.

| Otis Polelonema
HEMISKATSINA
1933–1936, Hopi.
Watercolour on paper, 37.1 x 29 cm
(14 5/8 x 11 3/8 in).
Heard Museum, Phoenix.

articulated arms and legs. They are often dressed in miniature costumes of painted cloth and sport both hair and ornaments. Some of the Zuni dolls represent Saiyatasha, or 'One Horn,' the 'rain priest of the north', member of the council of the gods, who arrives at Zuni during the Shalako ceremonies in November. The man who is to impersonate Saiyatasha is selected during the previous Winter Solstice ceremony. It is a serious responsibility that requires an individual of great decorum and reverence. During Shalako, Saiyatasha leads a retinue of four different *kachina* beings to the six *kiva* shrines at Zuni where they offer blessings. They prepare the way for the appearance shortly thereafter of the six pairs of Shalako *kachinas*, one for each *kiva*, messengers who herald the intentions of the *kachinas* to visit during the following year.

Most Hopi dolls are carved of cottonwood, with painted masks and costume. Cloth, hair and other materials are not required. Their tense stiff posture contrasts with the dancing poses of the Zuni *kachinas*. The Hopi doll illustrated here represents Hemis *kachina*, the most beautiful and best-loved actor in the *niman* dances at summer solstice. Niman is the last performance of the season before the *kachinas* return home, taking the prayers of the Hopi with them. The Hemis *kachinas* begin the day of ceremony bearing stalks of corn and melons from the first harvest to the village plaza, to symbolize the bounty that has come from the *kachinas'* blessings. Then the long double line of Hemis and Hemis mana (female Hemis) *kachinas* dance together to the accompaniment of singing and drumming. Each dancer wears a cylindrical mask with a flat, wooden *tablita* rising above, its stepped shape signifying thunderclouds. Phalluses painted on the *tablita* are metaphors for the rains that bring fertility to the earth. These symbols express and acknowledge the gifts of nature which make life in the South-West possible.

NAVAJO FIRST-PHASE CHIEF'S BLANKET

1850s, Arizona.
Wool, 174.6 x 137.5 cm
(68 3/4 x 54 1/8 in).
National Museum of the American Indian,
New York.

Navajo weaving and metalwork

The Navajo arrived on the Colorado plateau quite recently, compared to the Pueblo agriculturalists. Linguistically related to the Athapaskans of north-west Canada, the 'Dene', as they call themselves, had settled in northern Arizona by around AD 1500. They were hunter-gatherers who came both to trade with and to prey on the Pueblo agriculturalists. It was the Navajo who skilfully (by theft or trade) acquired horses from early Spanish colonists. They exported the horses northwards, thus sparking off the revolution in Plains Indian life during the 1600s and 1700s. By the mid-1600s, they owned flocks of *charro* sheep, whose ancestors had also come from Spain. Navajo women learned from the Pueblo how to weave textiles. They used an upright loom with a heddle, producing patterns by a tapestry technique. Navajo and Pueblo wool textiles resembled each other very closely until the 1700s, when Navajo weavers began to make garments with their own distinctive designs. By 1800, they were famous for a unique style of striped wearing blanket, known today as a 'chief's blanket'. The simple composition of horizontal stripes contrasts natural wool of creamy white with dark brown or black, often supplemented with a trade indigo

blue. High standards of technical skill and workmanship made these blankets very popular for trade, particularly among the Ute of the Plateau region and the Plains tribes. The name 'chief's blanket' does not identify the owner as a chief, but probably stems from the fact that the blankets were so valuable and expensive that only wealthy prestigious men could afford them.

By 1850, second-phase chief's blankets included bars of red within broader central and edge stripes. The red was either a trade dye or produced by unravelling and reusing the yarn of trade blankets. When worn, the three central bars were meant to be aligned vertically down the centre of the back, while the bars on the ends met in front when the blanket was pulled around the shoulders. In third-phase blankets, made after the 1860s, the centre and edge bars expand beyond the width of the black and white stripes to form large diamond or oblong shapes, often with stepped contours.

Navajo weavers worked in tandem with the New Mexican descendants of the Spanish colonials, many of whom were their clients for trade textiles. For them, the Navajo wove *serape*-style garments, to be worn like a tunic with a slit cut in the centre for the head, and adapted New Mexican textile patterns such as

NAVAJO SECOND-PHASE CHIEF'S BLANKET
1860–1865, Arizona.
Wool, 196 x 147.5 cm
(77 1/8 x 58 in).
Museum of Indian Arts and Culture, Santa Fe.

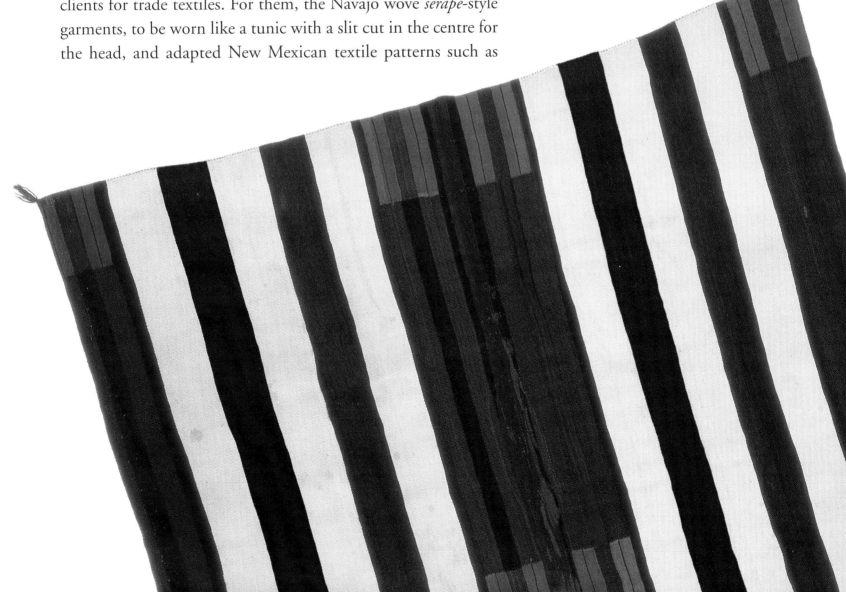

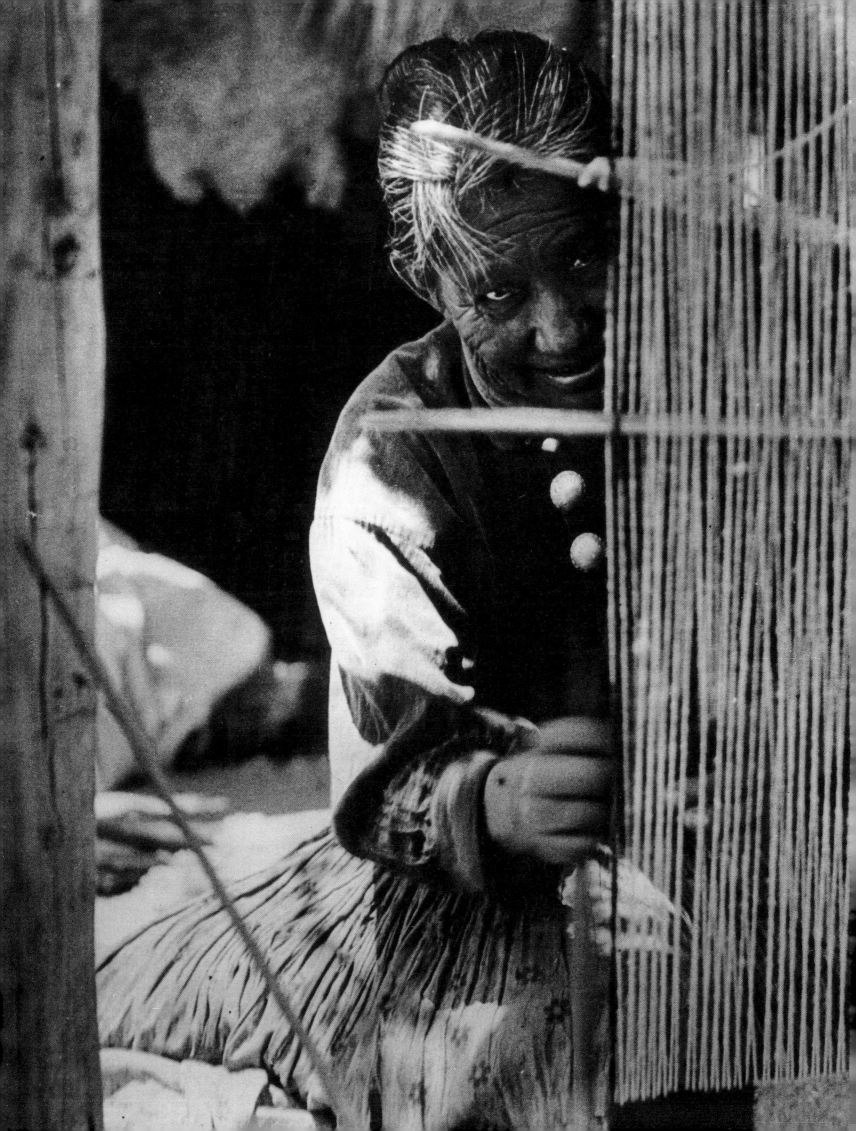

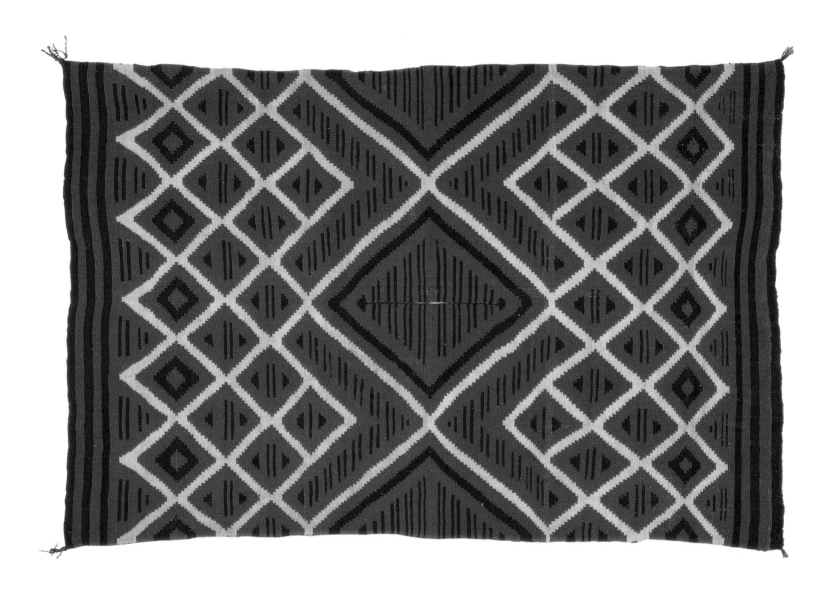

those seen on Saltillo and Chimayo weavings. These *serape*-style weavings can also be worn like blankets, and their designs are calculated to conform to the body in the same way as with second and third-phase chief's blankets. A typical pattern is divided into three sections, identical patterns on the two outer sections framing a slightly more elaborate centre.

When Americans claimed the South-West after the Mexican-American war of the 1840s, they found the Navajo increasing troublesome. An expedition was organized in 1863 to round them up and remove them from their traditional homeland to a concentration camp-like reservation at Bosque Redondo in eastern New Mexico. There they remained in captivity until 1869, when they were allowed to return home. The experience of exile reinforced the arts and crafts trade, since there were

CLASSIC STYLE NAVAJO SERAPE
1840–1860, Arizona.
Cotton cord and spun wool,
210.2 x 135 cm
(82 3/4 x 53 1/8 in).
Museum of Indian Arts and Culture, Santa Fe.

A NAVAJO WEAVER
Arizona.

GERMANTOWN EYE DAZZLER
Circa 1880, Arizona.
Wool and cotton,
213.4 x 155 cm (84 x 61 in).
Museum of Indian Arts and Culture, Santa Fe.

hardly any other opportunities for work on the reservation; it also let the women observe even more closely the New Mexican styles of weaving with which they would have to compete. The so-called 'classic' *serape*-style blankets made in the 1870s represent a high-water mark for Navajo textile design. Ironically, this was the time when the Navajo economy as a whole was weakest and resources were dear. Women began to experiment with the colours available in commercial three-ply yarns, in addition to the vermilion red and military blue that had long been available. Germantown yarns coloured with bright aniline dyes, named after the factory town in Pennsylvania that produced them, spawned a renaissance of creativity in the 1880s. Their strong, hot colours were combined in dense patterns to produce weavings known today as 'eye-dazzler' blankets. Navajo women also started to incorporate pictorial elements in their weavings at this time: images of trains, cattle, architecture, and other novelties drawn from a world that was swiftly changing.

Atsidi Sani is generally credited with being the first Navajo to have made silver jewellery, an art he reportedly learned from a Mexican silversmith in 1853. Sani melted down silver coin and ingots, cast forms in sandstone moulds, and worked with a hammer and cold chisels to shape his creations, reheating them as he worked to keep them malleable. Whether or not Sani was actually first, several Navajo men began to practice these techniques while at Bosque Redondo, and others joined the ranks of the silver workers when the Navajo returned to Arizona. Silver disks known as *conchas* strung on leather belts, ornamental Spanish-style bits for horses, bracelets, *ketohs* (archer's wrist guards, which by this time were purely decorative), buttons, beads and crescent *naja* pendants for necklaces were among the earliest kinds of jewellery produced. From the 1880s onwards, men decorated their creations with ornamental stamps, soldered pieces together and created bezels for setting turquoise, thus further enriching the repertoire of their techniques. The Navajo wore jewellery themselves on formal occasions and it represented value as pawn that could be converted into goods or cash. Traders successfully established a market for Navajo silver among the tourists who visited the South-West in increasing numbers during the early 20th century.

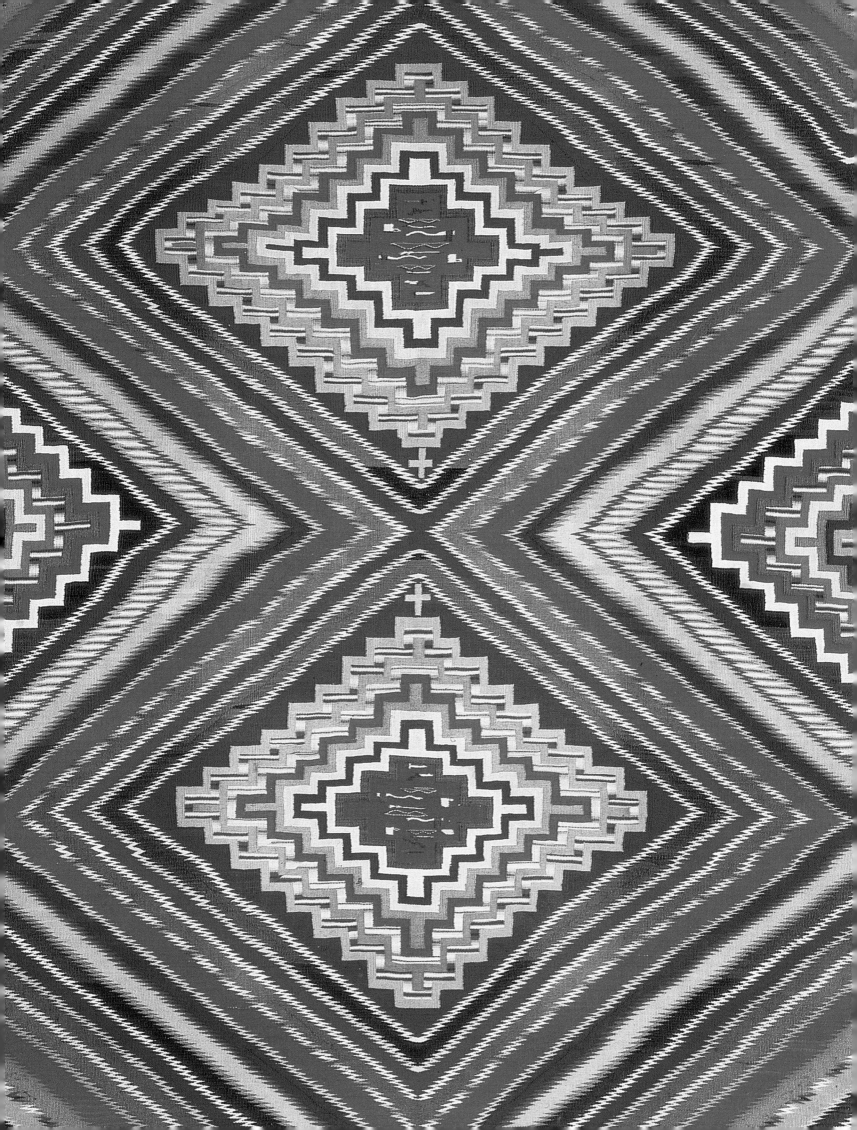

It was then too that Navajo artists – weavers and silversmiths – entered into even closer collaboration with their trading partners. It was the traders who, seeking new markets for Navajo weavings, shifted production from blankets to rugs. J. B. Moore of the Crystal Trading Post provided Navajo women in his vicinity with better quality yarns, limited the colours to natural dyes, forbade the use of Germantown yarns and published illustrated catalogues of the weavings he had for sale. He and other traders saw their success as depending upon control over production and effective marketing. Moore showed his weavers books illustrating Caucasus and Oriental rugs and encouraged them to emulate their designs. Without copying, the Navajo women took from them ideas for new designs and compositions. Traders also provided similar support for silversmiths, giving them stamps with motifs of proven popularity, pre-cut pieces of turquoise, and information about what sold and what did not.

During the first decades of the 20th century, traders and Native artists of the South-West worked out the template for the American Indian arts and crafts market we know today. This market falls into a border zone between Indian and white culture, where commodities intended to represent an ethnic reality ('traditional' American Indian culture) could be rethought in terms of the taste of the (white) consumer.

NAVAJO CONCHA BELT
Circa 1880, northern Arizona.
Saddle leather, silver, 98 x 7.2 cm
(38 1/2 x 2 3/4 in).
National Museum of the American Indian,
New York.

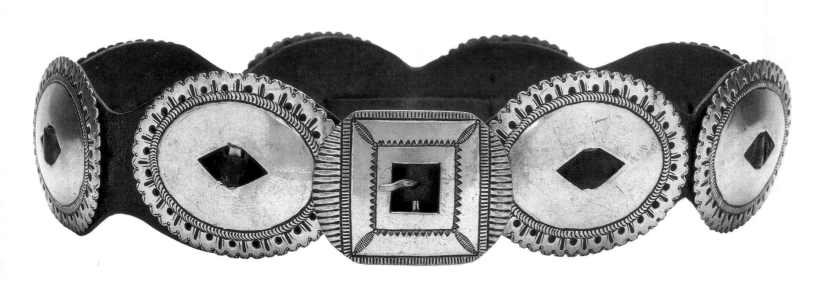

5. Basketmakers of California

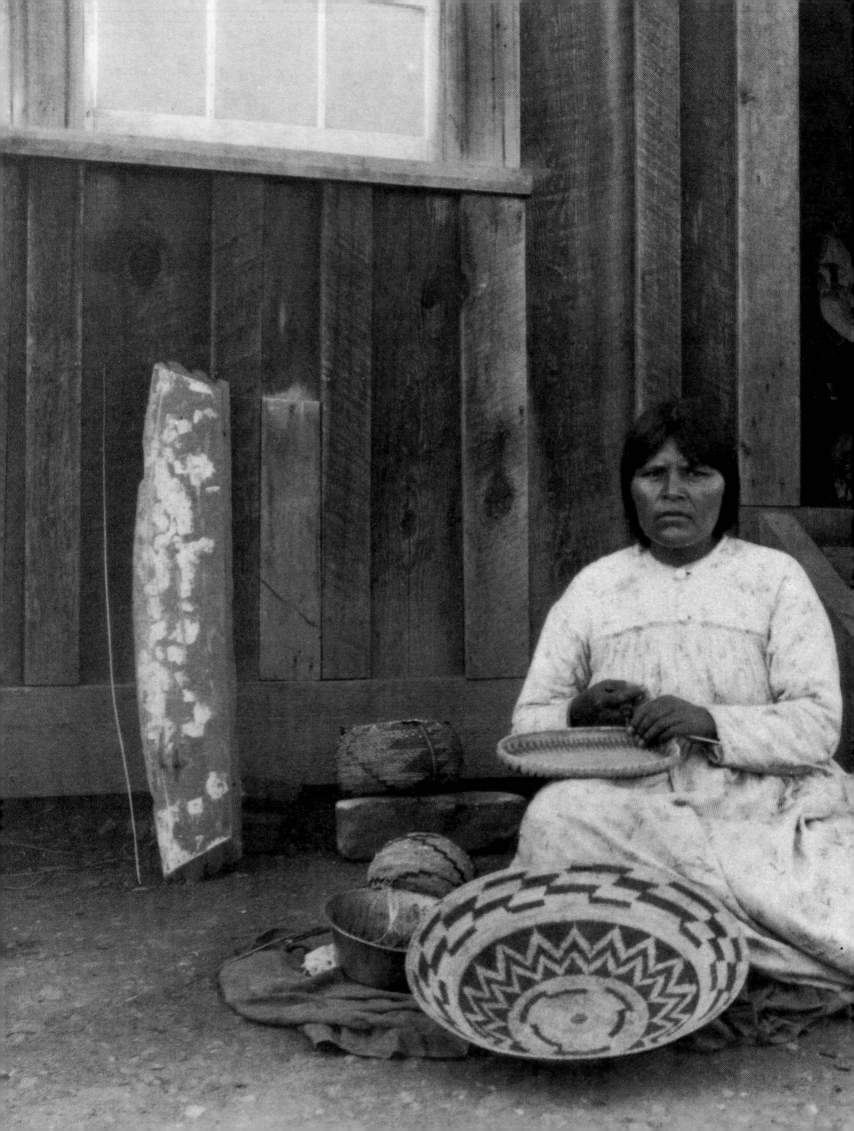

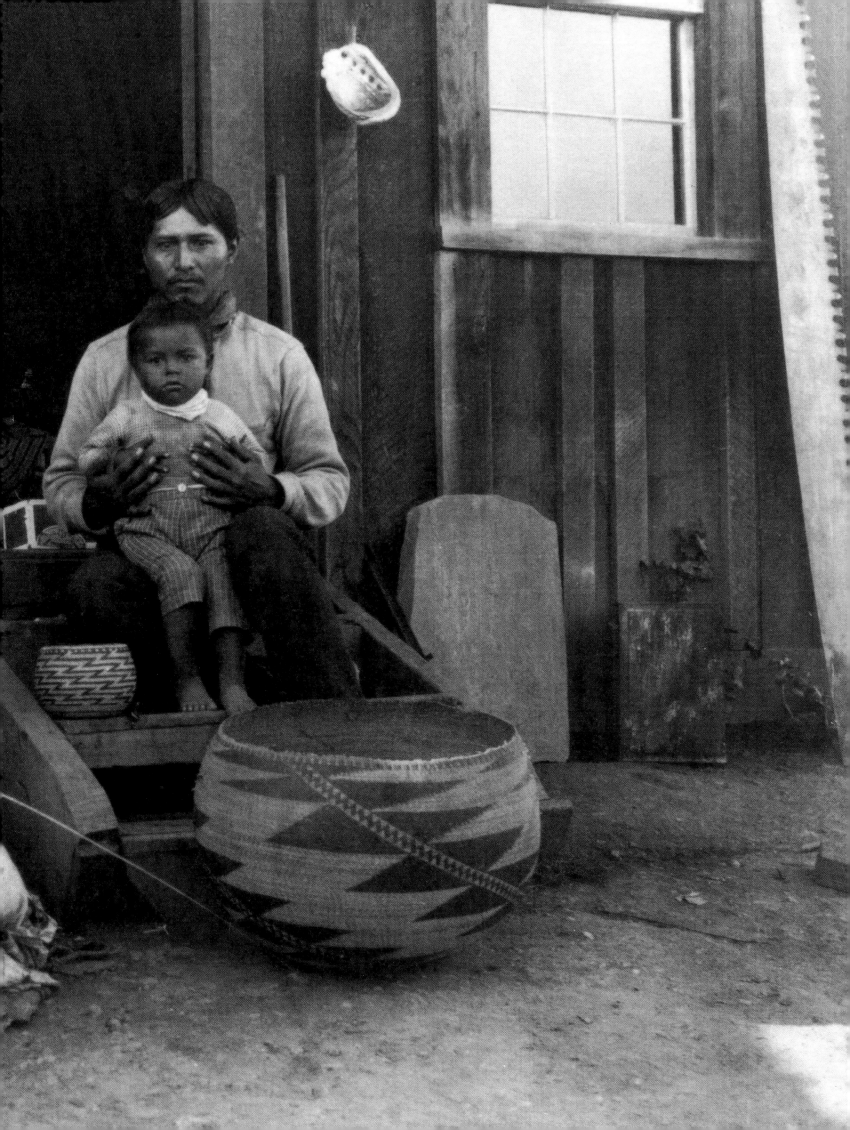

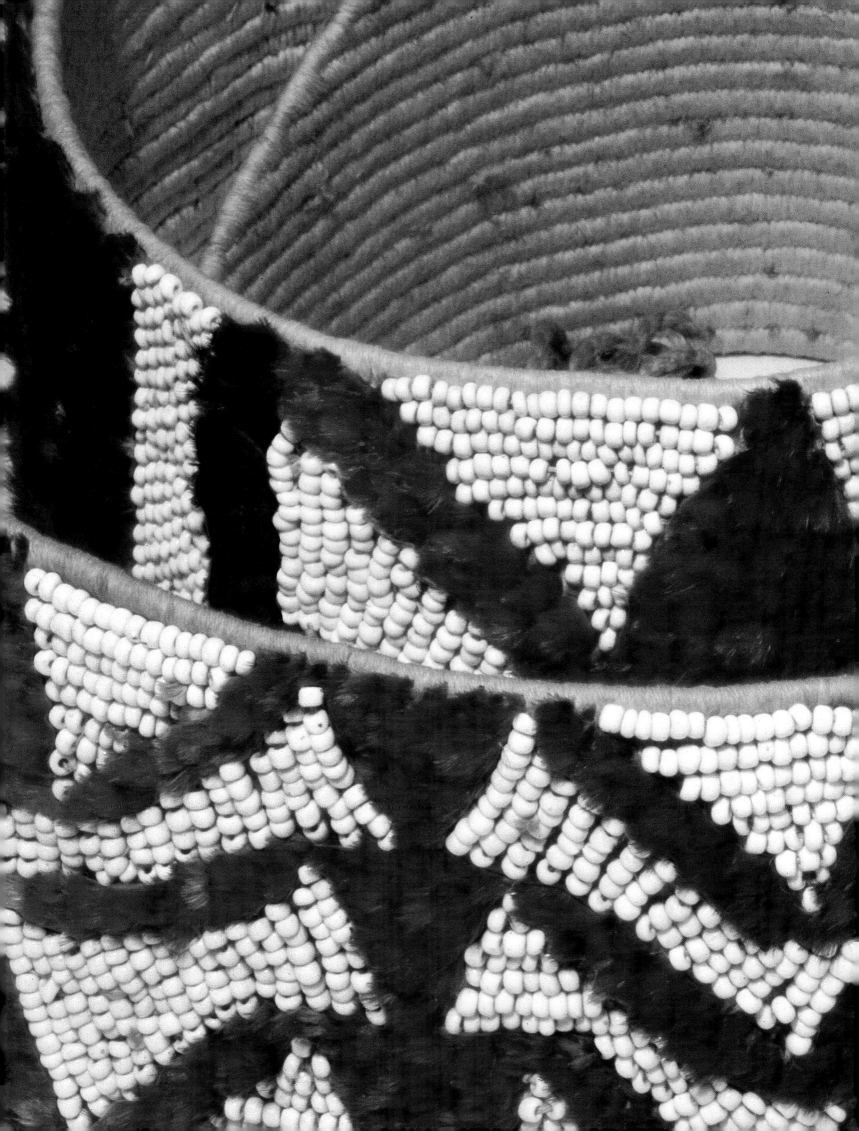

Indigenous California is the most environmentally diverse and ethnically complex area of North America. Its topography ranges from sea coast to alpine mountains, from temperate woodlands to arid desert. As many as eighty different languages were spoken by its Native residents, but only two dozen or so survive today. The land was not unduly demanding. There was enough food to support wealthy communities without resort to agriculture. Society was structured round the village and the lineage. A few settlements had a thousand or more residents, but most numbered no more than a few hundred souls. Social recognition stemmed from seniority and wealth. Large families became wealthy by controlling resources and the labour necessary to exploit them. Lineage heads could enhance the prestige of their families by sponsoring feasts and ceremonies. It was in the context of such events, where wealth was displayed and acknowledged, that the arts of Native California played their most prominent role.

Among the Maidu, who lived in the mountain valleys of the northern Sierras, a small number of wealthy men would own a belt decorated with beads and feathers to be worn only at ceremonial dances. Called *wa-tu*, such belts measured over six feet in length. Wrapped twice around the waist, they testified to the wealth and social rank of the dancer. They were woven of vegetable cordage and decorated with bright red feathers from the head of the acorn woodpecker. Over one hundred woodpecker 'scalps' might be required for a single belt. Among the Maidu, such belts were extremely valuable. It was the custom for a man when courting to present a *wa-tu* belt to his prospective in-laws. Elaborate spoons of elk antler carved by the Yoruk, Karok and Hupa of north-west California are another example of art as ostentatious display to signify wealth and high social rank. The spoons were used to eat an acorn flour gruel; at other meals, a simple mussel shell was used. Only men owned and used such spoons, which were reserved for special public occasions. The handles are carved with zigzags, pierced slots and other ingenious shapes.

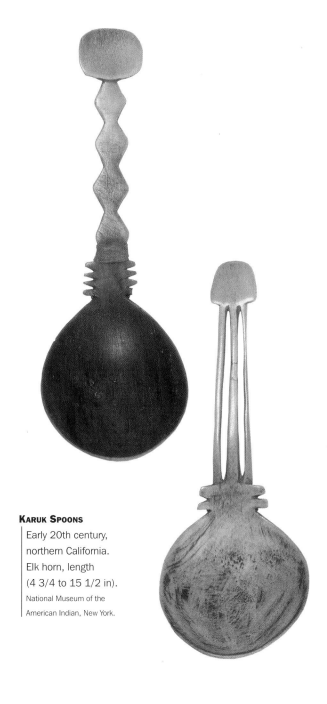

KARUK SPOONS
Early 20th century, northern California.
Elk horn, length (4 3/4 to 15 1/2 in).
National Museum of the American Indian, New York.

WA-TU BELT
Detail. Late 20th century, Konkow (North-Western Maidu) culture, California.
Plant fibre, glass beads, feathers, 177 x 11.4 cm (69 3/4 x 4 1/2 in).
National Museum of the American Indian, New York.

Pages 146–147
Joseppa Dick
A POMO INDIAN WOMAN MAKING A BASKET
1892, Yokaya, central California.

The Native people of California used baskets for day-to-day tasks, as well as for a wide range of aesthetic and ceremonial functions. They cooked in baskets, stored things in them, used them as bags, and even made basket baby carriers. Assembling the necessary raw materials required a thorough knowledge of many different plants, each of which had to be collected at the proper season; many required lengthy preparation. Shoots, roots and rhizomes were trimmed to a constant thickness, sometimes split, sometimes peeled, according to the properties of the plant and the intended use. It is often said that collecting and preparing the materials was the most difficult part of making a basket. The techniques used could be rough and ready for traps or impromptu packs, or fastidious and time-consuming for waterproof cooking vessels or gift baskets. Women generally made the

POMO BURDEN BASKET WITH TUMPLINE
Circa 1850, central California.
Willow, sedge root, redbud;
tumpline: plant fibres and seashell,
height 48.3 cm (19 in),
diameter 61 cm (24 in).
The Detroit Institute of Arts, Detroit.

POMO STORAGE BASKET
Circa 1850, central California.
Willow, sedge, redbud or bulrush,
height 30.5 cm (12 in),
diameter 47 cm (18 1/2 in).
The Detroit Institute of Arts, Detroit.

baskets that necessitated the most effort and care, and they took great pride in them. The number and quality of a family's baskets was one significant measure of its wealth and prestige.

The Pomo region of central California produced many fine basket makers. The term 'Pomo' actually embraces seven different language groups, who never thought of themselves as a single

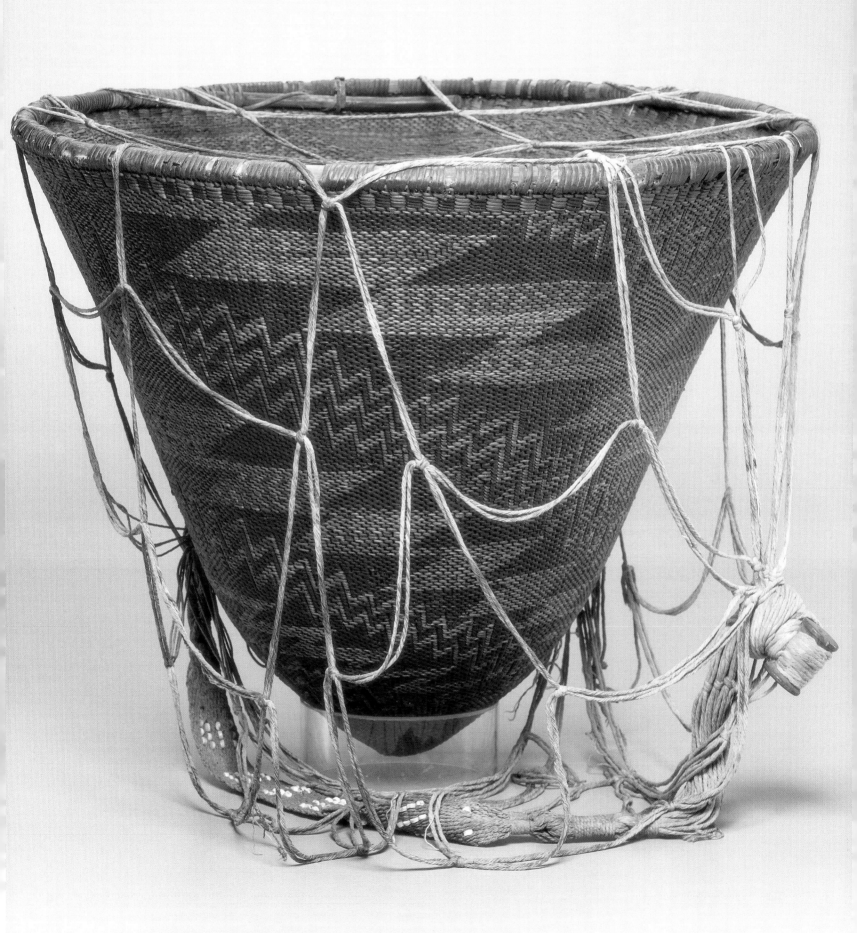

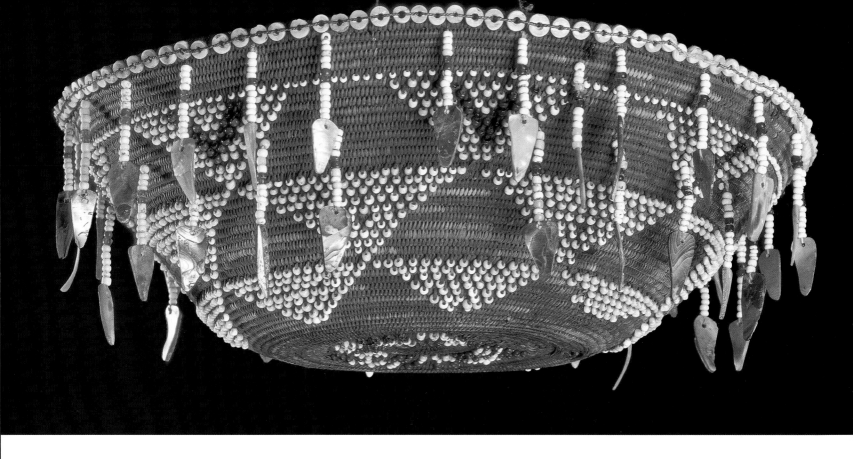

POMO BEADED BASKET

Circa 1850, northern California.
Willow rod, sedge root, glass beads,
abalone shells, clam shell,
height 17.8 cm (7 in),
diameter 27.9 cm (11 in).
Thaw Collection, Fenimore House Museum,
Cooperstown.

people, though the name given them by American settlers has stuck.

Pomo women made rugged yet elegant utilitarian baskets using several different twining techniques. Large, nearly spherical storage baskets were made from peeled willow shoots woven with a lattice technique, called 'ti-weave', which added a second hidden weft on the inside for strength. Some baskets have horizontal bands of geometric pattern made by alternating the dusky red of redbud shoots with the lighter blonde colour of the peeled willow. The repetition of each motif is interrupted, subtly, according to a convention known as *dau*. It is said that these 'breaks' allowed the spirit beings to enter and inspect the work. Large conical burden baskets were also made from twined willow and redbud. Women carried them on their backs in a kind of broad net attached to a tumpline strap fitted over

their brow. The broad mouth of the basket made it very practical for carrying firewood.

For fine gift baskets, a coiling technique was used. Sewing strands were wrapped or coiled around a foundation, generally of trimmed willow shoots. Contrasting materials were then alternated – for example, roots of sedge, bracken fern and bulrush – to create geometric designs. Tight, fine coiling was much valued, some baskets using as many as eighty stitches per horizontal inch of coil. Large pieces required many months, sometimes years, of work. Finely made baskets were very precious, and were often presented as gifts on special occasions, particularly when two families joined together in a wedding. It was also the custom to burn fine baskets during funeral ceremonies. To enhance their value and beauty, the Pomo often decorated such baskets with shell beads, pendants and feathers. On the occasion of her first menstrual confinement, a young woman's family would present her with a beautifully made 'washing' basket whose distinctive, flared mouth shape resembled that of the baskets used for wash-

POMO BASKET
Late 19th century, California.
Willow, sedge root,
shell beads, feathers,
diameter 29.2 cm (11 7/8 in).
National Museum of the American Indian,
New York.

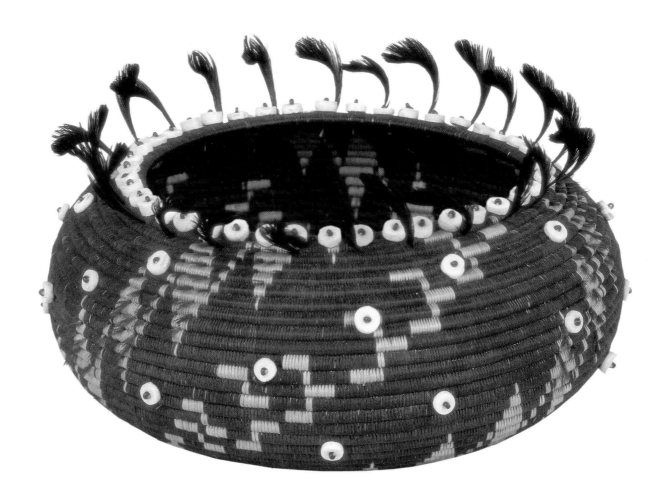

ing infants. The puberty basket, however, was elaborately decorated and finished with topknots of quail feather. It was intended as a life-long possession honouring the young girl's passage into womanhood.

The most beautiful of all Pomo baskets are the small circular 'jewel' baskets. The exterior is entirely decorated with colourful bird feathers: bright red crest feathers from the acorn woodpecker, yellow from meadowlarks, iridescent green from the heads of male mallard ducks. The feathers were added during the coiling process, tucking the quill ends beneath each stitch as the weaving progressed. Small, shallow baskets decorated exclusively with red feathers are the oldest and most traditional. They were made to be suspended over the funeral pyre and would thus be seen only from beneath. Later, basket makers added yellow and green feathers to dazzling effect.

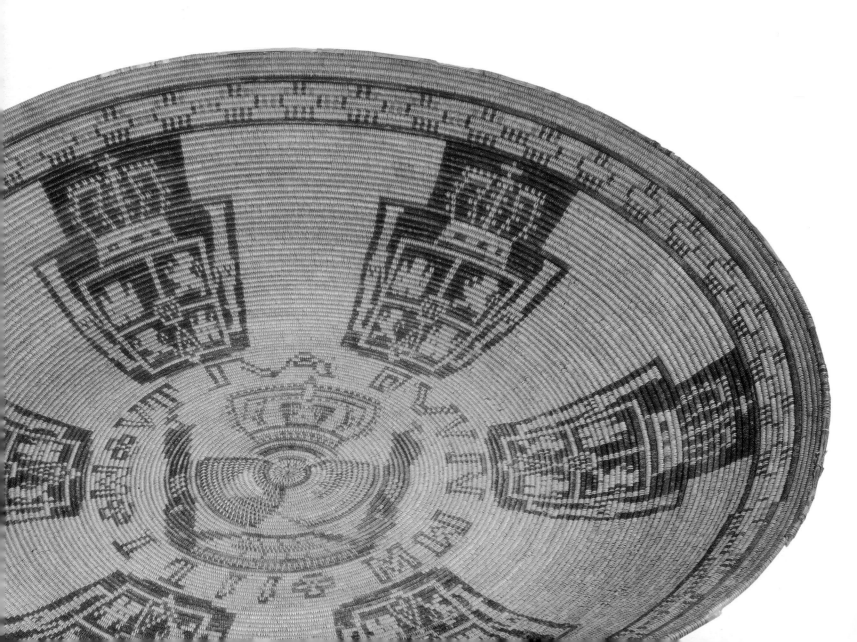

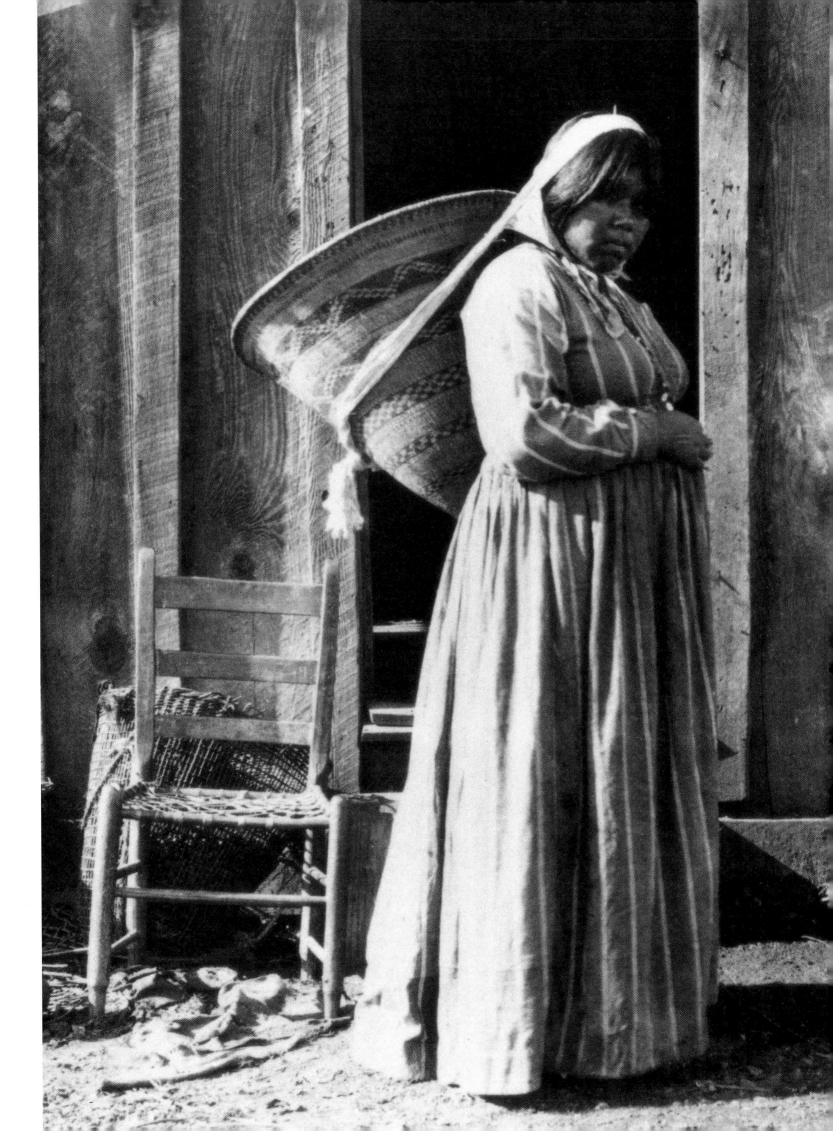

Makers and merchants

European settlement of California began with the arrival of the Spanish expedition of 1769 to set up a mission at San Diego. By 1800, twenty other missions had been built, stretching as far north as San Francisco. The Spanish aggressively recruited Natives for conversion, calling them 'neophytes', but treating them as slave labourers. The Chumash of the southern coast suffered terribly as a result of the five missions established in their territories. An estimated 20,000 when the Spanish arrived, they numbered less than 3,000 by the 1830s. The missions employed neophytes in a wide range of tasks: agricultural labour, caring for livestock, weaving textiles, tanning hides and other chores. Evidently, the basket-making skills of the Chumash impressed some of the Spanish priests and officials, who commissioned pieces for their own use or to send back to Mexico. The finely coiled basket tray illustrated here is one of these: the design includes copies of the stamped escutcheon of a Spanish coin, the 'pillar dollar' or 'piece of eight'. There are four known baskets of this type, probably all made by a woman named Juana Basila who lived at the Mission Buenaventura between 1806 and 1838. These Spanish commissions represent perhaps the earliest external engagement with California basketry art. As the pace of white settlement quickened during the 1800s, Native cultures came under increasing threat. By 1900 the Native population of California had declined to scarcely 20,000 all told. Fewer and fewer skilled individuals maintained the traditions of basket making. Among the Pomo, for example, only three communities reportedly still practised the art in the early 1900s. Anthropologists and collectors sought out fine pieces in the attempt to try and save something of this heritage. Others hoped to preserve the tradition for their own profit by creating a market for Indian baskets. During the late 1800s basket production was thus redirected from indigenous use to the demands of the market place. It was in this context that several talented individual artists emerged.

Mary Benson was born in the 1870s to a family of basket makers who lived in the Pomo community of Yokaya. She worked with her husband, William, who was one of the few men to make fancy baskets at that time. Together they produced large num-

bers of very high quality baskets for sale to outsiders. In 1904, their fame spread when they appeared as crafts demonstrators at the Louisiana Purchase Exposition in St Louis. Grace Nicholson, a successful basket dealer who supplied almost all the major American museums, eventually monopolized the Bensons' production, paying them $500 a year for all the pieces they could make. Nicholson stressed quality, as measured by the fineness of the stitching. Benson baskets belonged to traditional categories, but they tended to be smaller and more minutely woven than those of earlier generations.

Elizabeth Conrad Hickox was born in 1873 in a Yurok community in northern California. She married a white police officer and lived a comfortable middle-class life, but had been trained in the traditional Yurok way of making baskets. She was exceptionally talented and specialized in small finely-twined covered baskets with a distinctive knobbed lid. The lid with its handle was probably inspired by china sugar jars. The deftly woven designs of yellow bear grass and dark maiden hair fern are drawn from Yurok traditions, but the overall form of the basket was her own invention.

Today we applaud the originality of Elizabeth Hickox. Turn-of-the-century collectors, however, were more interested in authen-

| Mary Benson
STORAGE BASKET
Early 20th century, Pomo, California.
Willow and redbud,
diameter 18 cm (7 in).
National Museum of the American Indian, New York.

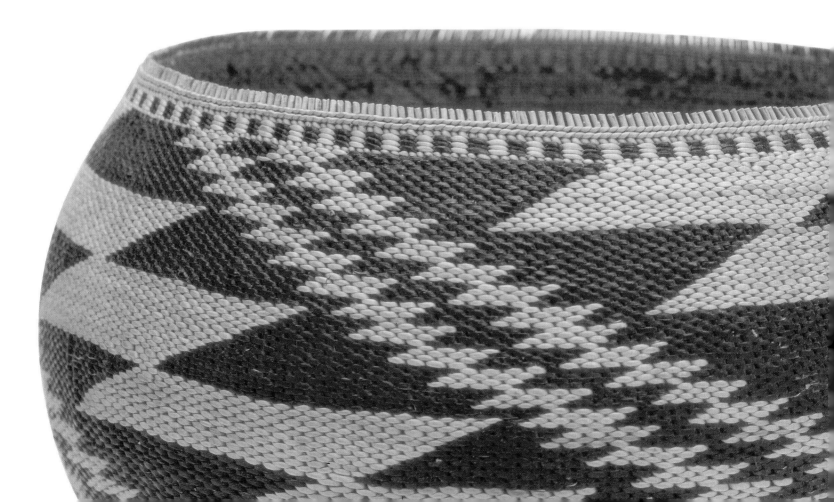

| Elizabeth Hickox
LIDDED BASKETS
1910–1930, Karuk,
northern California.
Coloured plant fibres,
heights from 6.7 to 13.3 cm
(2 5/8 to 5 1/4 in).
National Museum of the American Indian,
| New York.

Louisa Keyser |
DEGIKUP
1917-1918, Washoe, Oklahoma. |
Small willow branches, |
fern stalks, redbud, |
height 30.5 cm (12 in), |
diameter 41 cm (16 1/8 in). |
Philbrook Museum of Art, Tulsa.

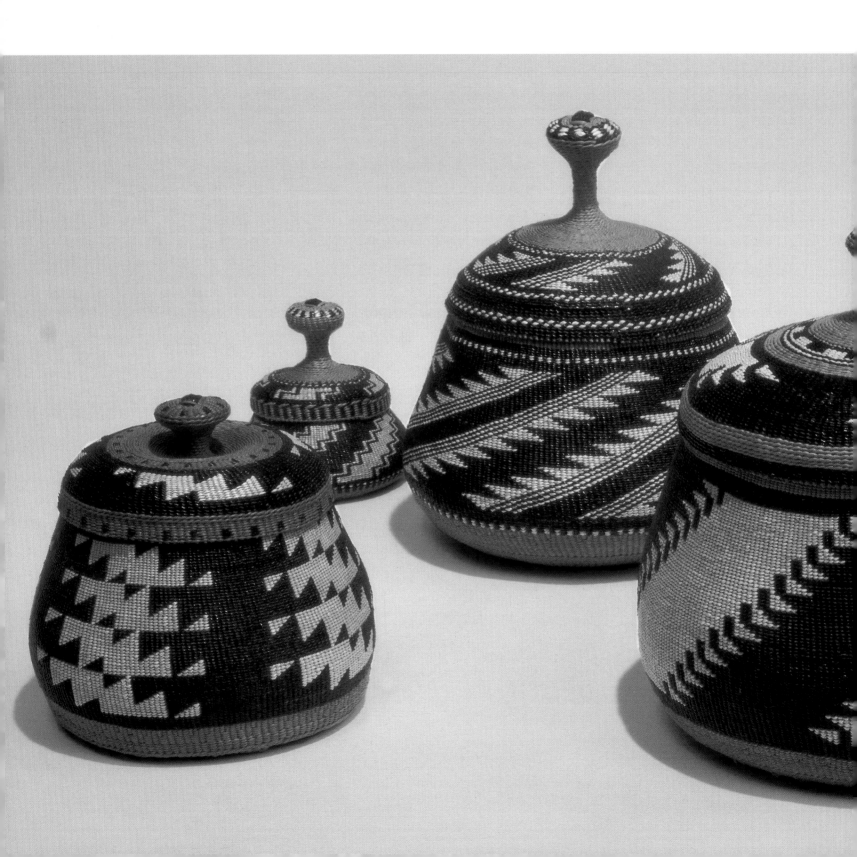

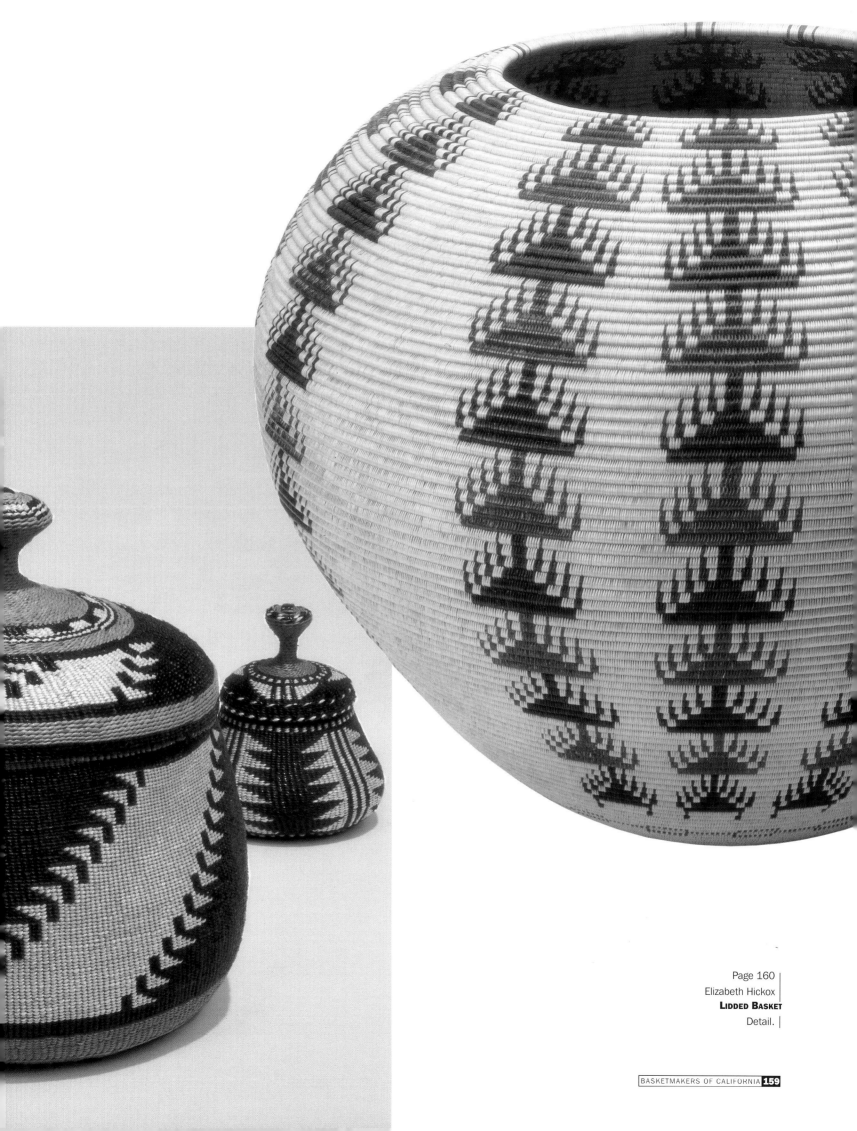

Page 160
Elizabeth Hickox
LIDDED BASKET
Detail.

ticity than in personal creativity. They wanted to buy 'authentic' expressions of a traditional craft. As a result, some traders created fictive 'traditions' for their more innovative artists. Louisa Keyser, a Washoe woman from western Nevada, was one of the great basket makers of that era. She devised an extremely beautiful and original form of coiled basket, called *degikup*, which was nearly spherical in shape and decorated with spare, elegant patterns. Washoe basket makers before her had never made anything like them; in fact, Keyser had been inspired by Pomo fancy baskets. The two traders she worked for, Abe and Amy Cohn, concocted a story to explain how these baskets were indeed 'traditional'. Keyser was a Washoe 'princess', they said, who possessed the exclusive right to weave *degikup* baskets. Paiute neighbours, the traditional enemies of the Washoe, had forbidden them to weave *degikup* as a condition of peace. Keyser wove them secretly, the Cohns said, at great personal risk. They even changed her name to 'Datsolalee', which sounded more fitting for a Washoe princess, although it translated as 'big hips' (a joke about Keyser's size). All of this was a lie, of course, but the story combined with Keyser's exquisite baskets led to unprecedented demand, and her *degikup* sold at much higher prices than any other contemporary baskets.

A recurring theme of American Indian art in this century is the tension between individual creativity and tribal tradition. When individuals made things for outsiders, their work responded to the opportunities of the market, often in startlingly original ways. Yet consumer interest in American Indian art focused on authentic ethnicity, not on personal expression. Sometimes it was tricky to reconcile these contradictions. The work of Mary Benson, Elizabeth Hickox and Louisa Keyser belongs to this moment of transition when white society was discovering the possibility of a Native American 'art', while still trying to make it fit with their preconceptions about American Indian 'artists'.

6. Making Magic on the North-West Coast

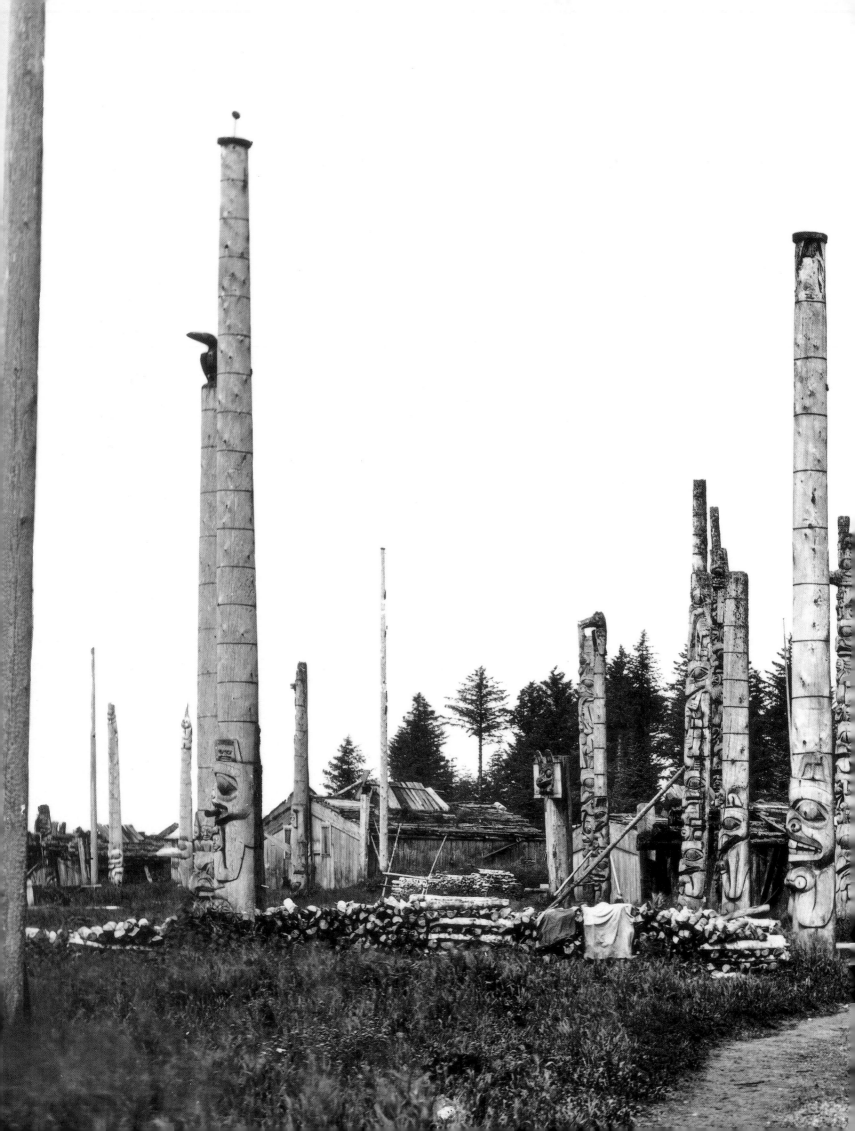

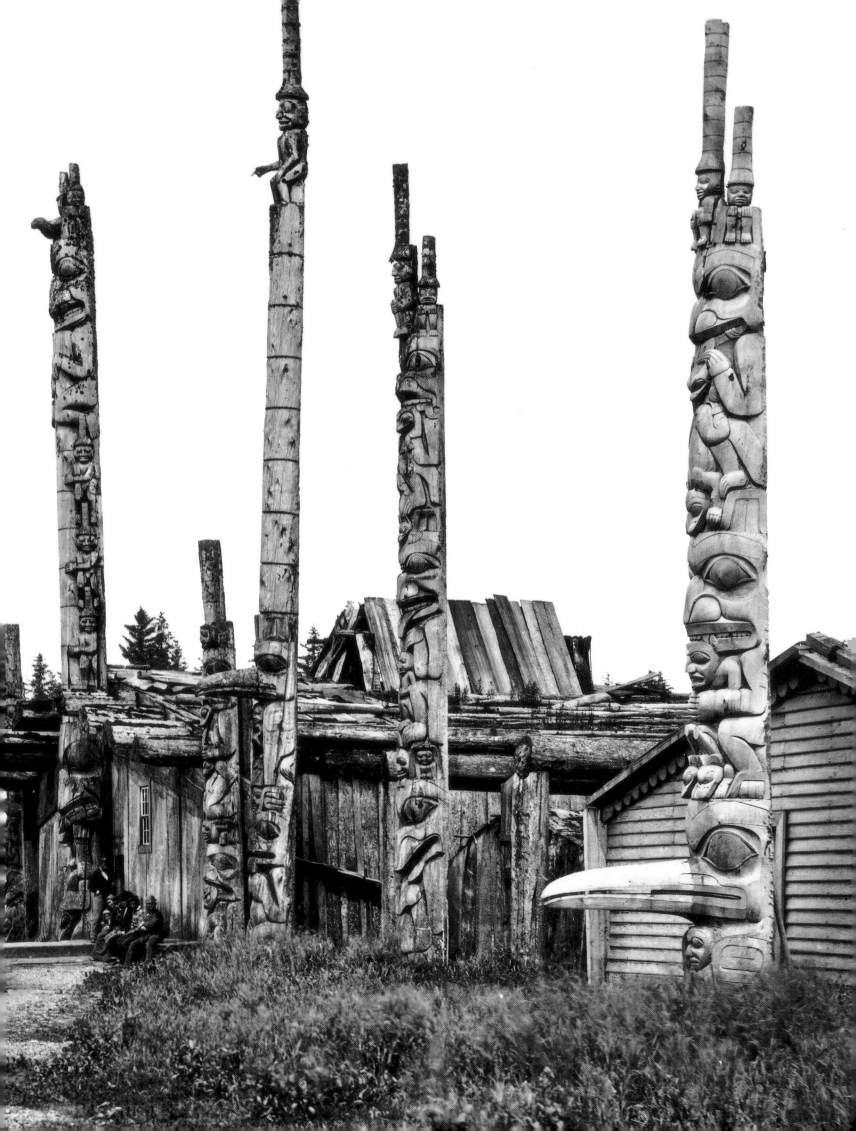

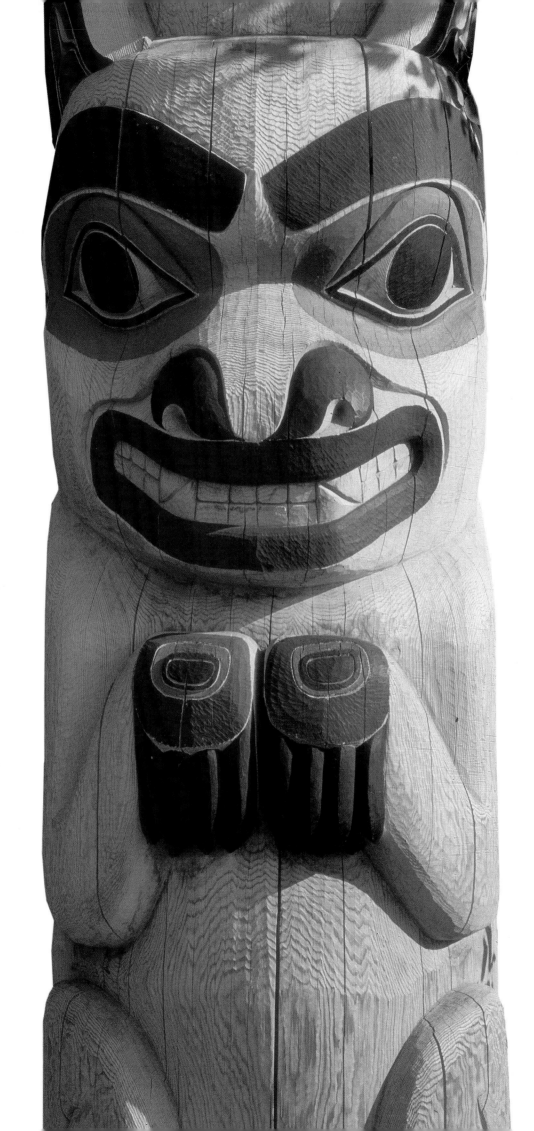

Pages 162–163
HAIDA VILLAGE
Queen Charlotte Islands.
American Museum of Natural History,
New York.

ANIMAL FIGURE FROM A TLINGIT CREST POLE
South-east Alaska.

HUMAN FACE FROM A KWAKIUTL CREST POLE
British Columbia, Canada.

The pine covered archipelagos and rocky shores that lie between the northern Pacific and the Canadian Rockies were home to villagers who harvested much of what they needed from the sea. Settlements clustered along the lower courses of the rivers, where massive spawning runs of salmon and eulachon, a kind of greasy smelt, take place every year. People have lived here for thousands of years, but there are only scant remains of their early history. The riches of their art are best represented by the woodcarving they have produced over the last three centuries, though few older pieces have survived.

The North-West coast of North America is home to several large language groups whose speakers share many general traits of economic, social and ceremonial culture, but who differ from one another in many ways. The northern-most Tlingit live on the mainland and archipelago of the south-east Alaskan panhandle, together with the Kaigani Haida. Their far more numerous Haida relations comprise the entire population of the Queen Charlotte Islands, which lie more than ninety miles offshore. The Tsimshian live south of the Tlingit, on the British Columbian mainland, with settlements located on the coast and some distance up the Nass and Skeena rivers. The Tlingit,

TLINGIT RAVEN BARBECUING HAT
Early 19th century, Sitka, Alaska.
Wood, deerskin, ermine, spruce
root, iron nail, bird beak,
height 52 cm (20 1/2 in).
University Museum, University of Pennsylvania,
Philadelphia.

SKETCH OF WHALE CREST POLE
Wrangell Village.
South-eastern Alaska.

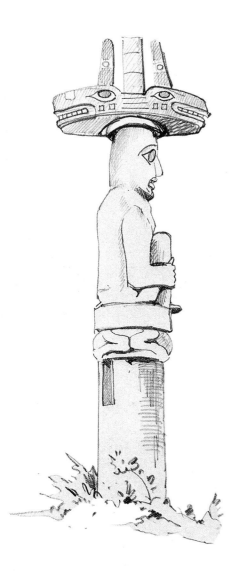

Haida and Tsimshian are very close, both culturally and artisti-cally. Further south, on the British Columbian mainland and in the north of Vancouver Island, live Kwakiutl speakers, the Haisla, Heiltsuk (or Bella Bella), Owekeno and southern Kwakiutl, who call themselves Kwakwaka'wakw, or 'speakers of the Kwakwaka language'. The Nootka or Nuu-chah-nuuth inhabit the stormy west coast of Vancouver Island, facing the open Pacific. In southern British Columbia and the north-west United States live several different groups of Salish language speakers, referred to collectively as Coast Salish. One of these Coast Salish groups, known as the Bella Coola or Nuxalk, also established themselves further north, as neighbours of the Bella Bella on the Bella Coola river.

The social organization of the northern North-West coast vil-lagers (Tlingit, Haida and Tsimshian) centres around member-ship in a household comprised of an extended, matrilineal lin-eage. Households are grouped into clans. The 'house' actually refers to a large cedar-wood house built in the winter village on the coast, where the entire lineage lives. The house itself is part of the tangible property of the lineage, along with hunting territo-ries and fishing camps. The lineage also owns intangible prop-erty, including proper names, stories about the origins of the lin-eage, the rights to perform certain ceremonies, and other kinds of restricted prerogatives and privileges. One kind of intangible property is a 'crest': that is the right to display a certain design or image of a supernatural being. The crest right derives from a lineage origin story in which the supernatural being figures. There are both lineage crests and clan crests, since every lineage belongs to a larger exogamous clan and moiety (Wolf and Raven for the Tlingit and Haida) or phratry (Grizzly Bear, Wolf, Eagle and Raven for the Tsimshian).

Thus, for example, the Silver Salmon lineage of the Raven moiety possessed a number of crests and crest objects. One was an elaborately carved wooden hat, called the 'Raven Barbecuing Hat', which was carved with the image of a raven. According to the origin myth, Raven had killed a king salmon. When he saw that he was expected to share it with a large crowd of birds and squirrels who had rushed to the scene, he tricked them into going to look for materials to cook the salmon with, while he

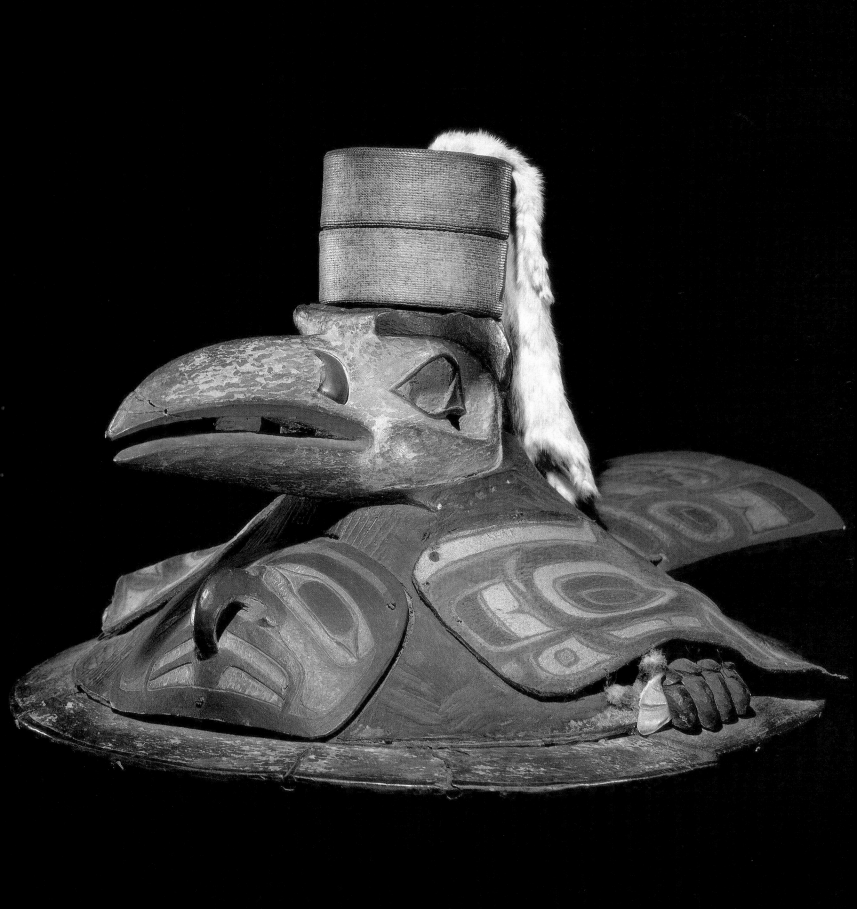

ate the fish alone. The story showed that only Raven had the right to eat the salmon he had killed, although others might desire it, just as the Raven lineages alone had rights to Raven crests.

A lineage chief would wear the Raven Barbecuing hat at a ceremonial feast called a potlatch. Clan hats were considered some of the most important lineage property and were worn only by senior males. A lineage would publicly display and thereby claim a crest as their property at a feast, where the guests witnessed and validated their host's right to do so. The hosts 'paid' the guests for this service by distributing wealth such as food and gifts. The potlatch staged this public transaction. Lineages competed with one another in organizing ostentatious potlatches and claiming important crests, each trying to outdo the others. This was serious business that often masked more naked aggression. When Raven lineages of rival Chilkat village disputed the right of the Silver Salmon lineage to display the Raven Barbecuing Hat at a potlatch, it led to a war that lasted five years and was only finally resolved by inter-marriage.

The decoration of the lineage house would include many crest images. Winter houses had a massive framework of cedar posts with side walls and roofing of hand-adzed cedar planks. Haida houses of the Queen Charlotte Islands often included a large totem pole or memorial pole as part of the entry way. Such poles, carved from a single cedar log, display a vertical sequence of sculptural images relating to a mythic narrative. One example can be found in the model carved by the famous Haida sculptor Charles Edenshaw of his uncle's house, the Myth House of Kiusta village. The pole tells how a young man, accused of laziness by his mother-in-law, transformed himself into a sea monster to shame her.

Inside the house, the most senior members of the lineage lived toward the rear. The section right at the back, opposite the entrance, was reserved for the lineage chief. This was where all the important lineage property was stored: the clan hats, regalia, feast bowls, boxes and other kinds of wealth. This space was separated from the rest of the house by a partition or screen, often elaborately carved and painted with crest designs and flanked by carved posts.

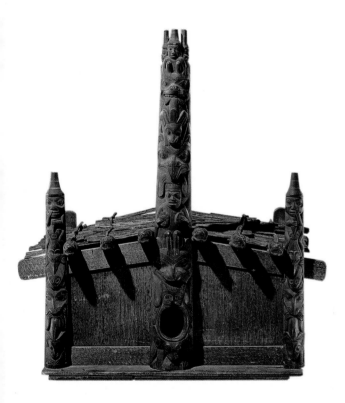

Charles Edenshaw
HAIDA WOODEN MYTH HOUSE MODEL
Circa 1900, Haida,
Queen Charlotte Islands.
Wood, height 76.2 cm (30 in).
American Museum of Natural History,
New York.

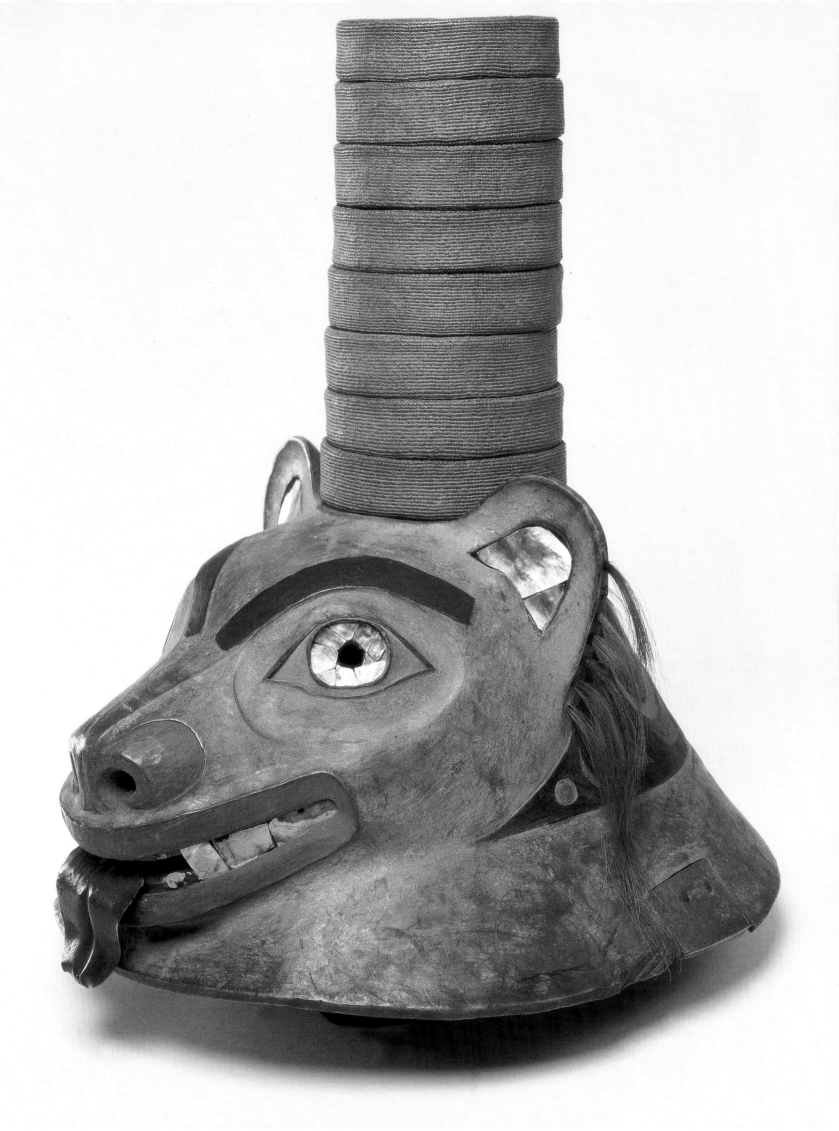

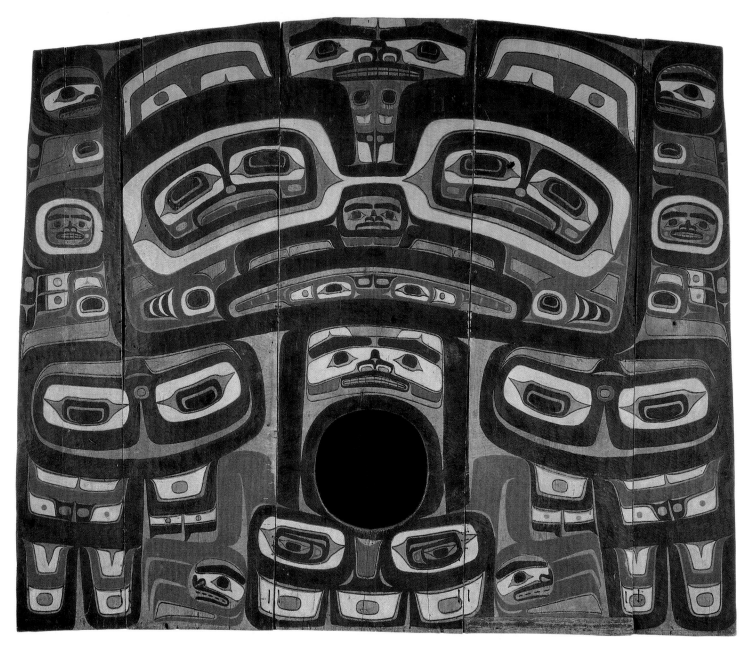

TLINGIT RAVEN SCREEN

Circa 1830, Klukwan village, Alaska.
Spruce, paint, 2.68 x 3.27 m
(8 13/16 x 10 3/4 ft).
Seattle Art Museum, Seattle.

**TSIMSHIAN TUNIC WITH BEAR AND
MOUNTAIN SPIRIT DESIGNS**

1830–1850, British Columbia.
Painted hide, 82.5 x 58.4 cm (32 1/2 x 23 in).
National Museum of the American Indian, New York.

The Raven Screen of the Frog House in the Tlingit village of Klukwan was made from five broad cedar planks that reached from floor to ceiling. A small circular aperture in the centre of this led to the private apartment behind. It is carved in shallow relief and painted with an elaborate, highly stylized design representing the raven. The bird's massive head fills the upper part of the screen. The circular doorway is located at the centre of its body, with its broad tail feathers below and wings spread to either side. The raven's legs and feet, painted red, fill the spaces between the tail and wings. The entire screen is covered with images of faces, inverted eyes and other details that seem confusing at first. The broad outlines of the raven are traced in massive black 'formlines'. The spaces are then filled in with a variety of conventionalized designs: the eyes and nose of the raven are

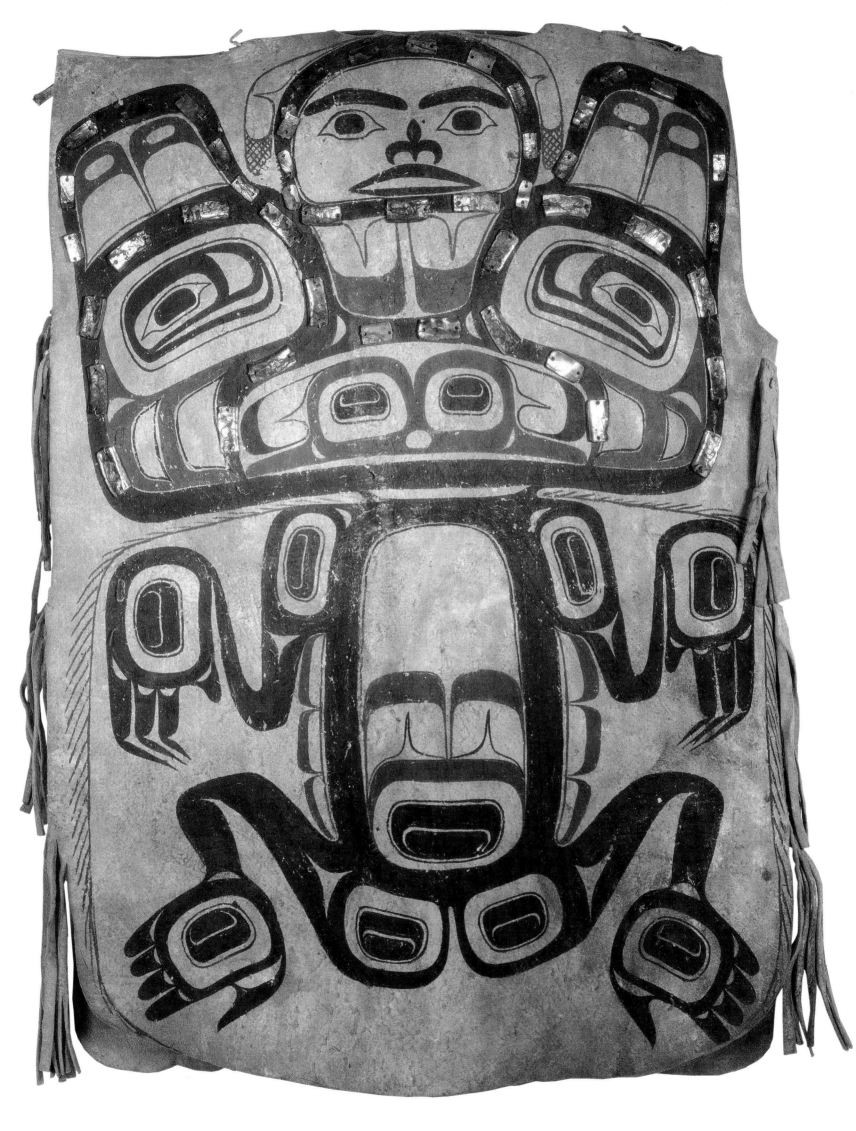

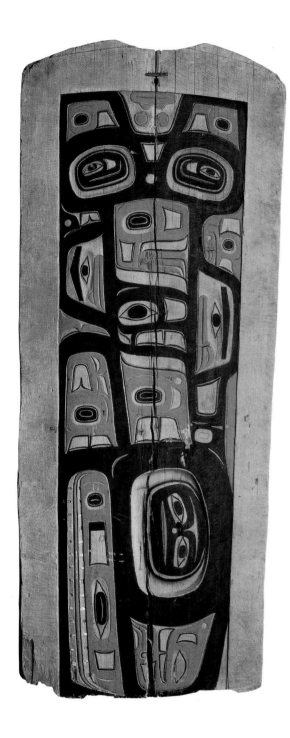

TLINGIT HOUSE PANELS
Late 19th century, Klukwan, Alaska.
Cedar, opercula shells, paint,
213 x 98 cm (83 7/8 x 38 5/8 in).
The Portland Art Museum, Portland.

faces; there is another face at the top of the breast above the doorway; the joints of the wings and tail look like inverted goggles with eyes inside; the tips of the wings and tail are composed of U-shapes in blue and red; the spaces around the head of the raven are loaded with similar 'fillers,' faces, profile heads, Us' and the like.

Formline design, of which this is a masterful example, was a conservative and highly formalized system of representation characteristic of northern North-West coast art. It was used to decorate every kind of objects, from buildings to bowls and spoons. The wings and tail of the raven on the Raven Barbecuing Hat are painted with formline designs. Some formline images are easier to decipher than the Raven Screen, thanks to a more naturalistic relationship between the different body parts. The two 'dog salmon' interior house posts from the Whale House at Klukwan are clearly recognizable as fish, even though they are replete with 'fillers' based on the same conventional motifs that were used elsewhere. All kinds of animals can be depicted by formline technique. An animal hide tunic painted by a Tsimshian artist sports the image of a bear-like mountain spirit. The enormous head with tab-like ears resembles the head of the raven on the Raven Screen, but the body that seems to dangle below is that of a more easily recognizable quadruped. The oval body contains an inverted eye or ovoid in black with two red 'split U's' above. The hips are designated by two more ovoids, as if it were an X-ray cross-section of the joint. Both hind and front paws are ovoids, the former with toes, the latter with claws.

Having understood the structure of 'configurative' formline designs, it is easier to interpret more complex 'distributive' designs where the different parts of the animal represented are spread out across the design field. Some of the more intricate designs of this kind are to be found on the cedar storage chests in which the treasures of the lineage were hidden. A number of such chests were produced by a master carver or perhaps a group of carvers from the Heiltsuk (Bella Bella) village of Waglisla, although they have been found among lineage possessions in Tlingit, Haida and Tsimshian villages. The sides are all made of a single plank of cedar bent, or 'kerfed', at three

corners and sewn together at the fourth. The base is lashed to the sides through holes in the bottom and a separate lid was made to fit snugly on top. The two long sides of the chest are carved in shallow relief and painted, while the short ends are painted more simply without carving. Narrow, graceful form-lines in black isolate the different anatomical portions of the animal design on the front. The substantial head of the creature is visible in the upper centre, with its eyes signified by narrow ovoid faces. The diminutive box-shaped body below is filled with ovoids and U's. The four ovoids distributed one in each corner represent the four major joints of the torso: shoulders and hips. The creature's hands rise up on either side of the body. With designs like this, it is difficult to identify the kind of animal portrayed. Sometimes filler details of the mouth suggest a bird's beak or a bear's muzzle. The hands that flank the body might resemble bird talons or bear claws. But very likely the designs were not intended to be too specific. Made to be used by any number of different lineages, they were often circulated through a series of potlatches, and so do not represent any particular crest.

Weavers in the Tlingit village of Chilkat specialized in making blankets with formline designs. Men painted patterns on wood for the women to weave, using mountain goat wool and cedar bark warps. In one example, the head of a creature inhabits the upper centre of the blanket. Feathered wings hang to either side of a squared body with grimacing face, and black bird talons are visible flanking the heavy tail. The patterns on either side of the central panel seem to defy interpretation – a nonsensical assortment of filler motifs arranged in an abstract composition. Chilkat blankets were widely traded and coveted up and down the North-West coast as chiefly potlatch regalia.

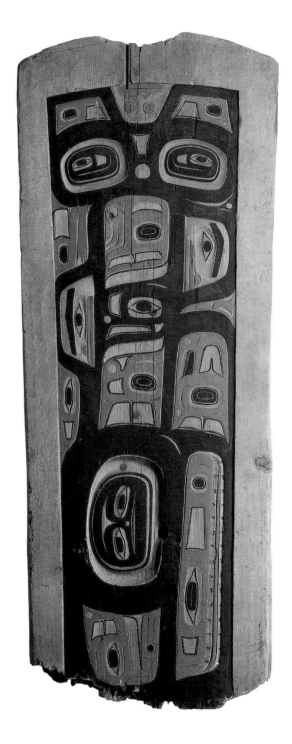

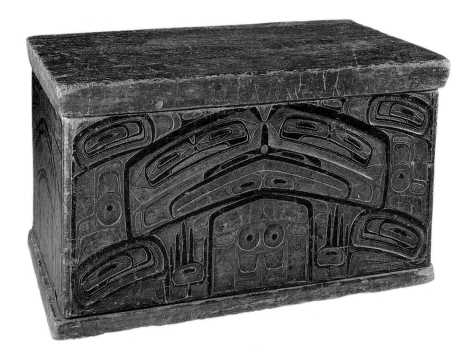

HEILTSUK STORAGE CHEST
Circa 1800, British Columbia.
Wood, 47.6 x 91.4 cm (18 3/8 x 36 in).
The Portland Art Museum, Portland.

Pages 176–177 |
WOVEN BLANKET
Circa 1880, Chilkat, southern Alaska.
Goat wool, yellow cedar bark, dyes,
131 x 168 cm (51 1/2 x 66 1/8 in).
Seattle Art Museum, Seattle.

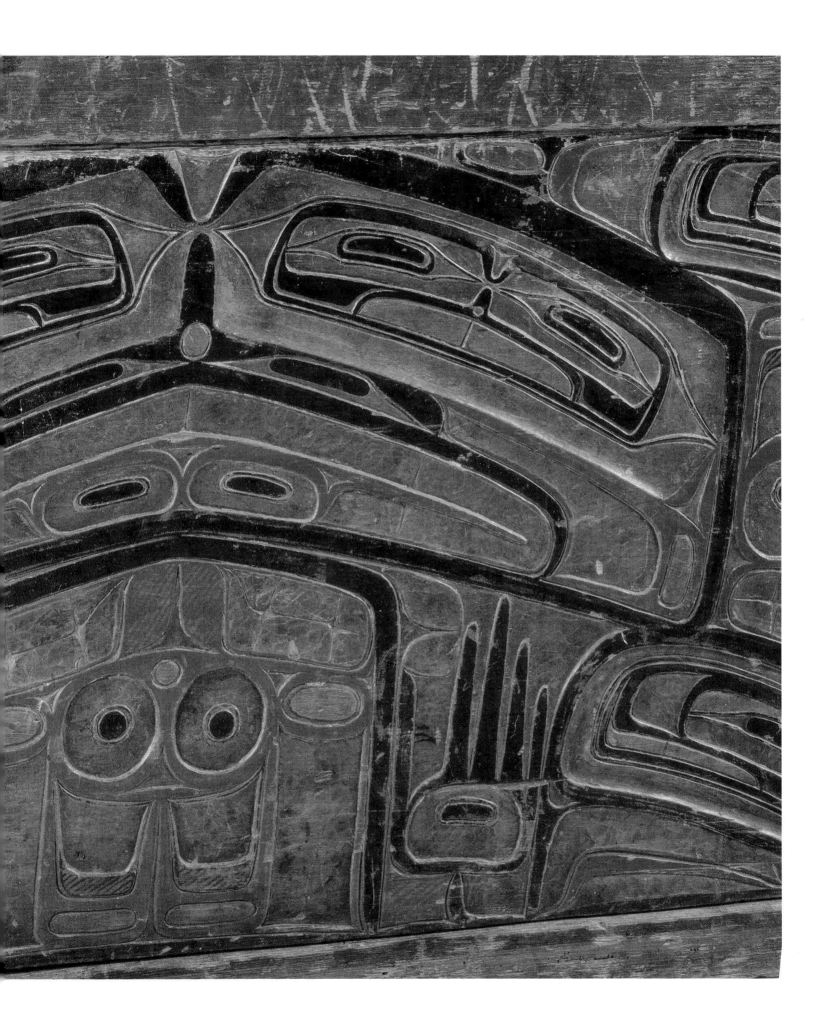

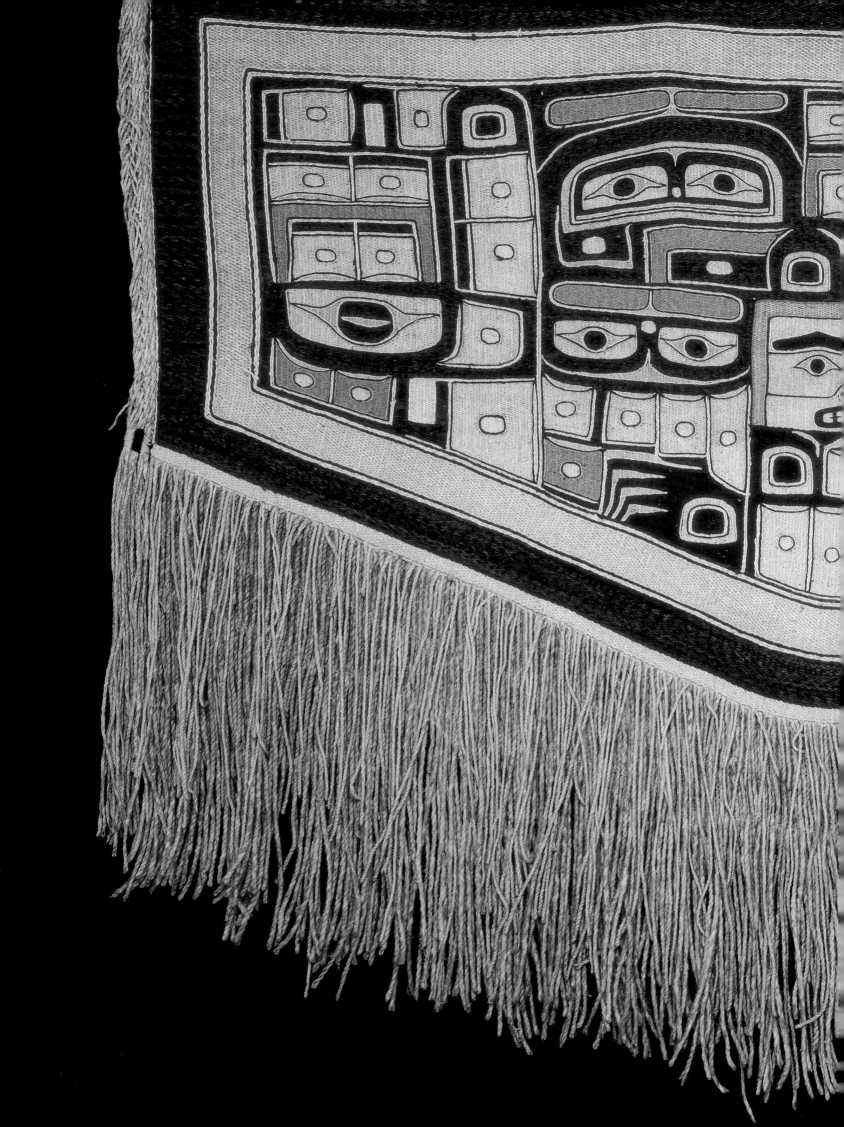

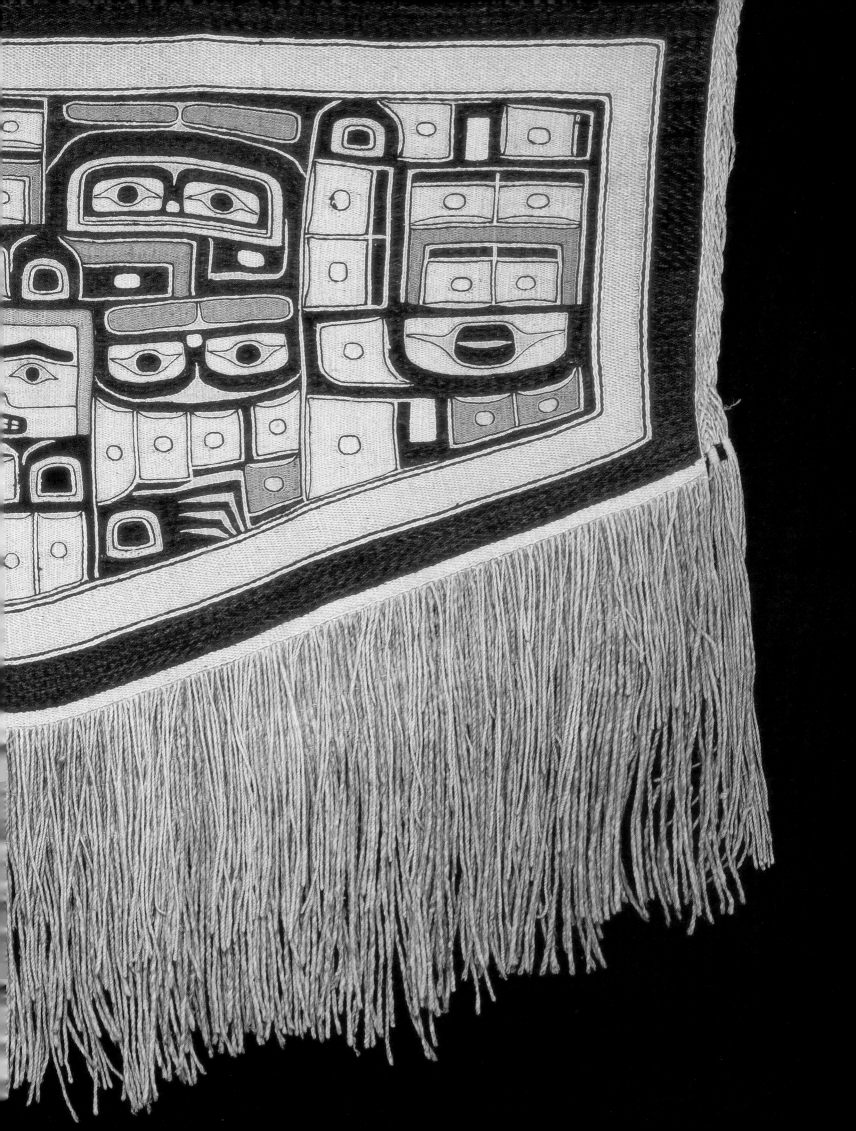

Ritual objects of the Tlingit shaman

The Tlingit shaman cured the sick, exorcized malevolent spirits, sought out and destroyed witches, predicted the future and weakened enemies during battle. He was the only member of the community capable of dealing with the dark unpredictable forces of the spirit world. His services were at once indispensable and liable to inspire fear and apprehension. The shaman accomplished his work by moving freely from the everyday world to the spirit world and back again. He was assisted by spirit helpers called *yek:* creatures who could travel between different realms of the cosmos or beyond the edges of the known world. These included the land otter, who was equally at home on land and water; the oyster catcher, a shorebird who lived on the line between land and sea; the octopus, which defied classification as fish or animal, and resided in the nether land of rocky coastal waters; and the mountain goat, whose home was the inaccessible heights of the mountain cliffs. The practising shaman brought the powers of these spirit helpers to bear through a variety of ritual objects – masks, rattles and charms – carved with images of these mysterious creatures.

To cure the sick, the Tlingit shaman used a collection of face masks, usually four in number. The Tlingit believed disease was caused by infection with harmful spiritual substances which the shaman sought to purge. While working over the sick, the shaman held a mask over his face and thereby transformed himself into the *yek* depicted on the mask, whose instructions he would follow.

The shaman received gifts of power from his *yek* during a long fast at a remote location, where the spirits approached and dropped dead at his feet, their tongues protruding from their mouths. The shaman would cut out their tongues and keep them in a sacred pouch, called a *sutch*, which then became the source of his power.

The Tlingit shaman's collection of masks presents an eerie assortment of creatures combining human and animal features. Common animals would metamorphose to reveal their true spirit aspects. A mask representing the octopus spirit depicts a frightening, wide-eyed, human-like being with its eyebrows and beard made from bear hide and its lips and nostrils sheathed in

TLINGIT SHAMAN
South-eastern Alaska.

copper. The only hint of its identity as an octopus is the tentacles painted in red across its cheeks.

The shaman used a rattle to perform his cures, which he would shake to give a sustained buzzing sound. Many rattles were carved with the image of the oyster catcher. One rattle, collected from a grave house near Klukwan village, is sculpted in the form of an oyster catcher whose tail becomes the head of a mountain goat. Bordering its back are the tongues of *yeks*, probably those of the land otter. Figures carved on the centre of its back illustrate another type of cure, used when the *yek* informed the shaman that an infection was caused by witchcraft and identified the culprit. The shaman would then torture the witch to elicit a confession. On this rattle, the shaman stands behind the accused, grimly twisting his arms which are bound behind his back, while the witch grimaces in pain.

The shaman would wear a necklace of pendants carved from bone or whale teeth in the image of his spirit helpers. Some allude to the shaman's journey, with the image of a canoe filled with shamans and *yeks*. In one such pendant, three skeletal figures – human beings as they appear in the spirit world – are riding in a canoe, which turns into a large land otter with protruding tongue. The tentacles of an octopus are visible beneath the figures.

The shaman was respected and yet also feared by his community. The disposal of his body after death differed from that of common people. Since his corpse was dangerous, it was buried far from any habitation, together with all his ritual equipment – masks, rattles and charms. The tomb itself was a simple wooden box often surrounded by a series of carved figures representing shamans, who would guard it against any disturbance. Ethnographers, who did not share the community's fears of reprisal, have collected many of the objects left in shaman's tombs, including 'guardian figures'. One such figure, which may be a miniature 'model' made for sale, shows a shaman standing on the head of his mountain goat *yek*. He holds a small mask in one raised hand.

Sketch of Crest Pole
Wrangell village,
south-eastern Alaska.

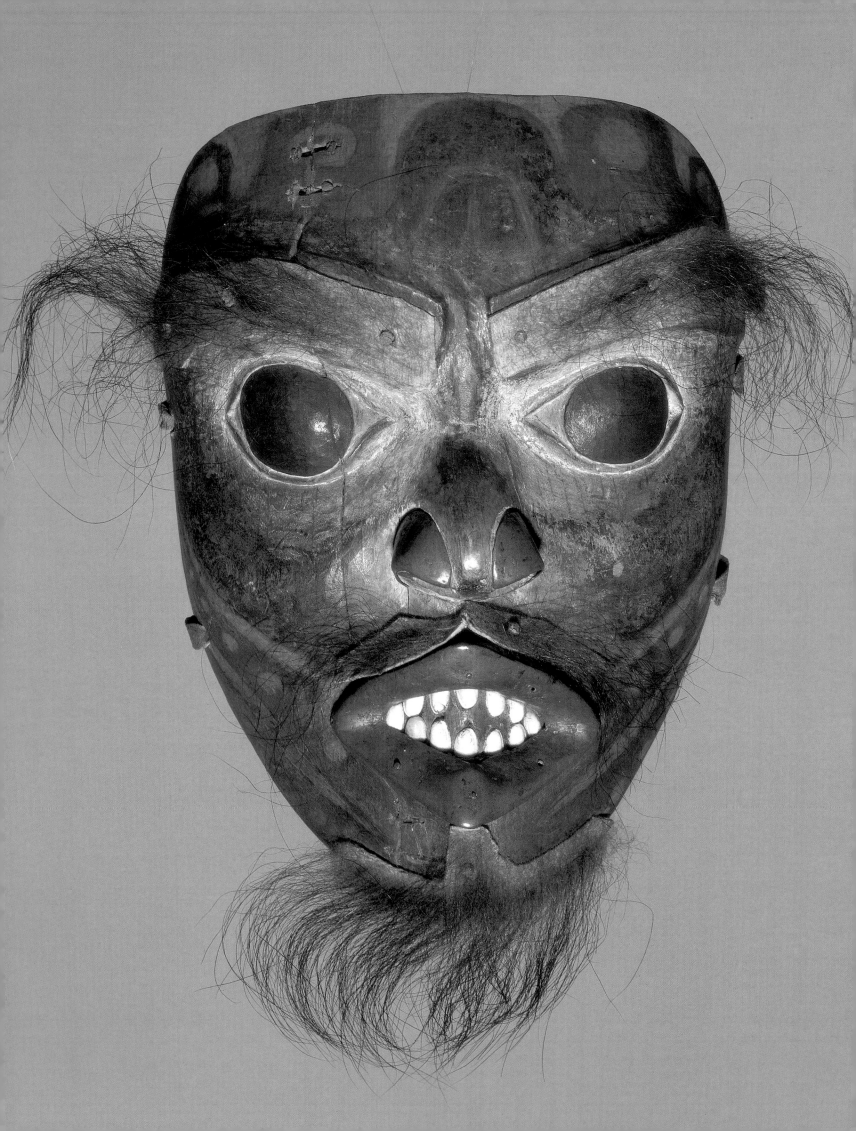

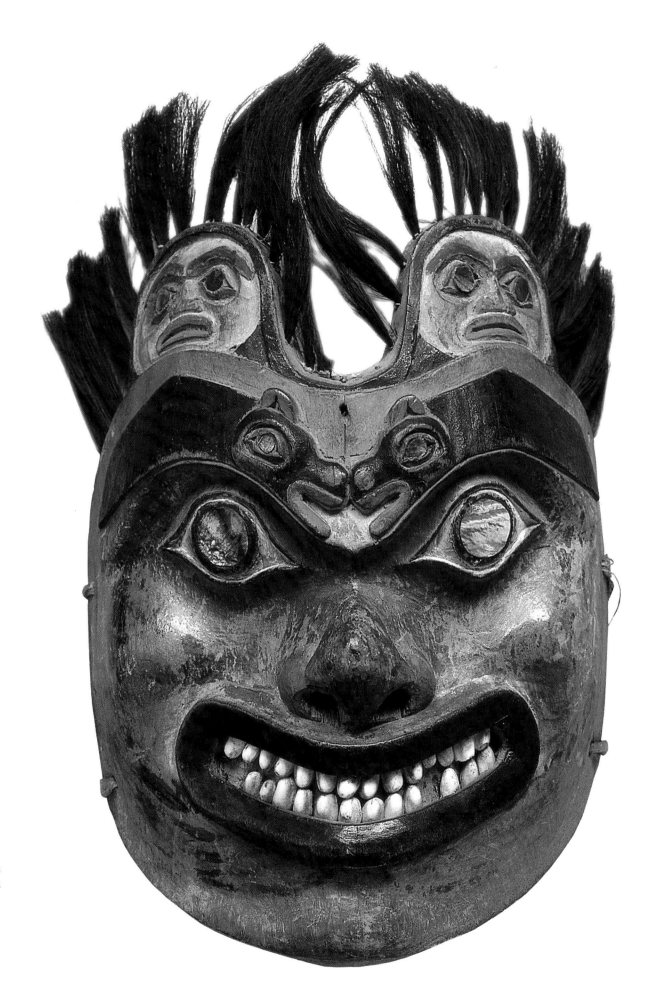

TLINGIT OCTOPUS MASK
1800–1840, Alaska.
Wood, copper,
bearskin, leather, shell,
24 x 17.7 x 8.8 cm
(9 1/2 x 7 x 3 1/2 in).
Thaw Collection, Fenimore
House, Cooperstown.

**TLINGIT SHAMAN'S
MASK**
1830–1850,
South-East Alaska.
Wood, opercula,
height 33 cm (13 in).
National Museum of the
American Indian, New York.

The Winter Ceremonial

The Kwakiutl people of the southern North-West coast did not possess a strict crest system like their neighbours to the south. The shaman was a powerful figure among the Kwakiutl, but he or she did not use masks, rattles and carved charms as Tlingit shamans did. Kwakiutl lineages were aggressive potlatchers, however, and competed with one another to stage the most ostentatious feasts and give-aways. Kwakiutl intangible property included certain names, or 'seats', and the rights to certain ritual performances, some of them elaborate masquerades presented during potlatch feasts. The latter were acquired through marriage. While the groom brought wealth and tangible goods to his

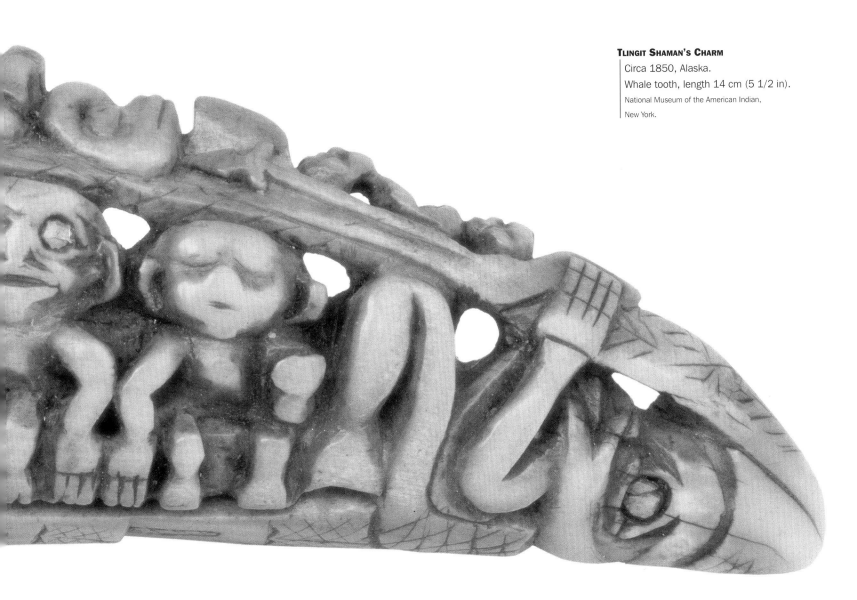

TLINGIT SHAMAN'S CHARM

Circa 1850, Alaska.

Whale tooth, length 14 cm (5 1/2 in).

National Museum of the American Indian,
New York.

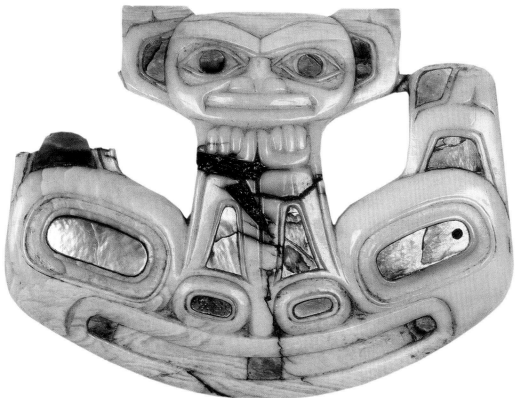

TLINGIT SHAMAN'S CHARM

Early 19th century, Alaska.

Walrus ivory, length 7.6 cm (3 in).

National Museum of the American Indian,
New York.

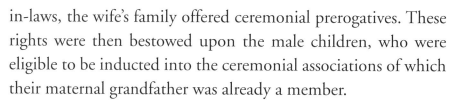

SHAMAN'S GRAVE FIGURE
Late 19th century, south-eastern Alaska.
Wood, hair, height 64.2 cm (25 1/4 in).
Marion and Richard Pohrt Collection, Flint.

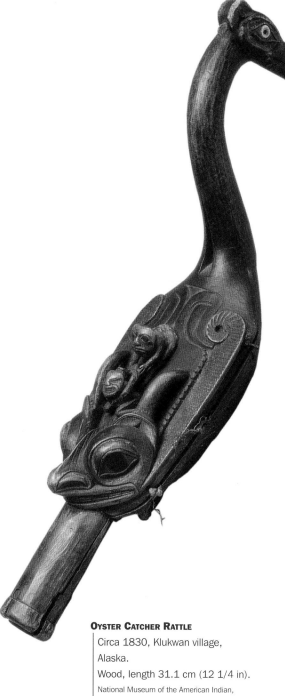

OYSTER CATCHER RATTLE
Circa 1830, Klukwan village,
Alaska.
Wood, length 31.1 cm (12 1/4 in).
National Museum of the American Indian,
New York.

in-laws, the wife's family offered ceremonial prerogatives. These rights were then bestowed upon the male children, who were eligible to be inducted into the ceremonial associations of which their maternal grandfather was already a member.

Kwakiutl potlatches and masquerades took place during the winter. On a pre-arranged date, the guest lineages assembled. They heard speeches and then retired to the host's large cedar house to be feasted. During the formal potlatch, rival lineage members were presented with robes, blankets and other tangible wealth according to their rank. A speaker recounted the host lineage's history, boasting of the accomplishments of great chiefs of the past. Near life-size 'potlatch figures' carved in wood were set up inside the house to represent the chiefs' assistants, or their rivals, who were held up to ridicule. One such figure depicts a chief wearing a headdress and holding a 'copper'. A copper is a copper plate with a distinctive pentagonal shape; it was the most highly valued of potlatch gifts, worth thousands of blankets. Some coppers had proper names, and those who offered them would recount the history of their previous circulation.

Late in the first night, the occasion would be interrupted by an odd whistling and shuffling sound up in the roof beams. One of the host's family would suddenly announce that the host's son had disappeared, kidnapped by dangerous cannibal spirits, who, during the winter season, travelled from their home at the north end of the world to visit the Kwakiutl villages. The noises were the voices of those spirits. The next day, elder members of the 'Cannibal Society' would successfully recover the young man, whom they had found in a wild state, charged with the cannibal power of the spirits who had abducted him. With cedar branches wrapped around his head and waist, the youth

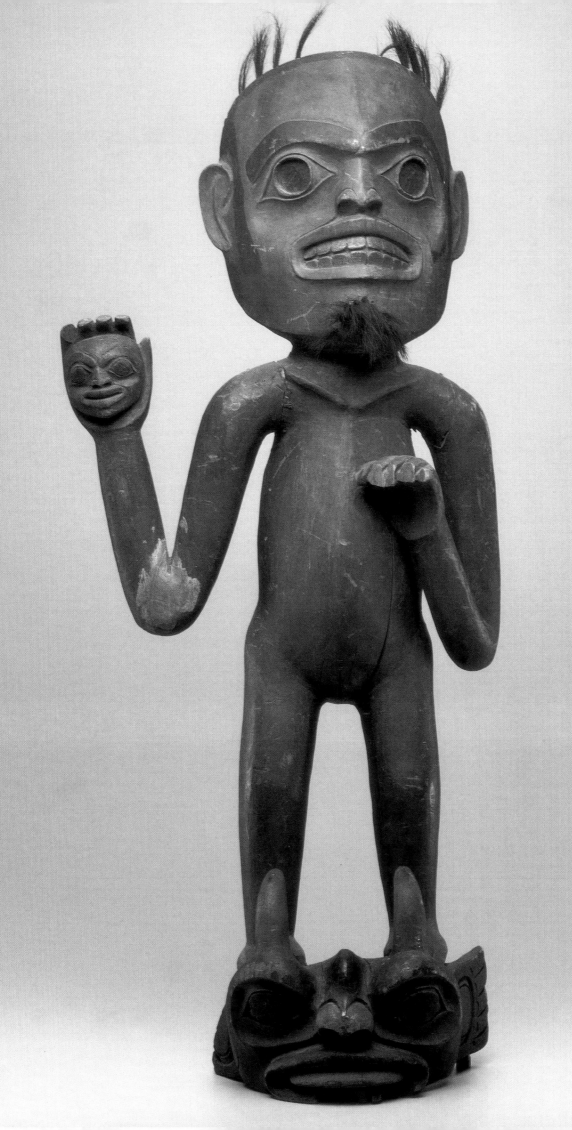

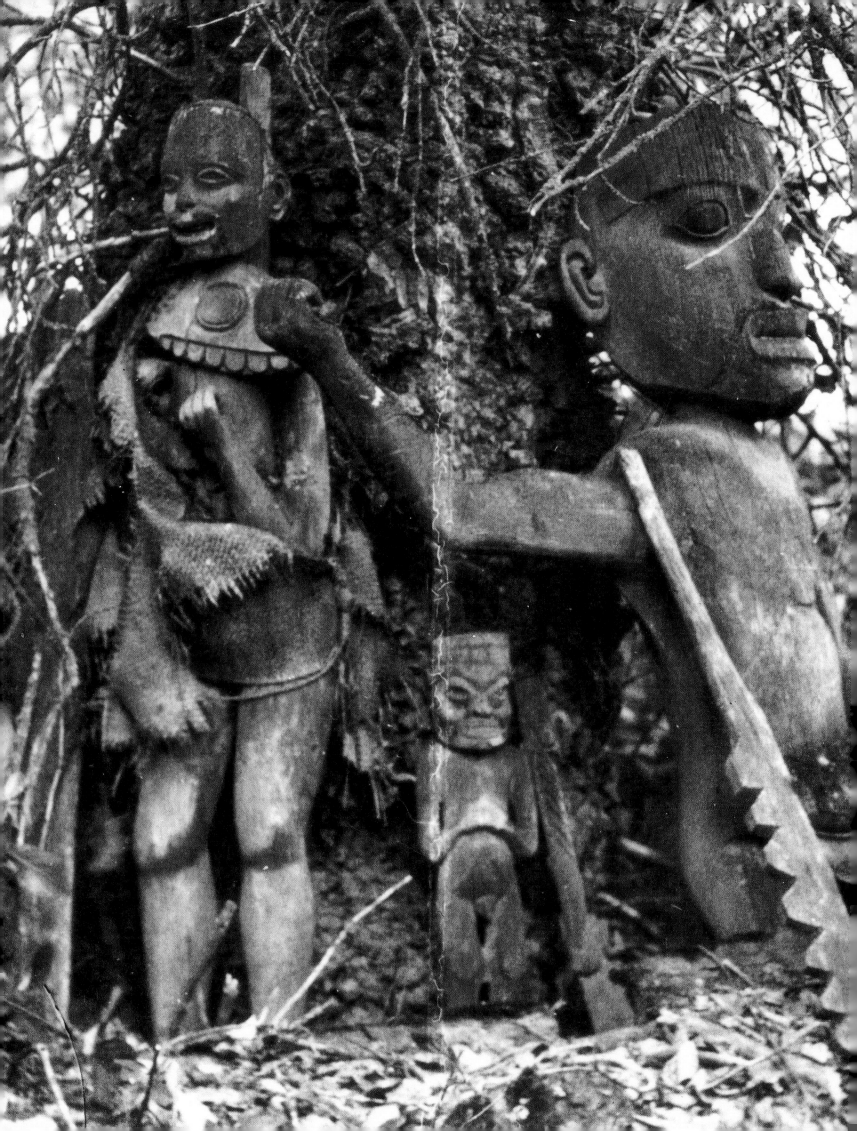

was paraded through the village by attendants who restrained him with ropes. He craved the taste of human flesh and snapped with his teeth at both attendants and spectators, sometimes drawing blood. That night, when the attendants brought him to the dance house where the guests had assembled, the youth arrived with a human corpse on which he fed voraciously. All this drama was staged by the initiates of the Cannibal Society. The spurting blood and the snapping bites were faked, the corpse the youth ate was a model, but the non-initiated were often taken in.

On the fourth night, the elders of the 'Cannibal Society' resolved to cure the host's son of his madness. They acted like shamans – even calling themselves the Shaman's Society – and sang songs and danced to purge the cannibal spirit from his body. At the climax of the ceremony the young man was cured, and the cannibal spirits themselves danced in the house, impersonated by men covered with long flowing strips of red cedar bark and wearing monstrous masks. The Kwakiutl themselves were not cannibals and, naturally, found cannibalism abhorrent. The performance showed how the cannibal spirits, the most powerful, deadly and horrific denizens of the spirit world, were in the end controlled and banished by the shaman power of the lineage elders.

In the more elaborate dances, as many as four masks were used, all depicting cannibal birds. Their heads with long beaks were brightly painted. The dancers would hop and squat, angling the beaks upward and swaying from side to side. The jaws were hinged and worked with strings, and the dancers would make them snap shut with a resonant clap to accompany the slow, dirge-like music sung by attendants. The dramatic trio of cannibal spirit masks carved by the famous Kwakiutl artist Mungo Martin (1881–1962) includes the Crooked Beak of Heaven with its arched crest over its nostrils, the Cannibal Raven who crushes skulls with his beak, and *huxwhukw*, the Cannibal Crane who sucks men's entrails out through their anus.

The Cannibal Dance is the most prestigious in the hierarchy of the Kwakiutl Winter Ceremonial performances. The *nulamal* or Fool Dancer is a lesser performance of the *tseka* (or red cedar bark) series of the Cannibal Dance. In fact, Fool Dancers often

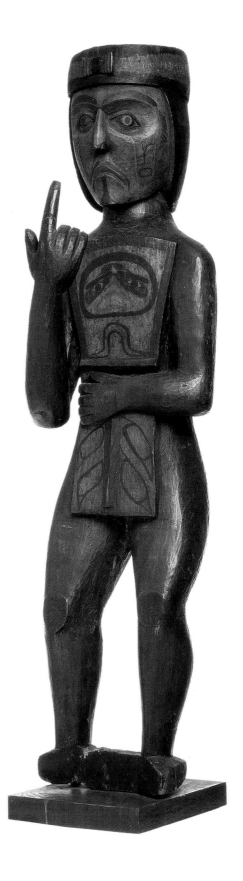

TLINGIT SHAMAN'S GRAVE
Undated, Klukwan, Alaska.
American Museum of Natural History, New York.

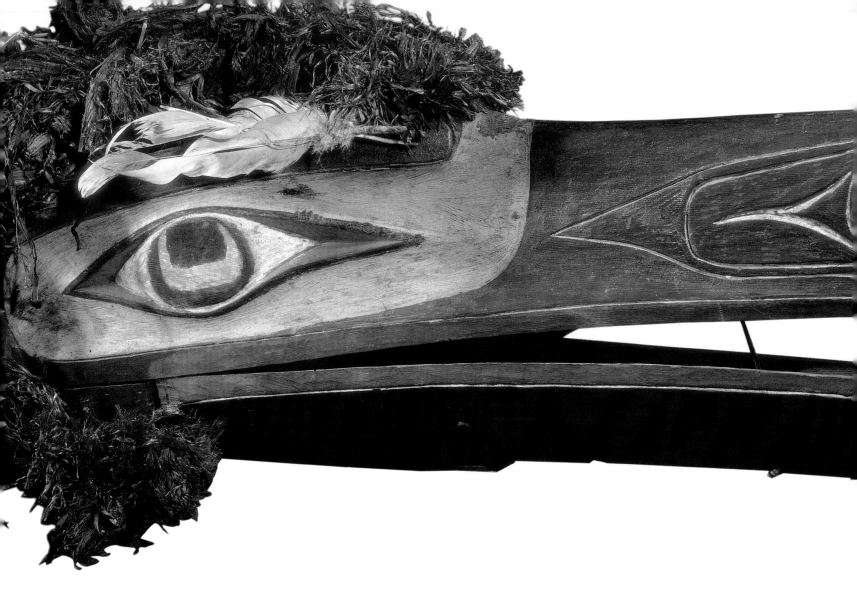

KWAKIUTL RAVEN HAMATSA MASK
Undated, Blunden Harbor, British
Columbia.
Painted wood, feathers, cedar bark,
length 99.6 cm (39 1/4 in).
American Museum of Natural History, New York.

| Page 187
KWAKIUTL POTLATCH FIGURE
1880s, British Columbia.
Painted cedar, nails,
height 127 cm (50 in).
Thaw Collection, Fenimore House
| Museum, Cooperstown.

act as the messengers and assistants of the Cannibal Dancers.
The overall structure of the performance is the same. The initiate
is infected with destructive, anti-social spirit power and must be
cured. His nose runs with mucus which he eats or smears over
his body. He scratches himself incessantly and his behaviour may
become violent, breaking things, overturning order, acting
crazily and whinnying with a high-pitched squeal. The mask
depicting the Fool Dancer emphasizes his nose, often with
streams of mucus flowing from it like a moustache. A ring of
twisted red cedar bark rope frames his face.

Intermarriage with the Heiltsuk, northern Kwakiutl, brought
south another series of Winter Ceremonial dances called the
tla'sala. Here, a powerful chief impersonates a shaman and
dances in a distinctive frontlet headdress while shaking a rattle.
He draws into the dance house a series of powerful spirit beings
embodied by masked dancers. Kumugwe' is one, the Master of
the Sea who controls all the ocean's creatures and resources. He
is reputed to be a source of great wealth. His mask shows a

Mungo Martin
CANNIBAL BIRD, RAVEN AND CROOKED BEAK
Before 1962. Kwakiutl,
British Columbia.
Painted wood, feathers, cedar bark,
length 137.2 cm (54 in).
Royal British Columbia Museum, Victoria.

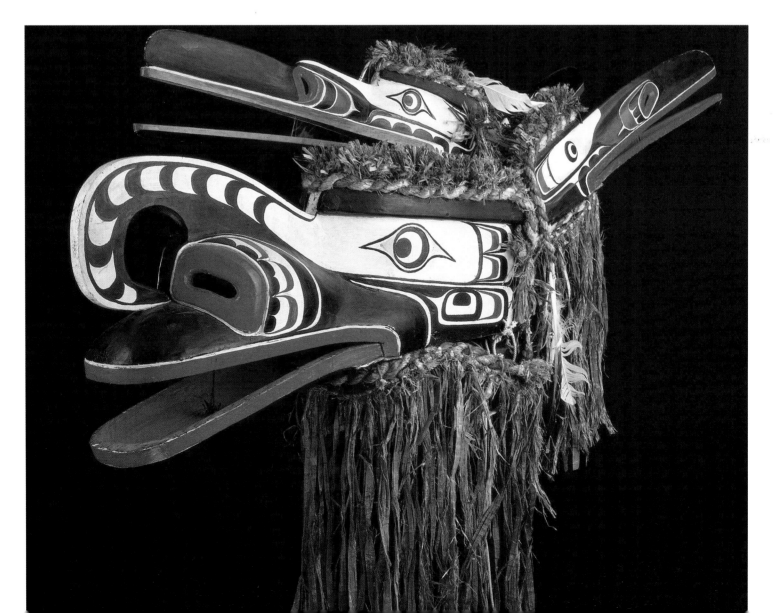

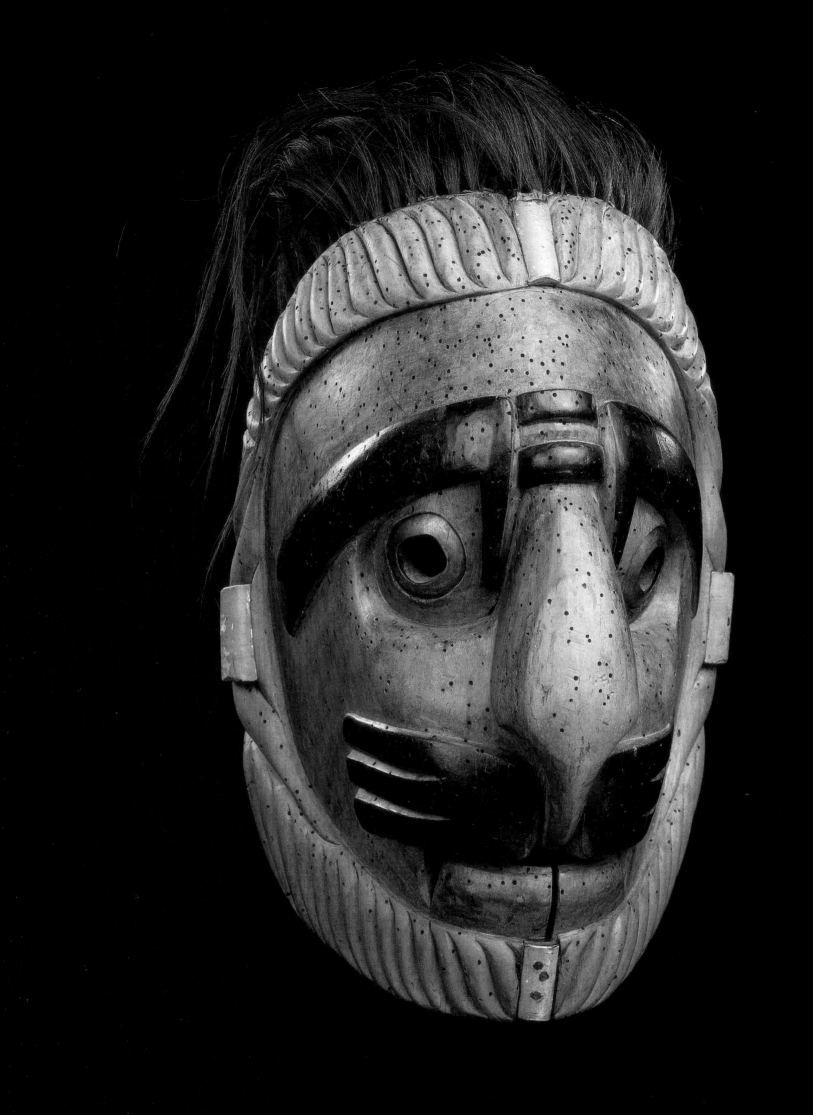

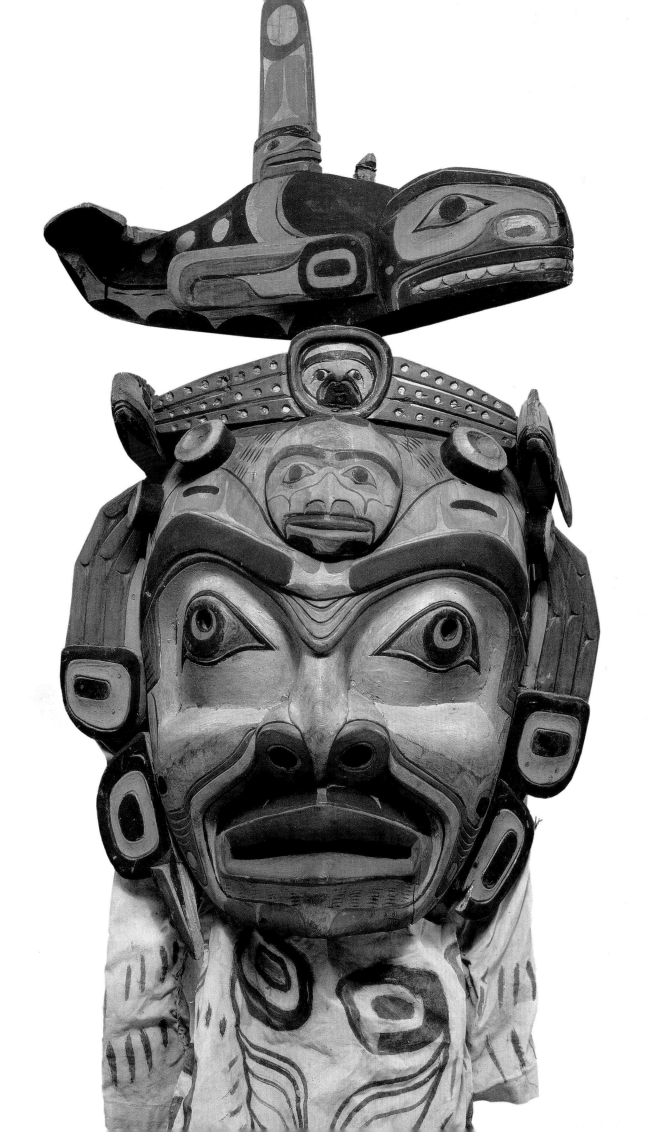

large amphibious face with claw-like hands held up on either side of his head. A killer whale perched on top of his head can be made to spin. An octopus sits upon his brow flanked by two rock fish.

Kwakiutl masks often incorporate clever mechanical devices: mouths or eyes that open and close; faces that split open to reveal a different face inside. A killer whale mask almost five feet long can be made to 'swim'. Its dorsal fin rises and descends, the flukes sweep up and down, the pectoral fins wave back and forth as the mouth opens and closes. The dancer works all these mechanisms while moving gracefully around the dance house. Kwakiutl dance masks are colourfully painted and dramatically carved so that their sculptural forms stand out in the glimmering firelight. More than sculpture, though, they are intended to function theatrically in a context of movement and dance.

The Tsimshian, to the north, also used masks for chiefs' power demonstrations before potlatches. Each Tsimshian family owned rights to certain *naxnox* names, as they were called,

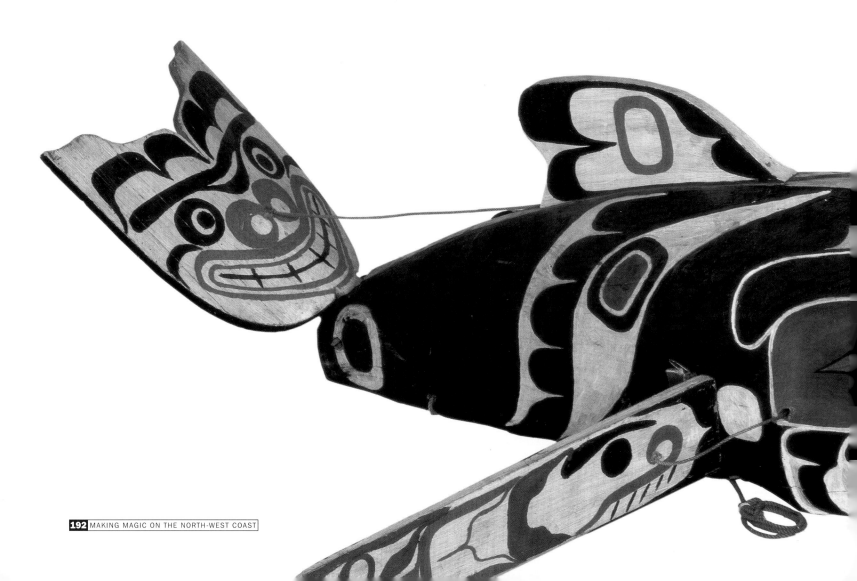

including the right to present them as masquerade performances. The masks were made and the presentations orchestrated by a special group of ritual artists called *gitsontk*, or 'people secluded', since they worked in secrecy. Some of the masks represented strangers or foreigners; others represented attributes physical or psychological ('blind', 'careless') or forms of behaviour ('choking while eating'). Others again represented non-crest animals. The identity of the masks is not always evident; this was, it seems, part of the performance. The audience remained in suspense until the actions of the mask revealed its identity or the speaker announced its name.

The Native residents of the North-West coast suffered many of the consequences of contact with the outside world experienced elsewhere in North America. Beginning in the early 1800s, the region became a provisioning stop for the whaling industry. Germs brought by outsiders caused devastating epidemics of measles, smallpox and other diseases. In an effort to administer, control and convert Native peoples to a more European way of life, the British Columbia government outlawed potlatches in

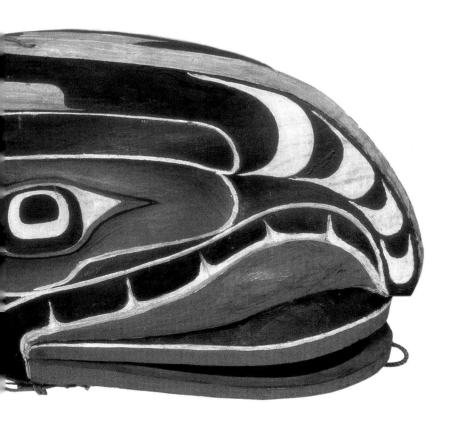

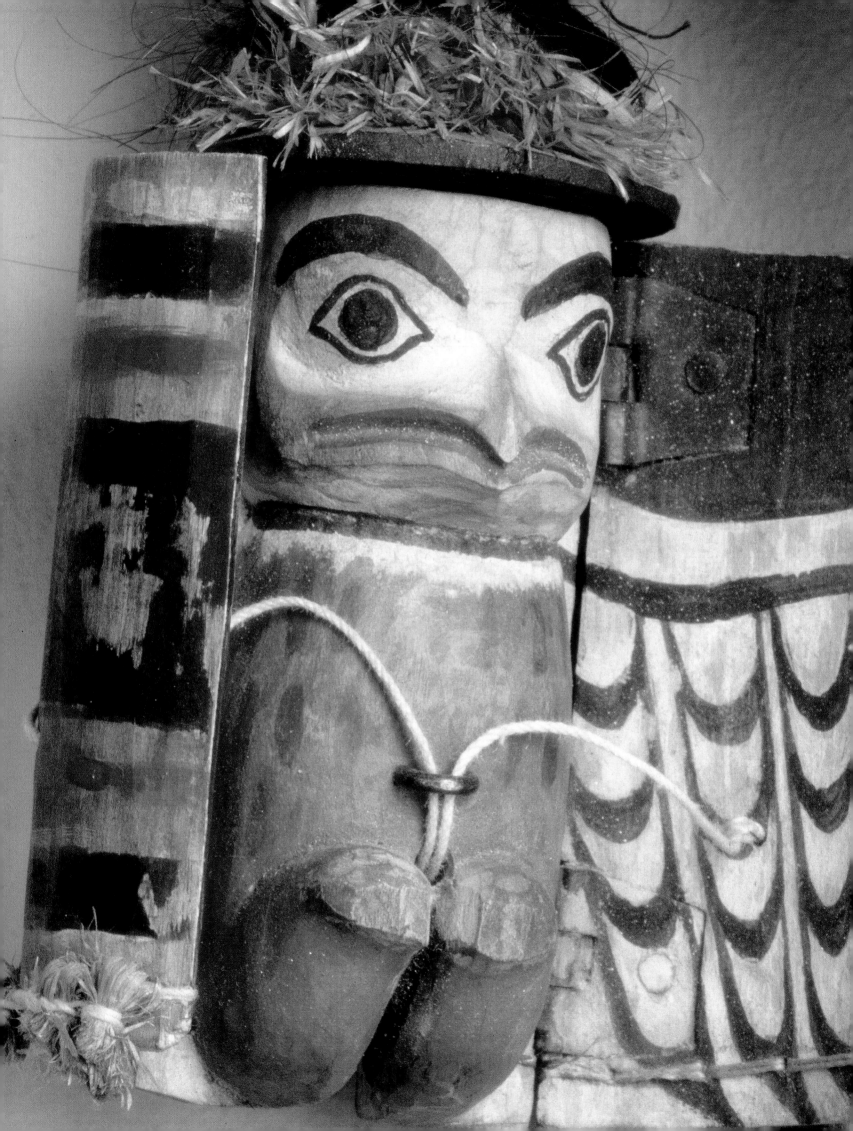

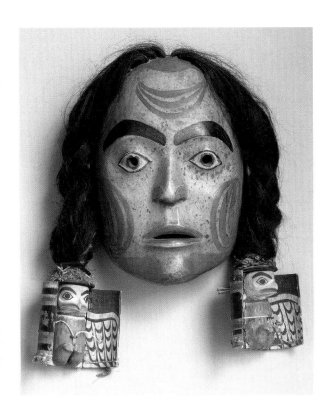

1885, although they continued in secret. After the 1880s, representatives of museums from all the major cities of America came to collect artefacts. Soon there was more North-West coast Indian art in New York city than in all of British Columbia. Native peoples were encouraged to sell or 'give up' their 'old-fashioned things', and were sometimes forced to do so, as for example when Government agent William Halliday in 1921 confiscated a large collection of masks and other objects during a raid on a Kwakiutl potlatch. He then sold his haul to different eastern museums. Kwakiutl artists like Willie Seaweed (1873–1967) and Mungo Martin (1881–1962) helped preserve the traditional ways until the potlatch ban was deleted from the revised Canadian Indian Act in 1951. Seaweed inherited chiefly names and responsibilities at his home village of Ba'a's, where he was able to conduct potlatches and stage dances in relative seclusion. Martin worked at the British Columbia Provincial Museum, teaching young artists the techniques of carving and house posts from 1952 until 1962. He hosted the first 'legal' potlatch in 1953, successfully bridging the gap of ignorance and arrogance that had driven Kwakiutl traditions underground for three quarters of a century. Today, the potlatch and masquerade performances remain a central part of contemporary Kwakiutl life.

Charles Edenshaw (1839–1924) also inherited chiefly titles from his Haida ancestors of the Queen Charlotte Islands. A skilled carver, he was often sought out for commissions by anthropologists and museum curators who wanted house models or miniatures of memorial poles for their collections. Like several other Haida artists, he also carved a black slate called argillite, which is unique to the Queen Charlotte Islands. Argillite had been used traditionally for pipes, but during the 1800s it became the favoured medium for models, trinkets and other kinds of miniatures for sale to visitors. The argillite dish illustrated here represents a slightly risqué episode from the Raven myths. Raven brought many gifts to the earth. Here, dressed as a warrior, he has embarked in a canoe on a quest to restore to women their genitalia. Edenshaw stressed the humour of the story, contrasting Raven's grim expression with the terror visible in the posture of his companion, a shelf

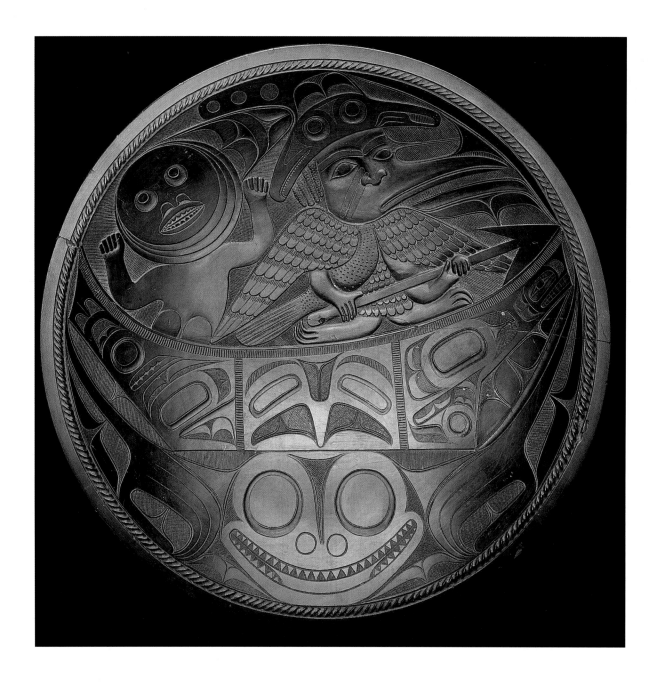

Charles Edenshaw

PLATE

Before 1920, Haida,
Queen Charlotte Islands.
Argillite, diameter 30.5 cm (12 in).
Seattle Art Museum, Seattle.

fungus, whom Raven judged uniquely capable of approaching his fearsome quarry. Edenshaw combined traditional formline design with a more pictorial idiom for this typically innovative composition.

The formline traditions of the northern North-West coast were revived by a generation of artists who began work in the late 1960s and 1970s. Robert Davidson (b. 1946), a Haida from the Queen Charlotte Islands, began like Edenshaw as an argillite carver. He worked with the elder Haida artist, Bill Reid, on the totem pole restoration programme at the University of British

Columbia during the 1960s, but quickly emerged as an artist in his own right, with his mask carvings, prints and bronze sculpture. Like several of his contemporaries, he applied the principles of formline design to serigraph prints on paper. Davidson paralleled his elder, Edenshaw, in drawing on the Raven myth cycle, in this case, 'Raven Stealing the Moon'. His work stems from years of study of antique Haida formline designs on chests and boxes, but opens that tradition up to new possibilities.

TLINGIT SHAMAN'S DANCE APRON
Detail. Late 19th century,
South-eastern Alaska.
Painted hide, length 150 cm (59 in).
Smithsonian Institution, Washington, DC.

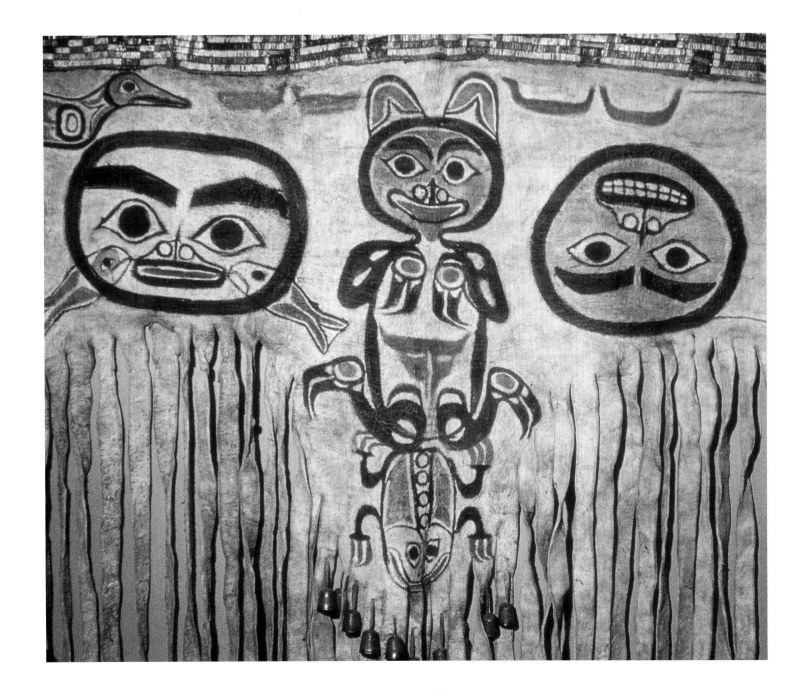

Robert Davidson
RAVEN STEALING THE MOON
1977, Haida,
Queen Charlotte Islands.
Silkscreen on paper, 58.1 x 27 cm
(22 7/8 x 10 5/8 in).
National Museum of the American Indian,
New York.

American Indian Art in the Twentieth Century

| Alan Houser
SHELTERED
| 1979, Chiricahua Apache.
Bronze, 38 x 15.3 cm (15 x 6 in).
| Heard Museum, Phoenix.

The social, cultural and economic constraints imposed on Native peoples at the end of the 1800s changed their lives irremediably. The traditions of art and craft offered for many a solution to the dilemmas posed by these unwelcome transformations. Artists like Margaret Tafoya, Louisa Keyser and Charles Edenshaw responded vigorously and creatively to the opportunities offered by traders, collectors and tourists. Trained in the traditional media and techniques, they adapted them successfully to produce objects that were much sought after. Yet in the marketplace, their work was rarely seen as 'art', at least not until recently. At best, their work was classed in the European category of 'decorative arts', but for the most part they were relegated to the rubric 'ethnic art', or 'craft'. During the first decades of this century, however, some Native artists and their patrons began to explore the possibility of creating their own American Indian 'fine arts'. At least to begin with, this meant working in the European fine arts media of painting and sculpture.

For most Native people, exposure to these media had begun at school. Talented students drew the attention of their teachers. An instructor at the Shawnee Indian Boarding School, for example, remarked that young Earnest Spybuck (1883–1949) wanted to do nothing but draw and paint. She encouraged him, provid-

ing him with materials and basic instruction. As a young adult, Spybuck painted pictures of traditional Shawnee life based on his experience in Oklahoma. He and many of his contemporaries were aware that their dances, ceremonies and way of life were in danger of being lost. His very direct pictorial style was intended to record these things for posterity in explicit narrative detail. Such anthropological self-consciousness was shared by several artists of his generation. Spybuck knew he was producing an 'auto-ethnography'.

The Santa Fe Indian School in New Mexico was an important training ground for young artists. There Fred Kabotie (1900–1986), a Hopi, quickly distinguished himself with watercolour paintings of the Hopi kachina dances. Other artists such as Stephen Mopope, an Oklahoma Kiowa, Alphonso Roybal and Otis Polenema from the South-West, also began to make pictures in which the ceremonies and regalia of their peoples were reproduced in ethnographic detail.

The 'Studio School' introduced the next generation of young artists to the ideas first explored by Kabotie, Mopope, and their contemporaries. Alan Houser (b. 1915), the son of one of Geronimo's Chiricahua band, became one of the most accomplished exponents of the 'Studio Style'. He eventually achieved fame with his monumental sculptures. Fully conversant with the latest ideas in aesthetics, Houser was convinced that American Indian art was defined not racially, but culturally, and that artists must express their experience in all its diversity.

| Stephen Mopope
DANCER WITH BUSTLE
| 1929, Kiowa.
Watercolour on paper,
27.7 x 17.8 cm (10 7/8 x 7 in).
| National Museum of the American Indian, New York.

| Kay WalkingStick
VENERE ALPINA
| 1997, Cherokee.
Oil on canvas, steel mesh with mixed media,
81.3 x 162.6 cm (32 x 64 in).
| Collection of the artist.

Truman Lowe |
CANYON SERIES: SUMMER SOLSTICE
BIRD FORMS
1995, Winnebago.
Mixed media on paper,
101.6 x 58.4 cm (40 x 23 in).
Jan Cicero Gallery, Chicago.

Jaune Quick-to-See Smith, on the other hand, a painter of Salish ancestry, chose a quite different path, becoming a powerful polemicist and a leader among the Native artists of her time. In her work, issues of identity, land and the environment predominate.

Emmi Whitehorse brings from her Navajo background a perception of and reverence for the pervading forces and energies that animate the earth. She describes her paintings as microcosms of a larger reality, images of the invisible life that swarms through, around and within the cosmos.

| Jaune Quick-to-See Smith
TALKING TO THE ANCESTORS
| 1994, Salish.
| Oil and mixed media on canvas,
| 152.4 x 127 cm (60 x 50 in).
| Jan Cicero Gallery, Chicago.

Truman Lowe grew up in a Winnebago community of Wisconsin and has never lived far from it. He makes constructions fabricated of wood, often using peeled and trimmed saplings bound together with lashings. His forms stem from traditional architecture (the sapling frame wigwams of the woodlands tribes), canoes and baskets, but veer off into many unexpected directions. Not all Native people grow up within strong traditional communities. Kay Walking Stick is the descendant of a well-known Oklahoma Cherokee lineage, but she grew up with her white mother in Syracuse. She pursued the craft of painter in New York city. Her work was minimalist, non-representational, rigorous and difficult. With her grounding in the avant-garde art world, she explored what it meant to be a Native person. Her most recent series of works are inspired by travels in Italy, one of the great traditional sources of European art. The landscape

portion of *"Venere Alpina"* is bathed in a Mediterranean light. The non-representational side is constructed of steel mesh rushed a golden brown. "It's about aging," she mused when asked about it. The slash down the centre is filled with violet rhinestones of plastic.

As the 21st century approaches, Native American culture can no longer be understood within merely local frames of reference. Native people are citizens of the world with special gifts inherited from the past. Their art has never been static; it has always drawn new energy from new experiences. These artists, like their ancestors, rework the traditions of the past and adapt them to the requirements of the future.

Emmi Whitehorse
MEADOW
1996, Navajo.
Oil and chalk on canvas,
101.6 x 127 cm (40 x 50 in).
Jan Cicero Gallery, Chicago.

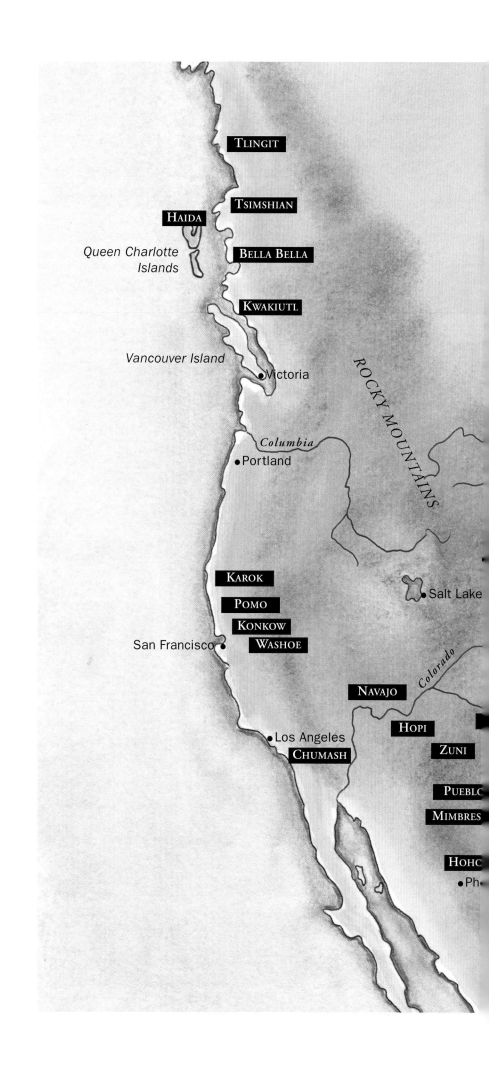

**North American Indian
Tribes and Cultures**

TLINGIT

TSIMSHIAN

HAIDA

*Queen Charlotte
Islands*

BELLA BELLA

KWAKIUTL

Vancouver Island

•Victoria

ROCKY MOUNTAINS

Columbia

•Portland

KAROK

•Salt Lake

POMO

KONKOW

Colorado

San Francisco •

WASHOE

NAVAJO

HOPI

•Los Angeles

ZUNI

CHUMASH

PUEBLO

MIMBRES

HOHC

•Ph

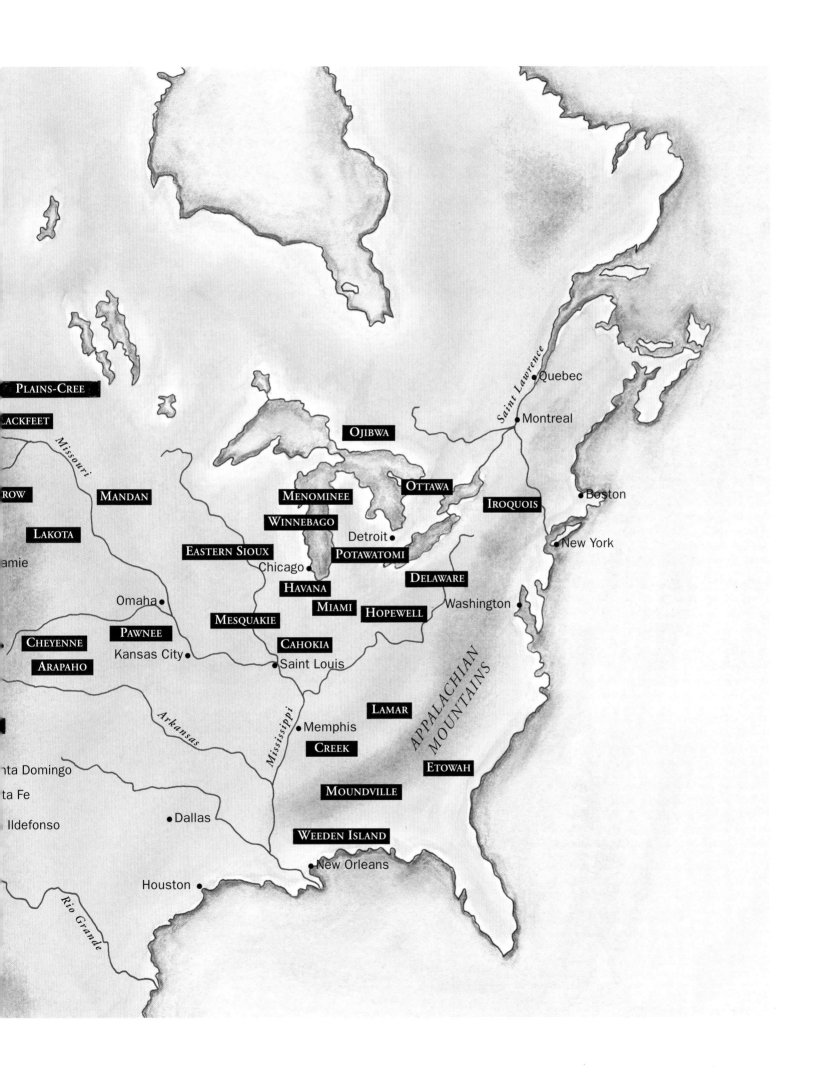

PLAINS-CREE

BLACKFEET

Missouri

ROW

MANDAN

LAKOTA

amie

CHEYENNE

ARAPAHO

Omaha

PAWNEE

Kansas City

nta Domingo

ta Fe

Ildefonso

Dallas

Houston

Rio Grande

Ojibwa

Ottawa

MENOMINEE

WINNEBAGO

Detroit

EASTERN SIOUX

POTAWATOMI

Chicago

HAVANA

MIAMI

HOPEWELL

MESQUAKIE

CAHOKIA

Saint Louis

Arkansas

LAMAR

Memphis

Mississippi

CREEK

MOUNDVILLE

WEEDEN ISLAND

New Orleans

Saint Lawrence

Quebec

Montreal

Boston

IROQUOIS

New York

DELAWARE

Washington

APPALACHIAN MOUNTAINS

ETOWAH

Bibliography

Helen Abbott (ed.), *The Spirit Within: North-West Coast Art from the John H. Hauberg Collection*, Seattle Art Museum, Seattle, 1995.

Lawrence Abbott (ed.), *I Stand in the Center of the Good: Interview with Contemporary Native American Artists*, University of Nebraska Press, Lincoln, Nebraska, 1994.

Suzanne Abel-Vidor et al., *Remember Your Relations: The Elsie Allen Baskets, Family and Friends,* Heyday Books with the Grace Hudson Museum and the Oakland Museum of California, Berkeley, 1996.

Janet C. Berlo, *Plains Indian Drawing 1860–1930*, American Association of Arts, New York, 1996.

Bruce Bernstein and W. Jackson Rushing, *Modern by Tradition: American Indian Painting in the Studio Style*, Museum of New Mexico Press, Santa Fe, 1995.

Ted J. Brasser, *Bo'jou, Neejee!: Profiles of Canadian Indian Art*, National Museum of Man, Ottawa, 1976.

David S. Brose, James W. Brown, and David W. Penney, *Ancient Art of the American Woodland Indians*, Harry N. Abrams, New York, 1985.

David S. Brose and N'iomi Greber, *Hopewell Archaeology*, Kent State University Press, Kent, 1979.

Ruth L. Bunzel, *Zuni Kachinas*, reprint of the Bureau of American Ethnology Annual Report, vol. 47, Rio Grande Press, Glorieta, New Mexico, 1984.

Joseph R. Caldwell and Robert L. Hall, *Hopewellian Studies*, Illinois State Museum Scientific Papers, vol. 12, Springfield, Illinois, 1964.

Linda S. Cordell, *Prehistory of the South-West*, Academic Press, San Diego, 1984.

John C. Ewers, *Plains Indian Sculpture: A Traditional Art from America's Heartland*, Smithsonian Institution Press, Washington, D.C., 1986.

Patricia Galloway (ed.), *The South-Eastern Ceremonial Complex: Artifacts and Analysis,* University of Nebraska Press, Lincoln, 1989.

Bill Holm, *North-West Coast Indian Art: An Analysis of Form,* University of Washington Press, Seattle, 1965.

Aldona Jonaitis, *Art of the Northern Tlingit,* University of Washington Press, Seattle, 1986.

Aldona Jonaitis, *From the Land of the Totem Poles*, American Museum of Natural History, New York, 1988.

Aldona Jonaitis (ed.), *Chiefly Feasts: The Enduring Kwakiutl Potlatch*, American Museum of Natural History, New York, 1991.

Stoval Pechham, *From this Earth: The Ancient Art of Pueblo Pottery*, Museum of New Mexico Press, Santa Fe, 1990.

David W. Penney, *Art of the American Indian Frontier: The Chandler/Pohrt Collection*, University of Washington Press, Seattle, 1992.

David W. Penney (ed.), *Great Lakes Indian Art*, Wayne State University Press, Detroit, 1989.

Ruth Phillips, *Patterns of Power: The Jasper Grant Collection and Great Lakes Indian Art of the Early Nineteenth Century*, McMichael Canadian Collection, Kleinberg, Ontario, 1984.

A.C. Roosevelt and J.G.E. Smith (eds.), *The Ancestors: Native Artisans of the Americas,* Museum of the American Indian, Heye Foundation, New York, 1979.

Alph H. Secakuku, *Following the Sun and Moon: Hopi Kachina Traditions,* The Heard Museum, Phoenix, 1995.

Mark F. Seeman: *The Hopewell Interaction Sphere: The Evidence for Interregional Trade and Structural Complexity*, Indian Historical Society Prehistory Research Series, vol. 5, no. 2, Indianapolis, 1979.

Tryntje Van Ness Seymour, *When the Rainbow Touches Down*, The Heard Museum, Phoenix, 1988.

E.L. Wade (ed.), *Arts of the North American Indian: Native Traditions in Evolution*, Hudson Hills Press, New York, 1986.

Alan Wardwell, *Tangible Visions: North-West Coast Indian Shamanism and Its Art*, Monacelli Press, New York, 1996.

Andrew Whiteford et al., *I Am Here: Two Thousand Years of South-West Indian Arts and Culture*, Museum of New Mexico Press, Santa Fe, 1989.

Lydia L. Wyckoff (ed.), *Visions + Voices: Native American Painting from the Philbrook Museum of Art*, The Philbrook Museum of Art, Tulsa, 1996.

Photographic credits

American Museum of Natural History, courtesy of the Department of Library Services, New York: pp. 168 (# K16509), 186 (# 336624). American Museum of Natural History, Dosseter: pp. 162-162 (# 44309). American Museum of Natural History, Lynton Gardiner: pp. 188-189 (# 4524), 191 (# 4531). British Museum, London: p. 34. The Brooklyn Museum, New York, Henry W. Henshaw: pp. 146-147, 155. Collection of the Musée de l'Homme, Paris: pp. 166, 178, 179. Courtesy of Kay WalkingStick: p. 200 (below). Courtesy of Jan Cicero Gallery: pp. 201, 202, 203. Courtesy of the US Department of the Interior, Indian Arts and Crafts Board, Washington: pp. 136-137. The Detroit Institute of Arts, Detroit, Dirk Bakker: pp. 2, 5, 12, 14-15, 16, 18, 22, 23, 24 (above, right and left), 25, 26, 27, 29, 32-33, 37, 39, 40, 42, 42-43, 44, 45, 47, 49, 50, 51 (above and below), 63 (Pohrt Collection), 78 (Pohrt Collection), 79, 87, 88 (above and below), 88-89, 90 (above and below), 91 (left and right), 96, 99 (left and right), 100 (Pohrt Collection), 101, 102, 112, 118, 119, 120, 122, 123, 125, 132, 133, 134, 135, 150, 151, 185 (Pohrt Collection). The Detroit Institute of Arts, R. H. Hensleigh: pp. 59, 60, 61, 62, 64-65, 66, 67, 68, 69, 74, 75, 80 (Pohrt Collection), 80-81 (above, Pohrt Collection), 82, 84 (Pohrt Collection), 96-97, 111, 126, 130 (left and right). The Detroit Institute of Arts, W. M. Oaks: p. 56 (Pohrt Collection). Explorer, Paris, Alain Thomas: pp. 114-115, 121, 127, 136. Explorer, François Gohier: pp. 116, 165. Explorer, C. Lenars: p. 197. Explorer, Sylvain Cordier: p. 164. Explorer, FGP International, New York: pp. 10-11, 128-129. Explorer, Keystone, New York: p. 140. Field Museum of Natural History, Chicago, Ron Testa: pp. 20, 21. Heard Museum, Phoenix: p. 199. Joselyn Art Museum, Omaha: p. 73 (Gift of the Enron Art Foundation). Milwaukee Public Museum, Milwaukee, Sumner Mateson: pp. 54-55, 98. Museum of New Mexico, School of American Research Collections, Santa Fe, Douglas Kahn: pp. 139 (cat. 9406), 141 (cat. 9315), 143 (cat. 9168). National Museum of American Indian, Smithsonian Institution, New York: pp. 6, 52, 58, 71, 76, 76-77, 83, 104, 107, 108-109, 148, 153, 157, 171, 181, 182-183, 183 (below), 184, 185, 198. National Museum of American Indian, Smithsonian Institution, Pamela Dewey: cover, pp. 85, 93. National Museum of American Indian, Smithsonian Institution, David Heald: pp. 41, 48, 95, 138, 149, 154, 158-159, 160, 169, 174, 174-175, 200 (right). National Museum of American Indian, Smithsonian Institution, K. Furth: pp. 46, 86, 144, 192-193. National Museum of Natural History, Department of Anthropology, Smithsonian Institution: pp. 105 (above and below), 106, 110. Peabody Museum of Archeology and Ethnology, Harvard University, Cambridge, Hillel Burger: pp. 19, 103. Philbrook Museum of Art, Tulsa: p. 159. Portland Art Museum, Portland: pp. 172, 173, 194, 195. Royal British Columbia Museum, Victoria: p. 189 (below, # 9201). Seattle Art Museum, Seattle, Paul Macapia: pp. 170, 176-177, 196 (Gift of John H. Hauberg). Thaw Collection, Fenimore House Museum, Cooperstown, John Bigelow Taylor: pp. 94, 124, 152, 180, 187, 190. University Museum of Pennsylvania, Philadelphia: p. 167 (# NA 8502). © Smithsonian Institution

This book is printed in
ITALY - Grafiche Zanini - Bologna